500 FIGURES IN CLAY

Ceramic Artists Celebrate the Human Form

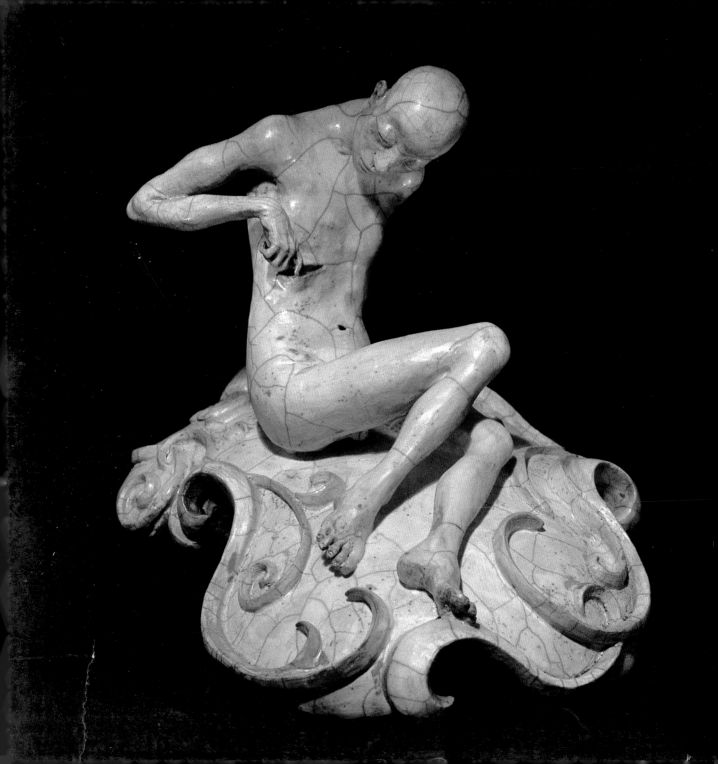

Ceramic Artists Celebrate the Human Form

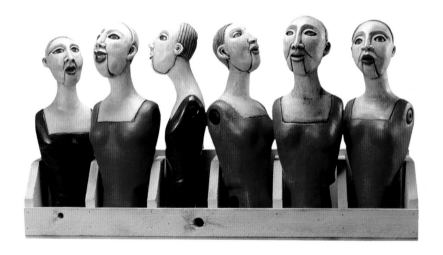

LARK BOOKS

A Division of Sterling Publishing Co., Inc.
New York / London

EDITOR: Veronika Alice Gunter
ART DIRECTOR: Stacey Budge

COVER DESIGNER: Barbara Zaretsky

ASSISTANT EDITOR: Nathalie Mornu
ASSISTANT ART DIRECTOR: Lance Wille
ASSOCIATE ART DIRECTOR: Shannon Yokeley
ART INTERNS: Melanie Cooper, Jason Thompson
EDITORIAL ASSISTANCE: Dawn Dillingham,
 Delores Gosnell, Rosemary Kast,
 Jeff Hamilton
EDITORIAL INTERNS: Meghan McGuire,
 Rebecca Guthrie, Kalin E. Siegwald,
 Ryan Sniatecki

COVER IMAGE:
Fred Yokel
Just Let Go, 1999
Photo by Roger Dunn

BACK COVER:
(Left)
Logan Wood
Invitation, 2003
Photo by Black Cat Studio

(Right)
Melody Ellis
Puppet Master, 2003
Photo by artist

SPINE:
Joy Brown
Sitter with Knees Up, 2000
Photo by Bobby Hansson

FRONT FLAP:
Sergei Isupov
Moody, 2003
Photo by Katherine Wetzel

BACK FLAP:
Adrian Arleo
Pretending, 2000
Photo by Chris Autio

TITLE PAGE:
(Left)
Justin Novak
Disfigurine #24, 2001
Photo by artist

(Right)
Barb Doll
Embodied Series #8, 2000
Photo by Bart Kasten

CONTENTS PAGE:
Wesley Anderegg
Man with Magic Hat, 2003
Photo by artist

Library of Congress Cataloging-in-Publication Data

500 figures in clay : ceramic artists celebrate the human form / [editor, Veronika Alice Gunter].
 p. cm.
 Includes index.
 ISBN 1-57990-547-1 (pbk.)
 1. Figure sculpture—20th century. 2. Figure sculpture—21st century. 3. Ceramic sculpture—20th century.
4. Ceramic sculpture—21st century. I. Title: Five hundred figures in clay. II. Gunter, Veronika Alice.
NB1930.A15 2004
731'.82—dc22
 2004001610

10 9 8 7 6

Published by Lark Books, A Division of
Sterling Publishing Co., Inc.
387 Park Avenue South, New York, N.Y. 10016

© 2004, Lark Books

Distributed in Canada by Sterling Publishing,
c/o Canadian Manda Group, 165 Dufferin Street
Toronto, Ontario, Canada M6K 3H6

Distributed in the United Kingdom by GMC Distribution Services,
Castle Place, 166 High Street, Lewes, East Sussex, England BN7 1XU

Distributed in Australia by Capricorn Link (Australia) Pty Ltd.,
P.O. Box 704, Windsor, NSW 2756 Australia

If you have questions or comments about this book, please contact:
Lark Books
67 Broadway
Asheville, NC 28801
(828) 253-0467

Manufactured in China

ISBN13: 978-1-57990-547-7
ISBN10: 1-57990-547-1

For information about custom editions, special sales, premium and corporate purchases, please contact Sterling Special Sales Department at 800-805-5489 or specialsales@sterlingpub.com.

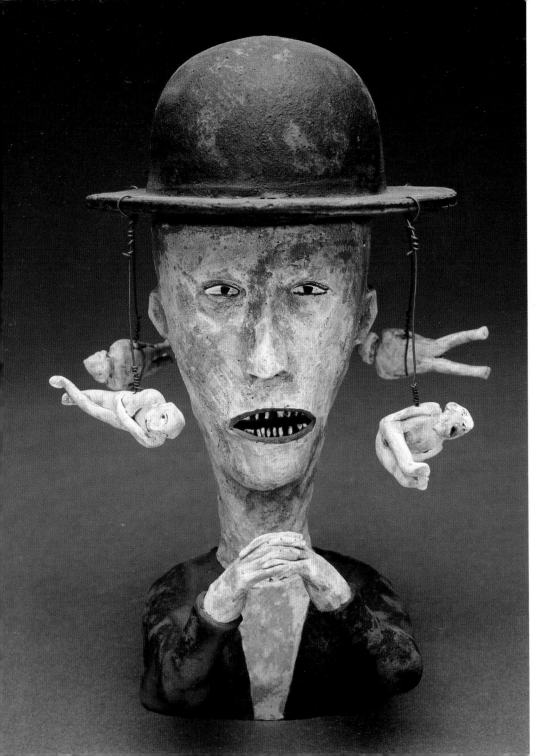

CONTENTS

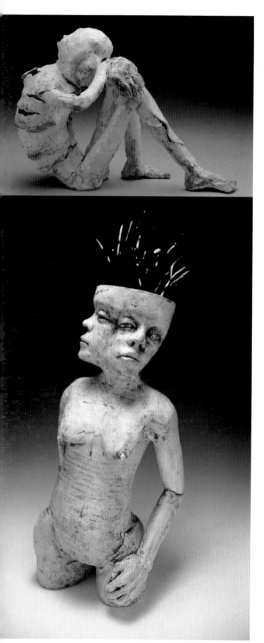

INTRODUCTION

Figural ceramic work is by nature narrative—as is much of the content in contemporary sculpture, painting, and photography. It tells a story. Today's strongest figural artwork presents subjects, tells their stories, and asks questions that provoke, titillate, and stimulate the viewer. This collection provides 500 examples of such work.

It is common for contemporary art to probe and present an extreme viewpoint, and this book demonstrates that trend. Extremes of anatomy are more common than accurate physical representation. The work is not always pretty or pleasant to look at; sometimes beauty is sacrificed entirely and shock value is instead the goal. Commentary on politics, religion, sex, and physical health is so pervasive that it is hard to identify a work in which one of these issues is not at the forefront.

Jim Budde's featured work focuses on political issues. He depicts current events in *Dubya,* and he draws from our past in *Calling Nixon.* Russell Biles plays with the color and scale of collectible figurines in his political satire. *Raw Recruit* features a child in fatigues with scenes from a cable television network reflected in her oversized eyes—a comment on television's power over our children, with reference to media's portrayal of violence, specifically war coverage. Biles uses religious iconography in *Mary Had A Little Lamb (Second Coming)* to satirize the issue of cloning.

The memoir or diary format that's been rediscovered in literature and film is evident among the many portraits and ensembles included in this collection. Other artists use surrealism to delve into personal, psychological elements of their lives. Judy Fox and Coille Hooven explore sexuality in their representations of female adolescence, while Sergei Isupov's work interprets universal relationships between men and women. Janis Mars Wunderlich's *Parenting is No Cup of Tea* and Kathryn McBride's *Mother's Balancing Act: Cirque C'est La Vie Series,* both narrative works, can be interpreted as exploring a feminist agenda or as straightforward autobiographical commentary on a particularly burdened and hectic stage in life.

The ceramic pieces in this book reveal that artists working in a figural format both mirror trends in the art world and reflect ideas and representations of contemporary culture. But today's artists also draw upon the scope of art history. Much of the artwork included in this book directly references figural work from the past in both form and content. Comparisons can be made to the erotic fertility figures from Peru, religious statuary of Christ on the cross or Mary with her infant, busts of cultural icons such as Shakespeare and Mozart, and the Chinese Warriors from the Tomb of Qinshihuang.

Chris Antemann uses the tradition of eighteenth-century Staffordshire figures to feature herself in a contemporary setting. Michelle Erickson freely associates historic periods to create her own world of blended decorative art. Red Weldon Sandlin uses the

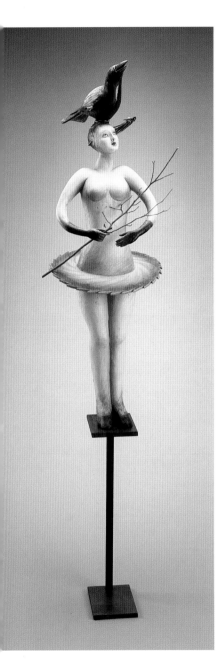

painting style featured on Chinese porcelain to illustrate interpretations of children's literature in her piece *The Chinese Quin Teapots,* based on *The Five Chinese Brothers*.

Most of the work featured in this collection was produced in the year or months preceding the fall of 2003. By the end of 2003, 1,200 artists had responded to an international call for submissions. More than 2,000 images of original artwork had arrived, presenting a sweeping survey of figurative ceramic work. Lark Books President Rob Pulleyn, Ceramics Editor Suzanne Tourtillott, Editor Veronika Gunter, Art Director Stacey Budge, and I reviewed the images. In making selections for this collection, we considered the quality and strength of each piece's concept and its execution.

Then, there was the challenge of organizing our selections. Should we present the work according to subject, such as autobiography, politics, portraits, or surrealism? The connections within one artist's body of work, or between a single artwork and another, quickly became tangled. How to organize a presentation of so many images with such intricate webs of connections? In the end, the artworks all but sorted themselves into chapters delineated by common physical characteristics or dominant content.

The chapters Heads & Busts, Torsos, and Body Details showcase work in which the outside shape is similar but scale and surface show variations and unique points of view. Issues of health, disease, deformity, and amputation are often explored.

Figurines & Statues, the largest chapter in the book, groups pieces based on the classic presentation of a single sculpture.

Couples & Multiples is perhaps the most varied chapter in the book in terms of physical characteristics, scale, message, and structure of the works featured.

In both the Caricature and Metamorphosis chapters, the content is clearly foremost. Throughout each, there is a running commentary on both the human condition and human nature.

Two-Dimensional Works is a chapter devoted to artworks in that format. The unifying element is surface decoration, often with the figure painted on the ceramic object.

What does this enormous group of figural work reveal to us about the interpretations of the human form at this time? What connections or conclusions can be drawn from the similarities in form and content? From my perspective, this body of work exhibits a commentary on issues of the day. It also reveals that, while the human form has remained relatively unchanged since man walked upright millions of years ago, the capacity of the human imagination to interpret and re-invent that form is unlimited.

Leslie Ferrin, Ferrin Gallery, Lenox, Massachusetts

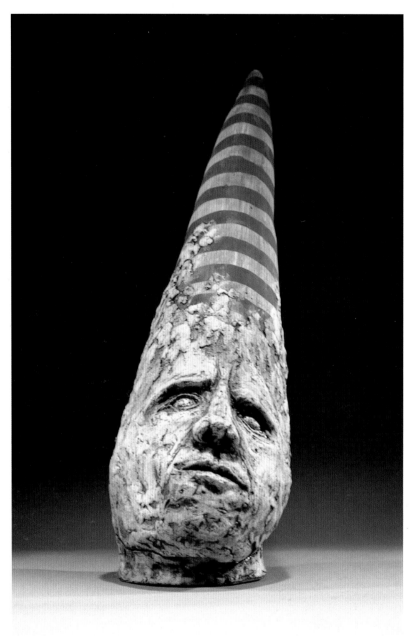

MICHAEL A. PRATHER
Large Self-Portrait, 2003

24 x 6 x 9 in. (61 x 15 x 23 cm)

Ceramic; black iron oxide wash; cone 06

Photo by artist

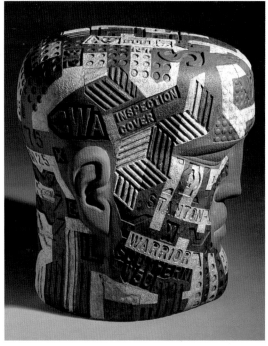

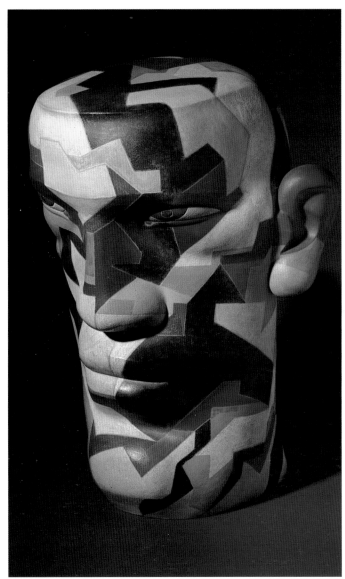

ANTHONY BENNETT
ABOVE
Urban Head II, 2002
14 ½ x 14 ½ in. (37 x 37 cm)

White earthenware; press molded,
pre-cast sections, slip cast; colored slips

Photo by Peter Greenhalf

LEFT
Gun Head, 2002

17 x 12 in. (43 x 31 cm)

White earthenware; slip cast; colored slips

Photo by Peter Greenhalf

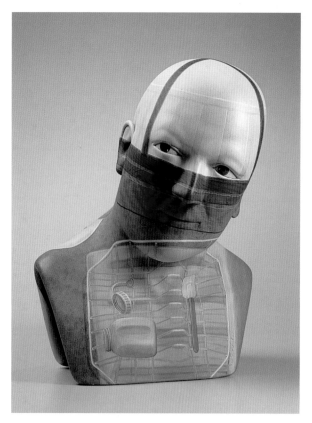

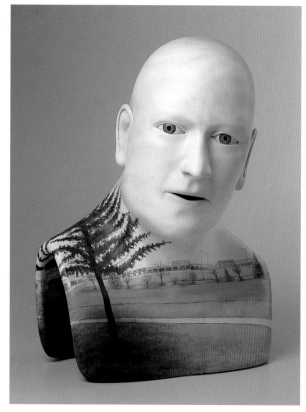

JOHN WOODWARD
LEFT
Kitchen Sink, 2002
28 x 18 x 16 in. (71 x 46 x 41 cm)
Painted ceramic
Photo by Tim Thayer

RIGHT
South Hill, 2001
27 x 20 x 18 in. (69 x 51 x 46 cm)
Painted ceramic
Photo by Tim Thayer

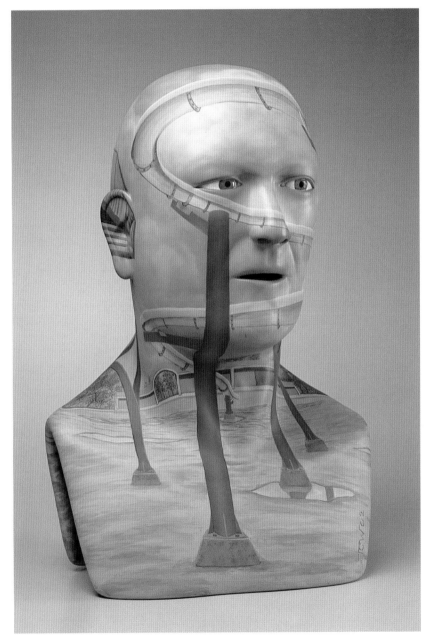

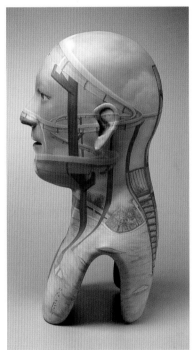

JOHN WOODWARD
Waterslide, 2002

29 x 18 x 16 in. (74 x 46 x 41 cm)

Painted ceramic

Photo by Tim Thayer

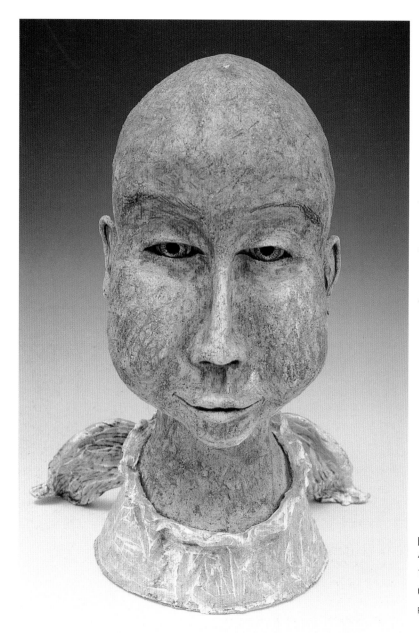

The head of this piece is hollow, as are the pupils of the eyes. The interior of the head has been painted and can be illuminated from a light placed inside the neck.

KINA CROW
Angel, 2003
18 x 12 x 9 in. (46 x 31 x 23 cm)
Coil-built earthenware; glazes, underglazes
Photo by Anthony Cuhna

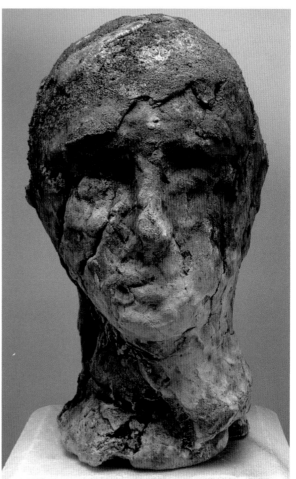

JEFF HAMILTON
Smoke-fired Mask, 2001

12 x 7 x 4 in. (31 x 18 x 10 cm)

Clay

Photo by Tim Barnwell

JIM JANSMA
Head on Marble Base, 1997

17 x 10 x 13 in. (43 x 25 x 33 cm)

Stoneware; anagama, wood-fired

Photo by Shirley A. Koehler

The two-faced figure invokes duplicity, or the folding of double images in conflict that is at once personal and universal—facing up to unpleasant truths in a post-modern world.

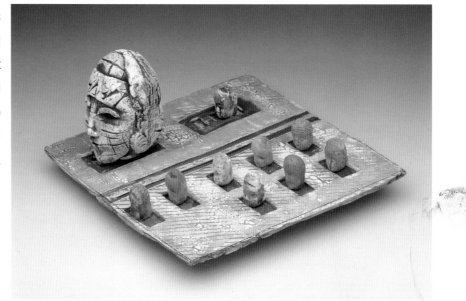

IRITH LEPKIN
ABOVE
Conflict, 2003

5 ¼ x 10 ¼ x 10 ¼ in. (13 x 26 x 26 cm)

Hand-built earthenware

Photo by Dale Roddick

LYNNE MCCARTHY
BELOW
Three Heads Are Better Than Two, 2002

12 x 24 x 4 in. (31 x 61 x 10 cm)

Raku clay, wood base; molded, paddled

Left head: underglaze, glaze; cone 05

Middle head: tung oil, pigments; unfired

Right head: bisque cone 04, saggar-fired electric with organic materials and copper wire

Photo by Michael Noa

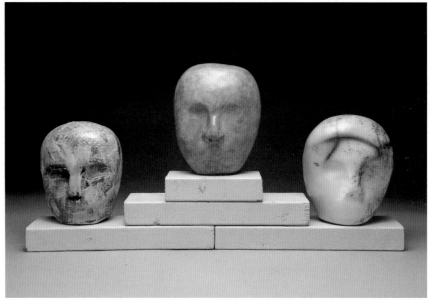

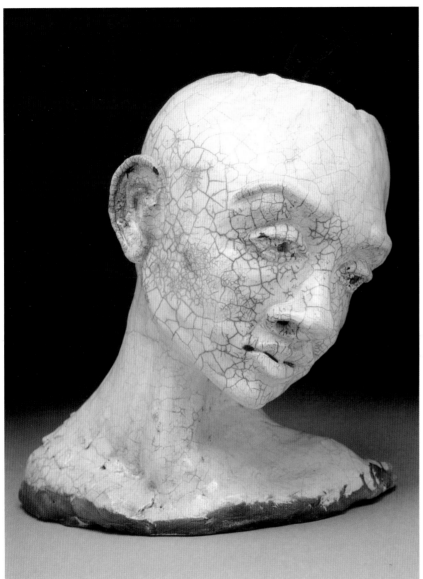

I was inspired by Joe Bova's slab relief technique from the *Penland Book of Ceramics*. It is amazing how you just push from the inside, then push from the outside, and the features emerge. Everything you need for sculpting is there.

JIM NEAL
White Raku Face, 2003

12 x 13 x 8 in. (31 x 33 x 20 cm)

White raku clay; clear crackle glaze; raku-fired with sawdust and paper

Photo by Michael Noa

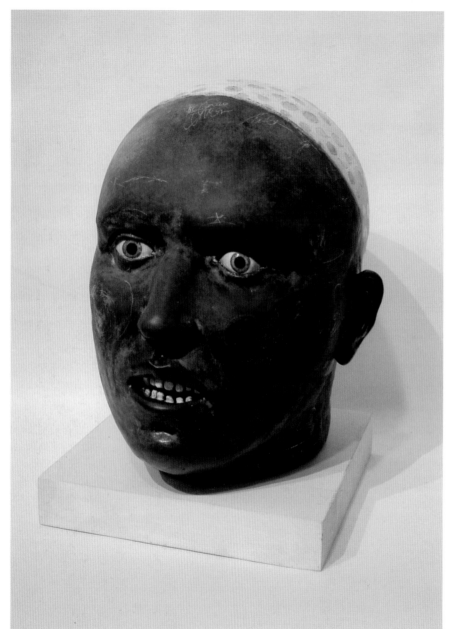

CRISTINA CORDOVA
Constelacion, 2003

17 x 10 x 12 in. (43 x 25 x 31 cm)

Stoneware; resin, silver leaf, wood, acid-etched glaze

Photo courtesy of Ann Nathan Gallery

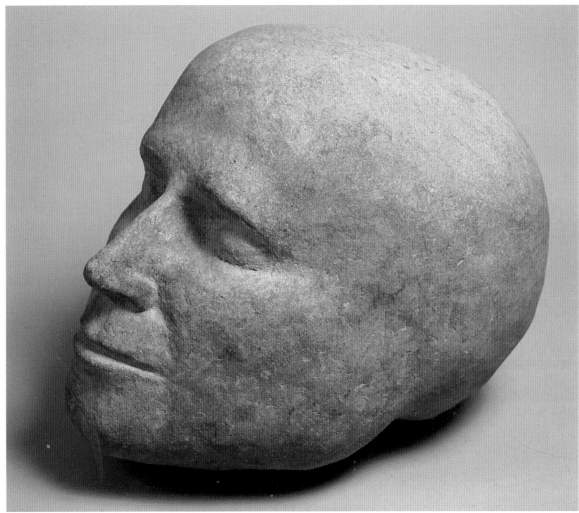

Artia was a goddess of Abundance, Strength, and Harvest.

DANIEL RHODES
Artia, 1989
19 x 17 in. (48 x 43 cm)
Stoneware; wood-fired
Photo by Gary Huibregtse
In the private collection of Marybeth Coulter

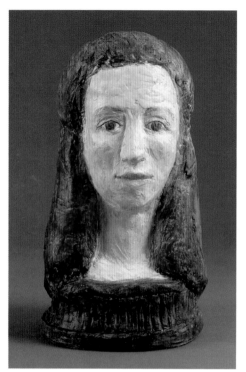

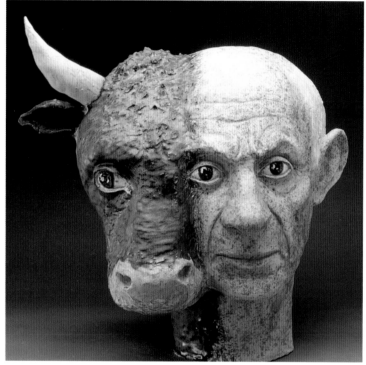

JOAN N. WATKINS
Portrait of a Woman, 2002

11 ½ x 6 ½ x 6 ½ in. (28 x 16 x 16 cm)

Low-fire white clay; coil built; acrylic paints,
acrylic glazes; bisque cone 04 electric

Photo by Richard Nicol

NOI VOLKOV
Great Picasso, 2003

17 x 17 x 12 in. (43 x 43 x 31 cm)

Hand-built earthenware; mixed
media

Photo by John De Camillo

DIANE EISENBACH
Captured Moment, 2000

14 x 12 x 10 in. (36 x 31 x 25 cm)

Stoneware, porcelain; hand built

Photo by artist

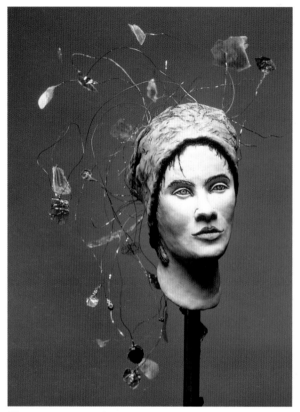

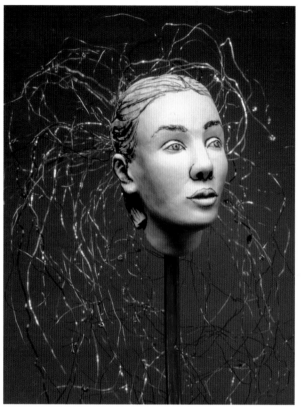

These are part of a
series based on the
sense of touch.

JUDY MOONELIS
LEFT
Touch Portrait (Pink Hat), 2000

63 x 10 x 10 in. (160 x 25 x 25 cm)

Porcelain; hand built, pinched;
copper, mica, glass

Photo by Malcolm Varon

RIGHT
Touch Portrait (Molly), 2000

68 x 9 x 7 in. (173 x 23 x 18 cm)

Porcelain; hand built, pinched; copper

Photo by Malcolm Varon

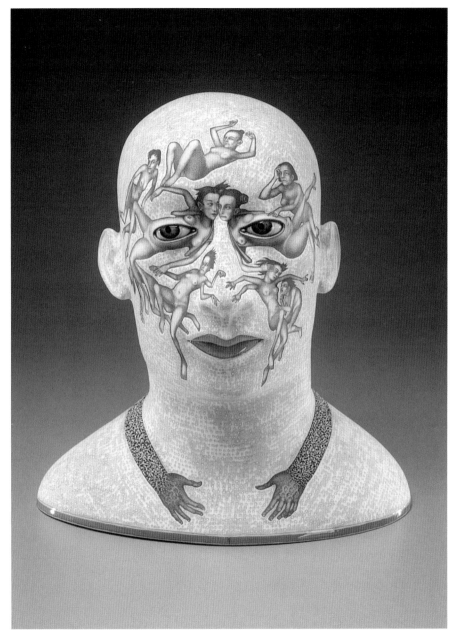

SERGEI ISUPOV
Links, 2002

13 x 11 ¾ x 9 ½ in. (33 x 30 x 24 cm)

Porcelain; glaze

Photo courtesy of Ferrin Gallery

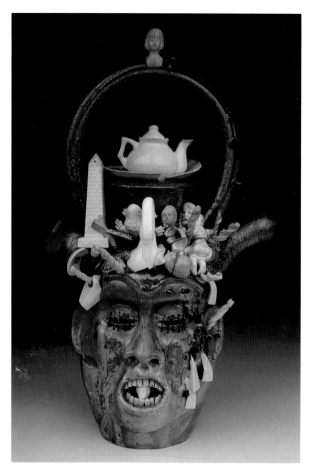 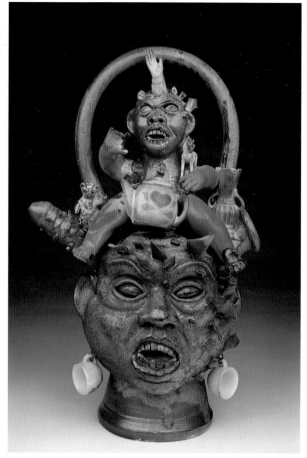

PETER LENZO
LEFT
Face Jug Fetish 9/11/2001—Prayer for the Dead, 2001

22 x 9 ½ x 8 in. (56 x 24 x 20 cm)

Porcelain, stoneware; salt glazed, found objects

Photo by David Ramsey

RIGHT
Face Jug Fetish—Red Lady, 2002

17 x 8 x 8 in. (43 x 20 x 20 cm)

Porcelain, stoneware; salt glazed, found objects

Photo by David Ramsey

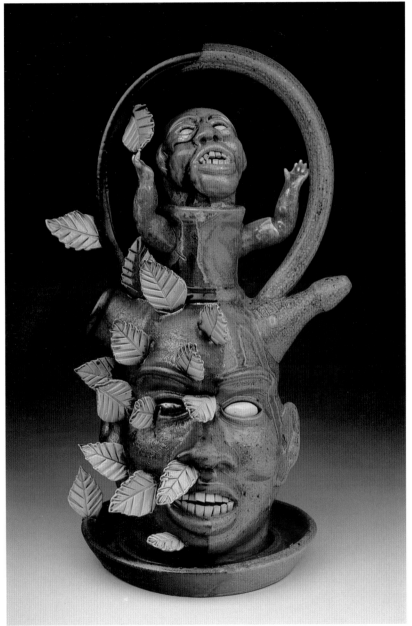

PETER LENZO
Face Jug Fetish—Prayer, 2001

22 x 9 ½ x 8 ½ in. (56 x 24 x 21 cm)

Porcelain, stoneware; salt glazed, found objects

Photo by David Ramsey

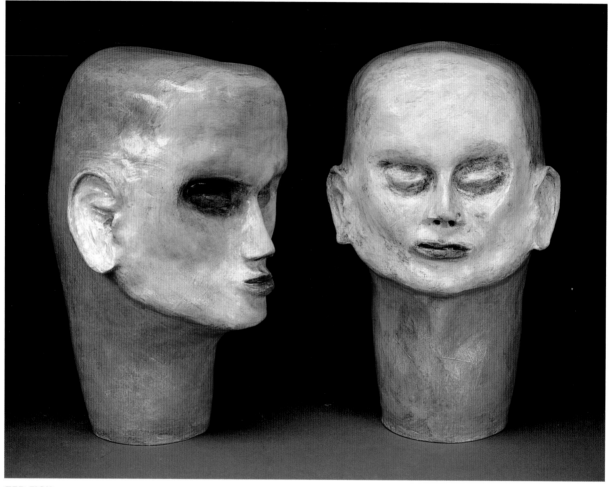

TED FISH
Loving Empathy, 2003

15 x 21 x 11 in. (38 x 53 x 28 cm)

Paper clay; slab built, coil built; acrylic paint; bisque-fired

Photo by Maddog Studio/John Bonath

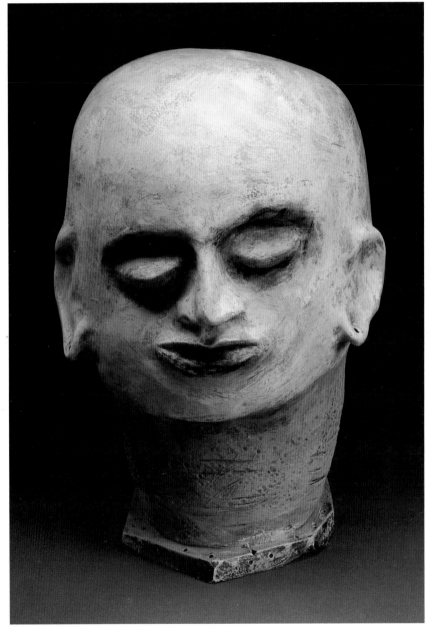

TED FISH
Priestly, 2000

13 x 9 x 9 in. (33 x 23 x 23 cm)

Paper clay; slab built, coil built;
acrylic paint; bisque-fired

Photo by Maddog Studio/John Bonath

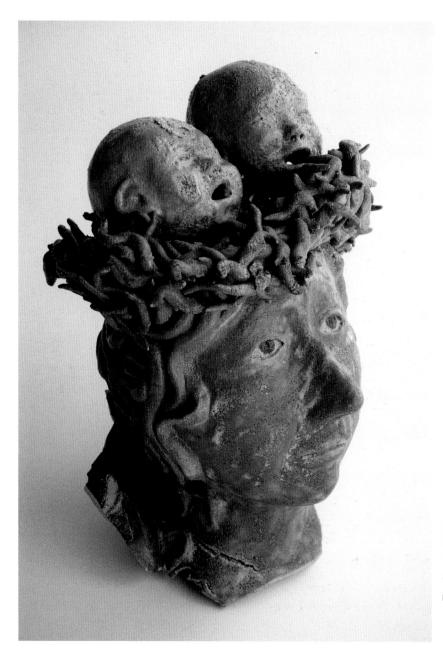

Part of my nesting series, exploring different stages of motherhood, and part of a larger body of work focusing on ambivalence toward Womanhood … the image of the nest merges ambiguously with suggestions of thorns and the snaky hair of the Medusa.

DEBORAH KAPLAN EVANS
Trial By Fire, 2003
14 x 12 x 11 in. (36 x 31 x 28 cm)
Coil-built stoneware; cone 5
Photo by Richard White

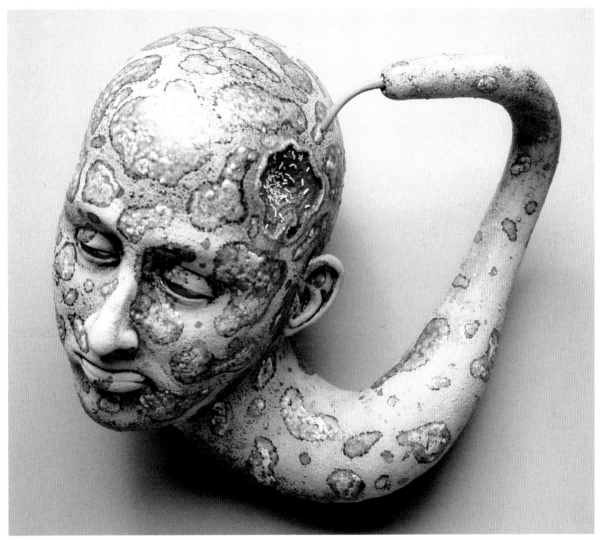

JARED JANOVEC
Touched, 2003

10 x 14 x 10 in. (25 x 36 x 25 cm)

Hand-built earthenware; engobes, glazes

Photo by artist

JEAN-PIERRE LAROCQUE
RIGHT
Untitled (head series), 2002

36 ¾ x 21 x 18 ½ in. (93 x 53 x 47 cm)

Glazed stoneware

Photo by Pierre Lontin

MARTY SHUTER
BELOW
The Rocket Scientist and the
Stone Carver, 2001

24 x 42 x 24 in. (61 x 107 x 61 cm)

Low-fire ceramic

Photo by Jerry Anthony

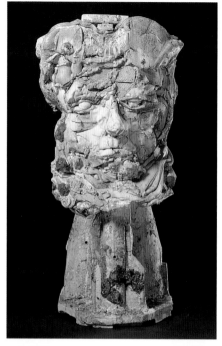

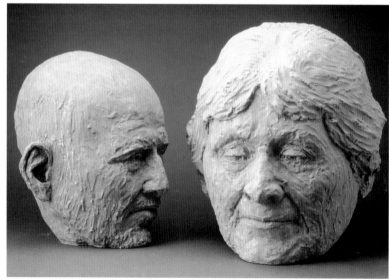

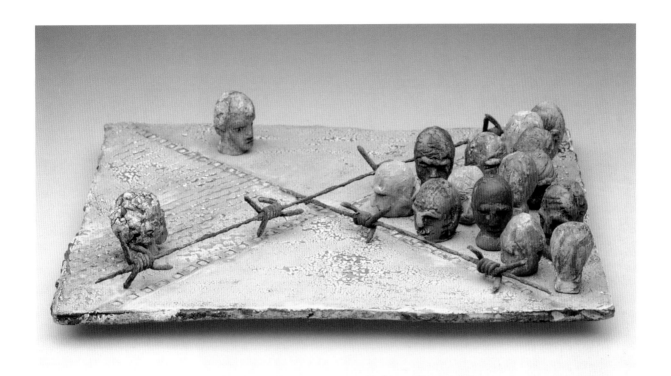

The figures appear behind barbed wire. The imprisonment is universal, for each face could belong to any creature trapped behind prison bars.

IRITH LEPKIN
Closed Quarter, 2003

3 ¾ x 10 ¼ x 10 ¼ in.
(10 x 26 x 26 cm)

Hand-built earthenware; barbed wire

Photo by Dale Roddick

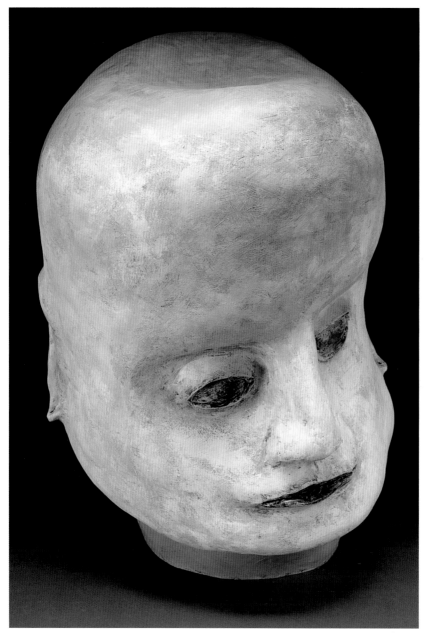

TED FISH
She Turned Her Head, 2002

24 x 16 x 22 in. (61 x 41 x 56 cm)

Paper clay; slab built, coil built;
acrylic paint; bisque-fired

Photo by Maddog Studio/John Bonath

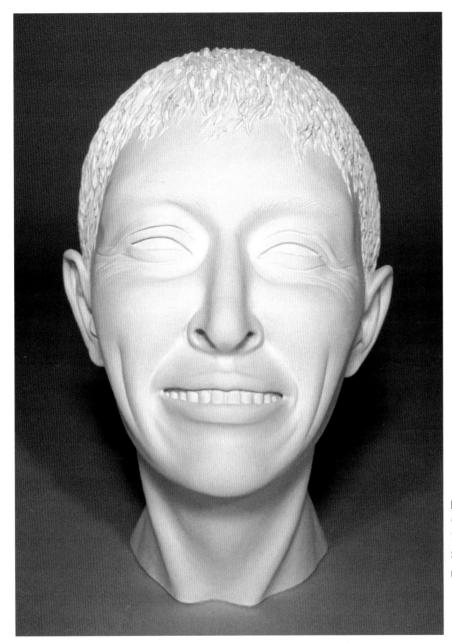

DIANE EISENBACH
Fleeting Memory, 2000

14 x 8 x 11 in. (35 x 20 x 27 cm)

Stoneware, porcelain; hand built

Photo by artist

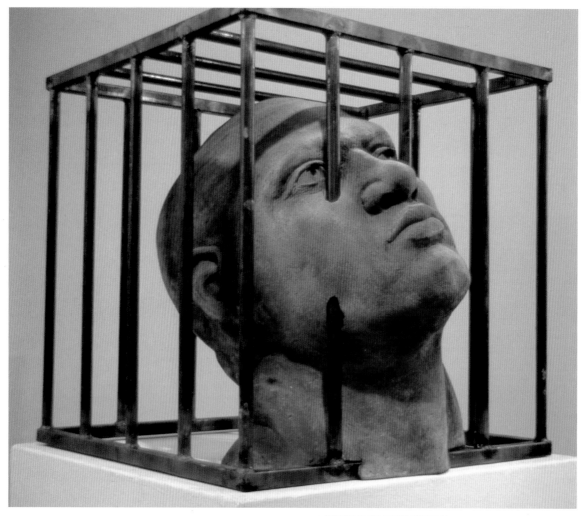

KEITH WALLACE SMITH
Incarceration, 1999

27 x 27 x 34 in. (69 x 69 x 86 cm)

Low-fire earthenware, ceramic, iron; press
molded, slab construction; engobe

Photo by Alan Cheuvront

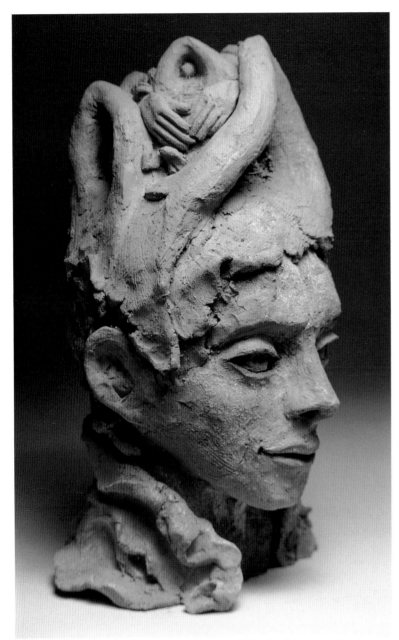

The color and texture of this piece are a result of sawdust in the clay body.

LAURA O'DONNELL
Nest, 2002

16 x 9 x 10 in. (41 x 23 x 25 cm)

Head: hand-built earthenware, cone 02 reduction

Bird: porcelain; cone 02 reduction

Photos by Chris Berti

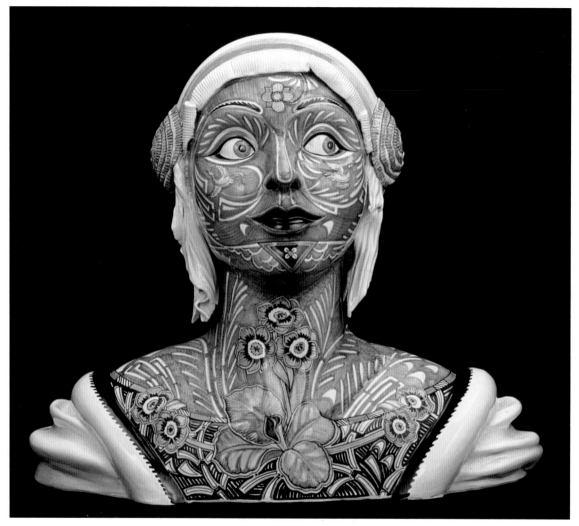

CONNIE KIENER
Wholly Girl, 2003

15 x 17 x 9 in. (38 x 43 x 23 cm)

Maiolica ceramic; earthenware glaze

Photo by Bill Bachober
Courtesy of Ferrin Gallery

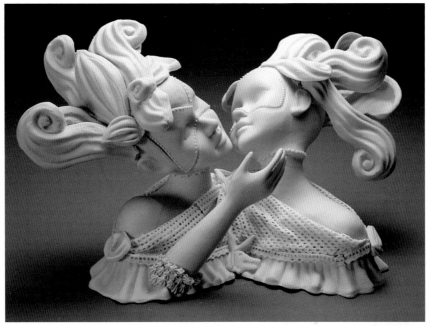

KATY RUSH
ABOVE
Dual Headvase, 2002

7 x 11 x 8 in. (18 x 28 x 20 cm)

Porcelain; slip-cast, altered; cone 6

Photo by artist

NOBUHITO NISHIGAWARA
RIGHT
Nobuism, 2002

24 x 21 x 11 in. (61 x 53 x 28 cm)

Hand-built porcelain; polished

Photo by artist

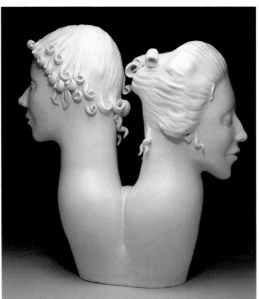

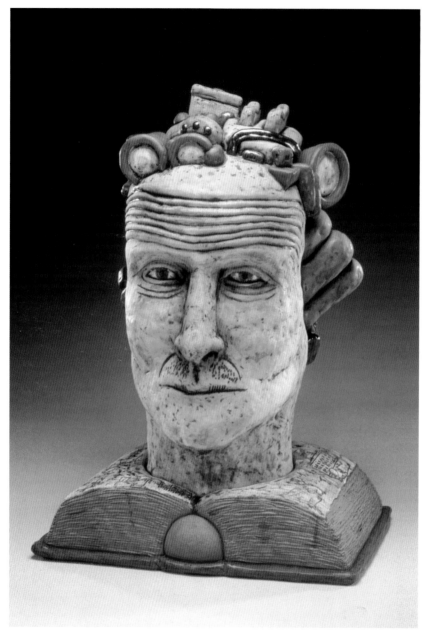

ALLAN ROSENBAUM
Tale, 2002

28 x 19 x 15 in. (71 x 48 x 38 cm)

Hand-built earthenware; stain, glaze

Photo by Katherine Wetzel

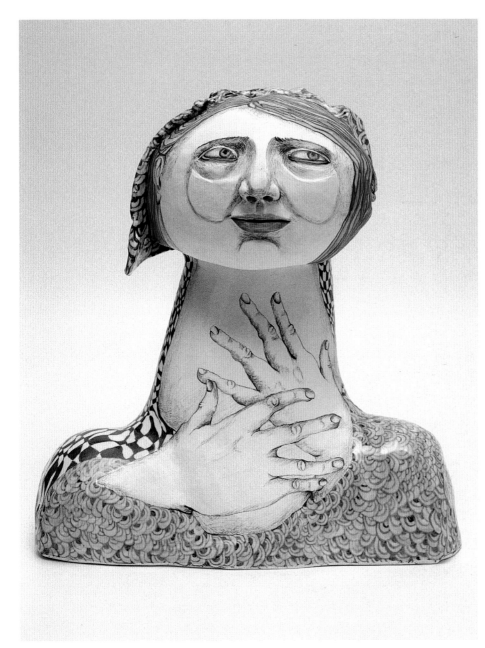

MARYLOU HIGGINS
Pondering, 2003

12 ½ x 12 x 5 in. (32 x 31 x 13 cm)

Slab-built stoneware

Photo by Edward Higgins

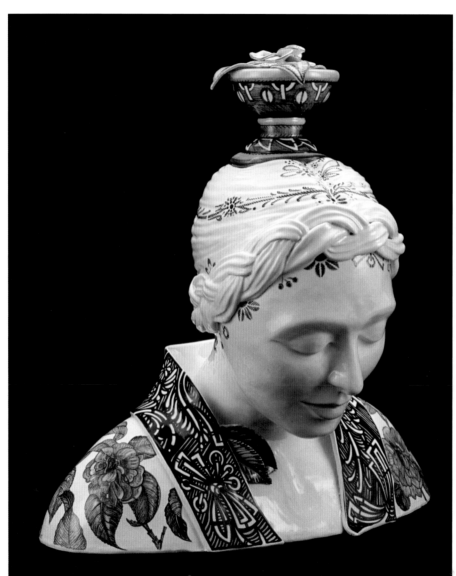

CONNIE KIENER
Camille, 2003

17 x 17 x 9 in. (43 x 43 x 23 cm)

Maiolica ceramic; earthenware glaze

Photo by Bill Bachober
Courtesy of Ferrin Gallery

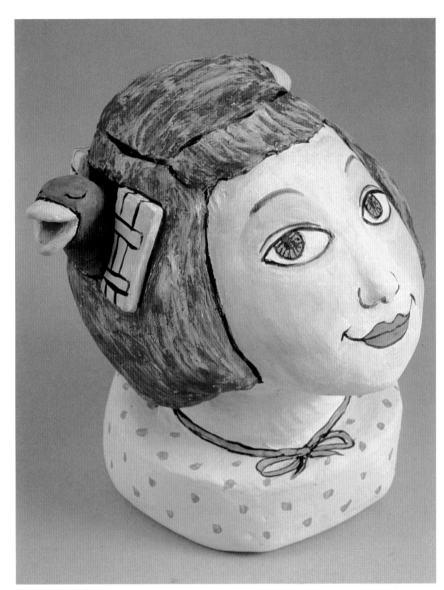

JOAN N. WATKINS
Music Lover, 2003

7 x 7 x 6 ½ in. (18 x 18 x 16 cm)

Low-fire white clay; slab built, coil built;
acrylic paints, acrylic glazes; bisque
cone 04 electric

Photo by Richard Nicol

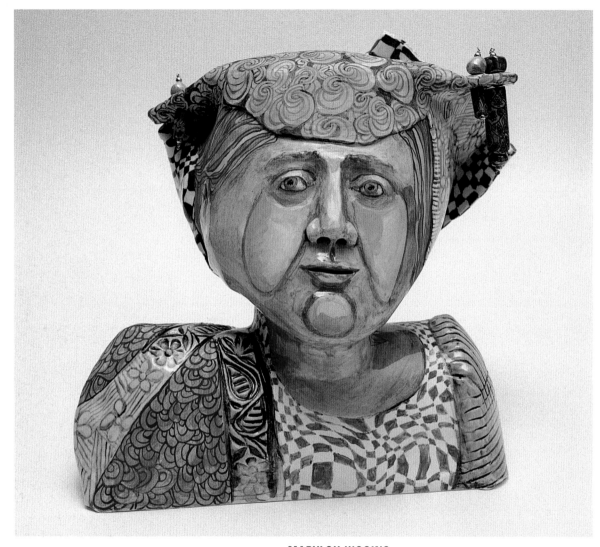

MARYLOU HIGGINS
Anticipating, 2003

9 ½ x 10 ½ x 9 in. (24 x 27 x 23 cm)

Slab-built stoneware

Photo by Edward Higgins

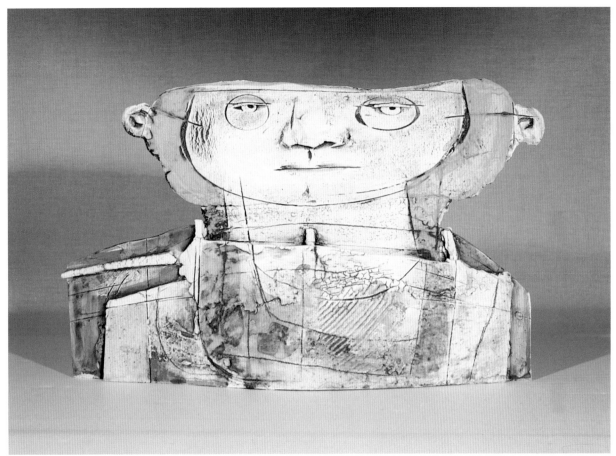

My inspiration comes from people I see or experiences I've had. Usually very insignificant observations spark something in my head: when I'm working on my car I'll look at my distributor cap and it'll give me ideas for my next figure. I try to find a form that I like and then incorporate the figure into it.

CHRISTY KEENEY
Flat Head, 2003
16 x 8 x 4 in. (41 x 20 x 10 cm)
Raku crank clay; hand built; kiln-fired

Photo by artist

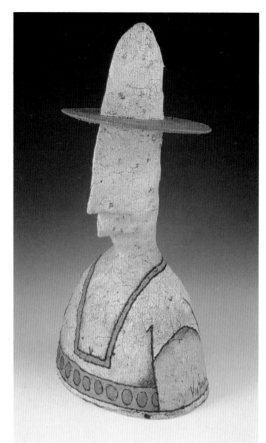

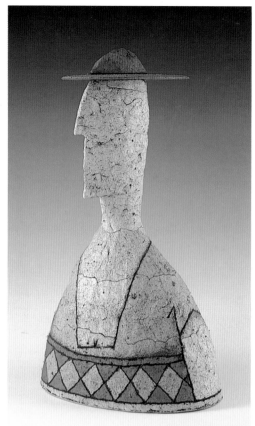

RIMAS VISGIRDA
LEFT
Even Cowgirls Get the Blues, 2000

16 x 8 x 6 in. (41 x 20 x 15 cm)

White stoneware with decomposed granite; coil built;
wax inlay, pencil shading, glaze, ceramic decal, lusters

Photo by artist

RIGHT
Mamas Don't Let Your Babies Grow Up to Be Cowboys II, 2002-2003

16 ½ x 9 ½ x 6 ½ in. (42 x 24 x 16 cm)

White stoneware with decomposed granite; coil built;
wax inlay, pencil shading, glaze, ceramic decal, lusters

Photo by artist

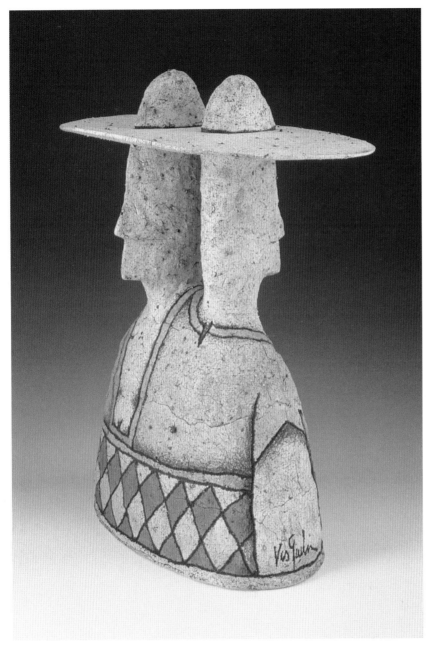

RIMAS VISGIRDA
*Looking Toward the Future,
Thinking About the Past,* 2000

15 x 11 x 6 ½ in. (38 x 28 x 16 cm)

White stoneware with decomposed
granite; coil built; wax inlay, pencil
shading, glaze, ceramic decal, lusters

Photo by artist

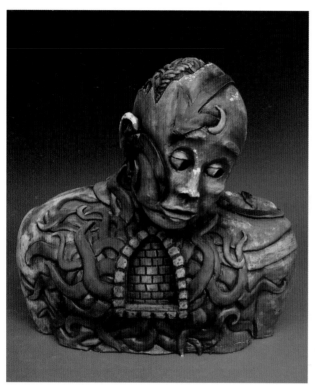 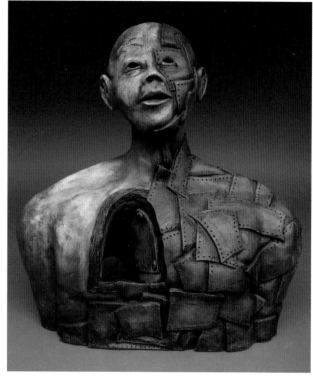

TY DIMIG
LEFT
Melancholy, 2001

20 x 22 x 10 in. (51 x 56 x 25 cm)

Ceramic; slips, stains; cone 1

Photo by artist

RIGHT
And So It Goes, 2001

24 x 22 x 11 in. (61 x 56 x 28 cm)

Low-fire ceramic; slips, stains; reduction

Photo by artist

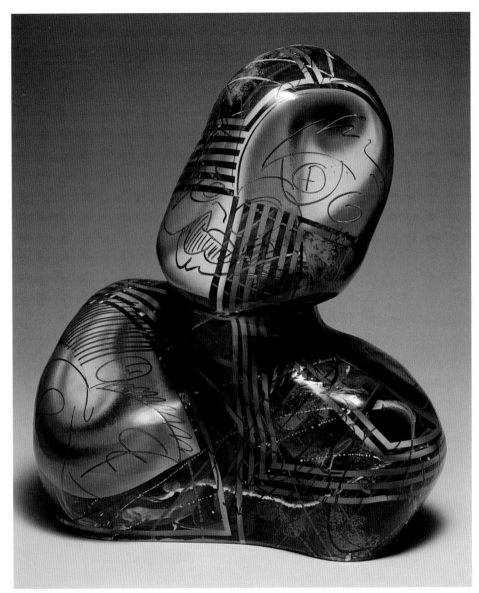

TOM HUBERT
Purple Haze, 1998

22 x 20 x 12 in. (56 x 51 x 31 cm)

Low-fire whiteware; underglaze,
clear glaze; multi-fired

Photo by artist

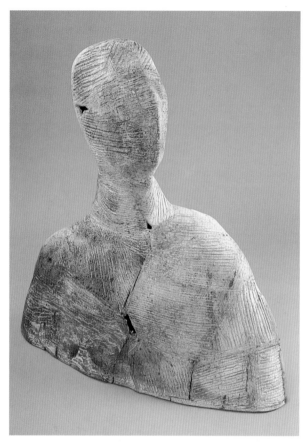

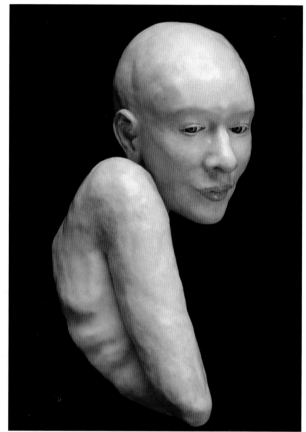

VERBRUGGEN MARC
*Look at the Clouds
(portrait series),* 2001

35 ¾ x 33 ¾ x 8 ¾ in. (91 x 86 x 22 cm)

Grogged white stoneware; slab built;
slips, oxides; 2012˚F (1100˚C)
gas reduction

Photo by Hans Vuylsteke

ANDREA E. HULL
Propheteer, 2003

17 x 9 x 6 in. (43 x 23 x 15 cm)

Hand-built stoneware; slip,
mason stains, glaze; cone 04

Photo by Walker Montgomery

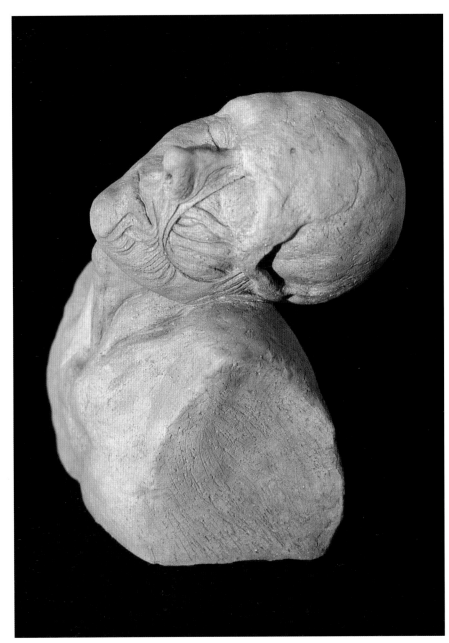

The focus of my practice is the study of the human form through drawing and sculpture. The evolving nature of my research includes interests in the figurative sculpture traditions of the past, particularly the accidental images created by fragments of ancient sculpture, as well as the study of structure.

KAREN LOUISE FLETCHER
Fragment IV, 2001

9 ¾ x 9 x 6 in. (25 x 23 x 15 cm)

Polychromed earthenware; solid built; copper

Photo by artist

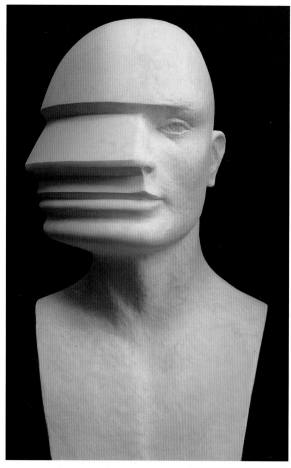

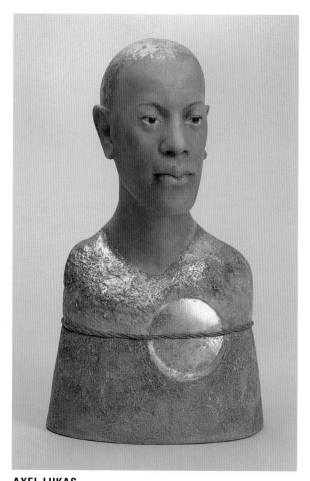

LEONID SIVERIVER
Motion, 2001

21 x 11 x 9 in. (53 x 28 x 23 cm)

Cast stoneware; unglazed

Photo by artist

AXEL LUKAS
Untitled, 2003

12 x 8 ½ x 6 in. (31 x 21 x 15 cm)

Cast porcelain; multi-layered
paint; multi-fired

Photo by artist

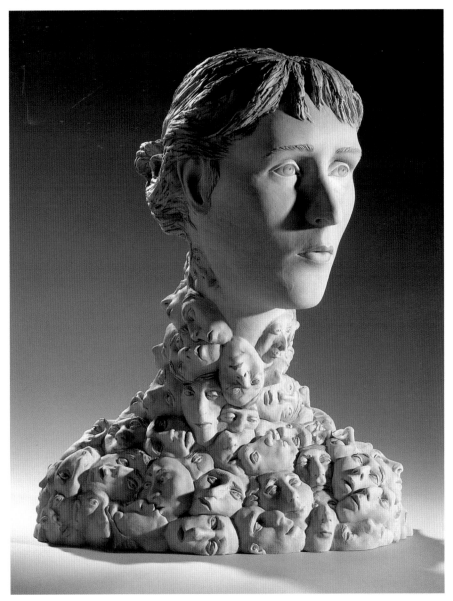

Woman with Many Faces shows the community of friends that makes up her support system. I liked using the small faces as texture on the piece.

BEVERLY MAYERI
Woman with Many Faces, 1998

18 x 12 x 15 in. (46 x 31 x 38 cm)

Low-fire clay; coil built on newspaper armature; acrylic paints

Photo by Craig Kolb

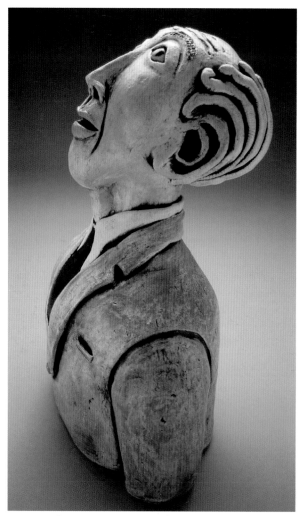

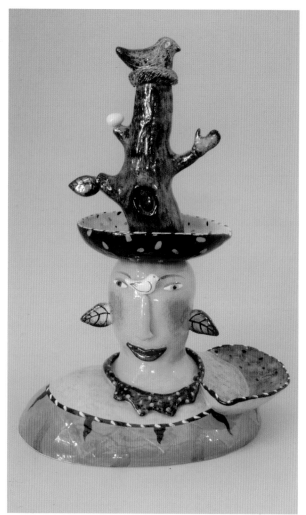

REGINA ACOSTA TOBIN
Pink Slipped, 2003

9 ½ x 8 x 4 ½ in. (24 x 20 x 11 cm)

Coil-built raku clay; underglazes,
sealer; cone 06, cone 04

Photo by Jeffrey Tobin

**SUSAN GARSON AND
THOMAS PAKELE**
Treelady, 2003

18 x 13 x 8 ¼ in. (46 x 33 x 21 cm)

Earthenware; cast, hand built

Photo by artists

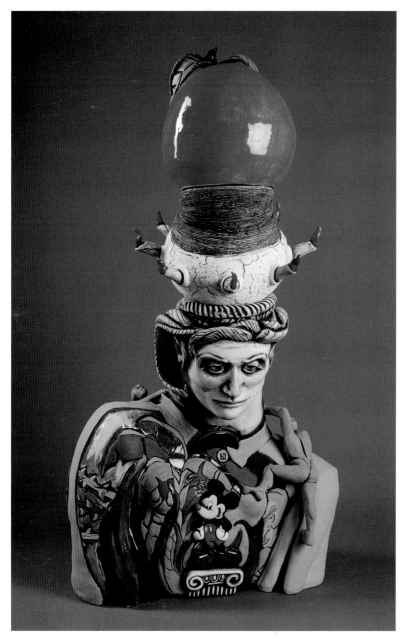

I feel that I am a student of human nature and am ceaselessly unsettled, bewildered, bemused, and amused—but most of all fascinated—by mortal man and our foibles.

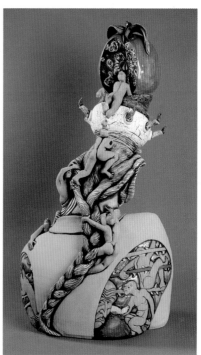

JEAN CAPPADONNA NICHOLS
Bedeviled By Thirteen Blue Demons, Mickey, And One Bad Apple, 2000

34 x 17 x 19 in. (86 x 43 x 48 cm)

White earthenware; hand built, coils on slab; underglazes, paint, stains

Photos by Jerry Mesmer, Venice, Florida
In the collection of Dr. & Mrs. Donald Loveman
Courtesy of Carol Robinson Gallery, New Orleans; Del Mano Gallery, Los Angeles; Matsumoto Gallery, Sanibel Island, Florida

 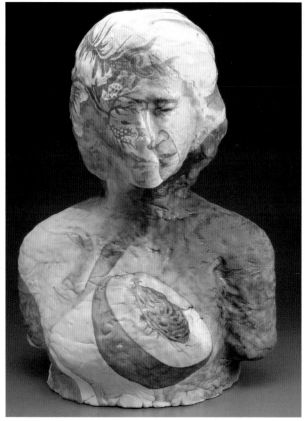

KATE BLACKLOCK
LEFT
Holding Leaves, 2003
23 x 17 x 14 in. (58 x 43 x 36 cm)
Porcelain; oils, China paint
Photo by artist

RIGHT
Peach Pit, 2003
20 x 16 x 11 in. (51 x 41 x 28 cm)
Porcelain; China paint
Photo by artist

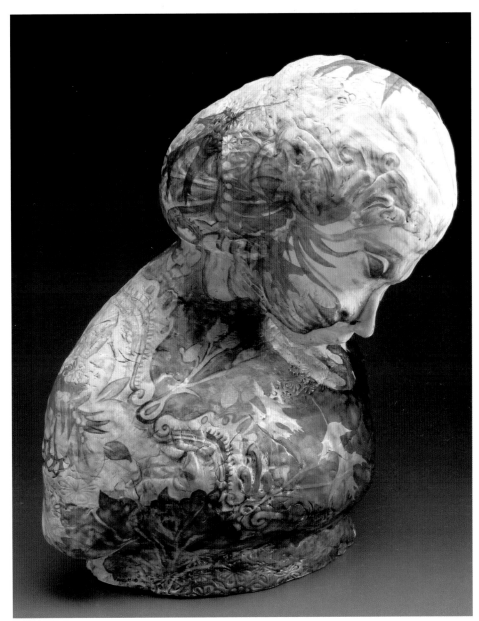

KATE BLACKLOCK
Changes, 2003

20 x 16 x 16 in. (51 x 41 x 41 cm)

Porcelain; China paint, gold luster

Photo by artist

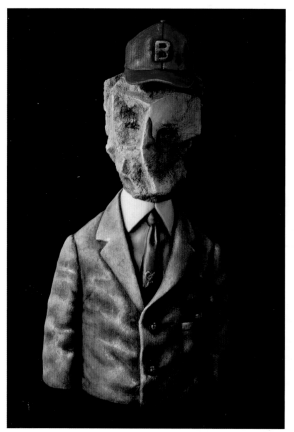

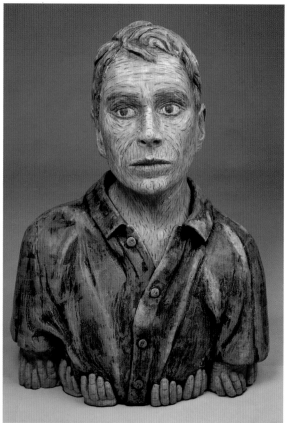

JACK EARL
Stoneman With a Cap, 2002

36 x 19 x 12 in. (91 x 48 x 31 cm)

Ceramic; oil paint

Photo courtesy of Nancy Margolis Gallery, New York

JUDITH N. CONDON
Carried Away, 2001

23 ½ x 19 ½ x 10 in. (58 x 50 x 25 cm)

Ceramic; colored slips, acrylic paints;
oxidation-fired

Photo by David Andrews

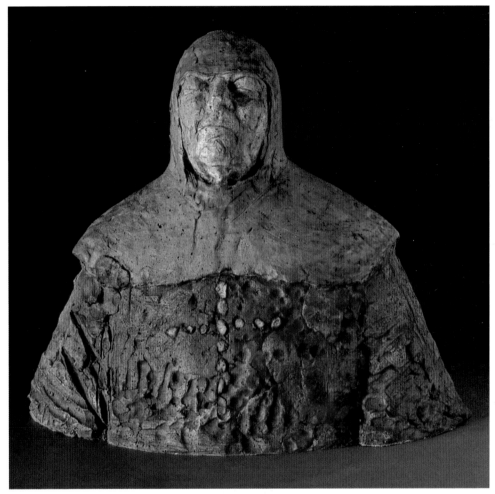

When this figure emerged, I was startled, almost shocked, to think he came out of me. Sometimes it takes intense discipline for me not to edit myself. I think he is one of my strongest pieces—precisely because I did not edit myself.

MARLENE MILLER
Sentinel, 2001

18 x 21 ½ x 10 ½ in. (46 x 55 x 27 cm)

Sculpted stoneware; ceramic stains, underglaze, acrylic; cone 6 reduction

Photo by artist
Private collection

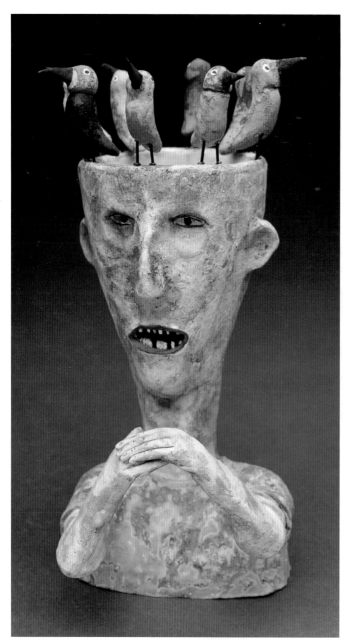

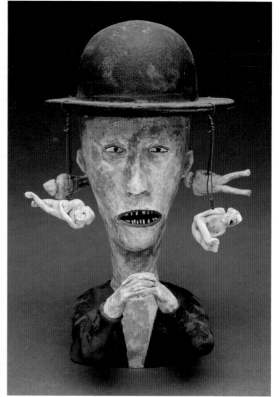

WESLEY ANDEREGG
ABOVE
Man with Magic Hat, 2003

8 x 5 x 5 in. (20 x 13 x 13 cm)

Hand-built earthenware

Photo by artist

LEFT
Bird Man, 2003

8 x 4 x 4 in. (20 x 10 x 10 cm)

Hand-built earthenware

Photo by artist

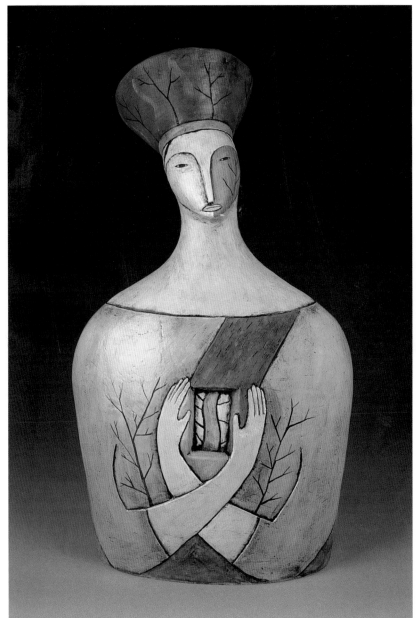

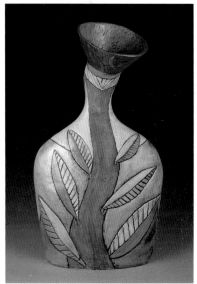

SANDRA ZEISET RICHARDSON
Waiting, 2001

23 x 12 ¾ x 7 ½ in. (59 x 32 x 19 cm)

Low-fire clay; coil built; underglazes

Photos by Stan V. Richardson

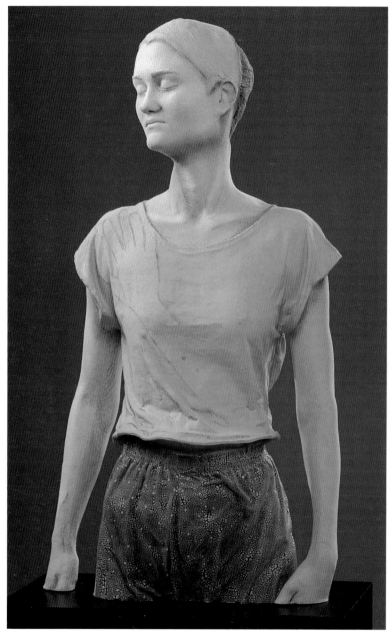

Built in sections, with fitted inner flanges

NAN SMITH
Observer: Searching For the True Self, 1993

35 x 19 x 11 in. (89 x 48 x 28 cm)

Buff earthenware; press molded, assembled; underglaze, textural glaze; cone 05 electric

Photo by Allen Cheuvront
In the collection of Wocek International Ceramic Collection, Ichon, Korea

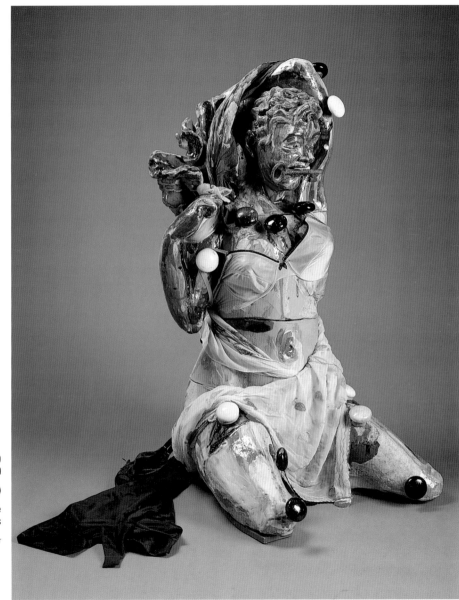

ANNE PERRIGO
Tell (Philomela), 2000

38 x 24 x 16 in. (97 x 61 x 41 cm)

Hand-built terra cotta; low-fire
glazes, China paint, found objects

Photo by Roger Schreiber

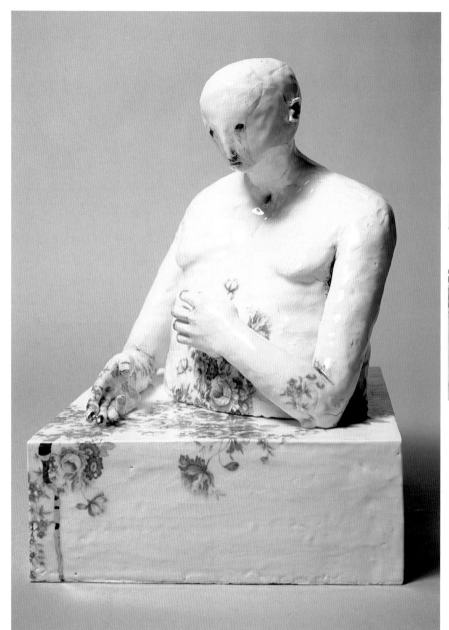

CLAIRE CURNEEN
Falling Slowly, 2003

19 ¾ x 15 x 11 ¾ in. (50 x 38 x 30 cm)

Hand-built porcelain; transparent glaze, flower decals

Photos by artist

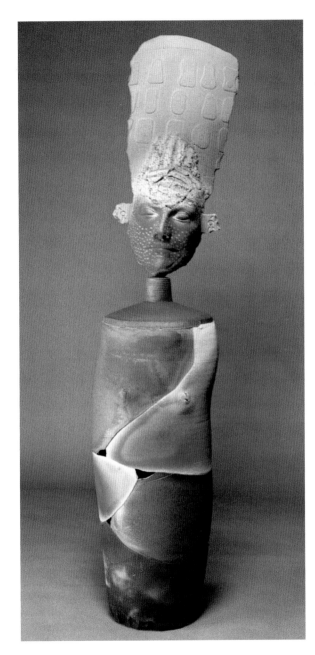

This figurative work is the synthesis of two concurrent paths of artistic discovery that I have pursued. The first path is the shard vessel series, which involved the deconstruction (breaking) and reconstruction (gluing) of the shards. The second path is the temple series, which involved architectural constructions and employed the face motif. Using both techniques and iconographies gave birth to the figure.

PATRICK S. CRABB
Dona Rosa I, 2003

45 x 8 x 8 in. (114 x 20 x 20 cm)

Ceramic; wheel thrown, press molded, glued; raku, cone 04 electric

Photos by artist

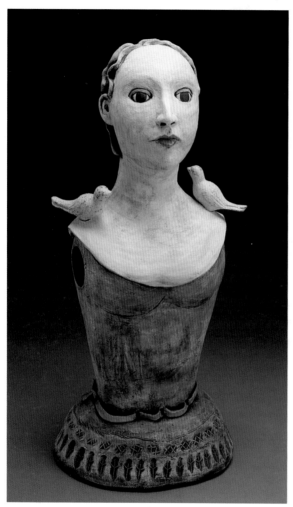

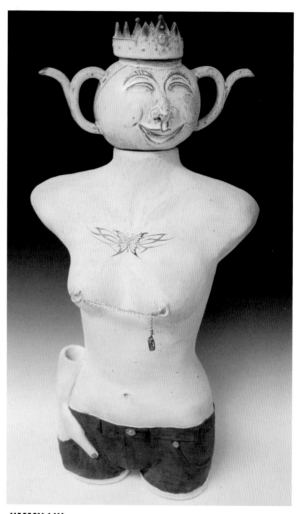

BARB DOLL
Listening to My Spirit, 2001

27 x 12 x 8 in. (69 x 31 x 20 cm)

Hand-built clay

Photo by Bart Kasten

JIMMY LIU
Queens Teapot, 2003

17 x 14 x 9 in. (43 x 36 x 23 cm)

Hand-built stoneware; cone 10

Photo by artist

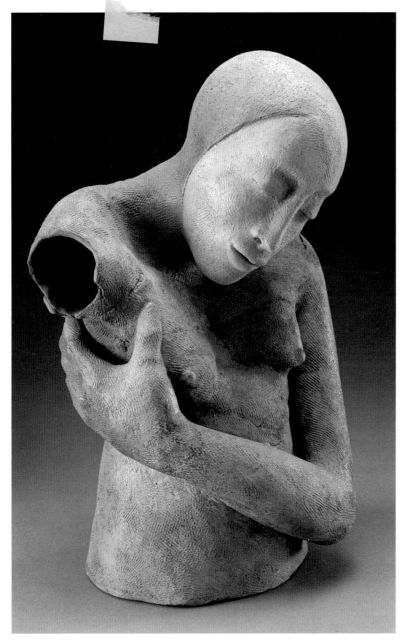

MELISA CADELL
A Memory Held Her, 2003

17 x 12 ½ x 9 in. (43 x 32 x 23 cm)

Red earthenware; extruded, coiled, slab built, pinched; engobe washes

Photo by Tom Mills

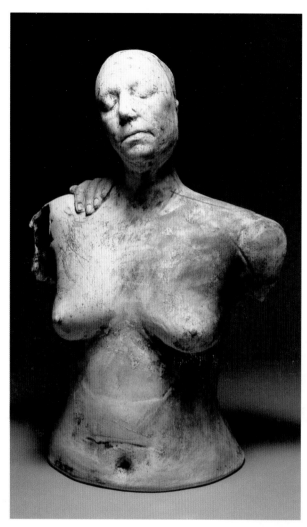

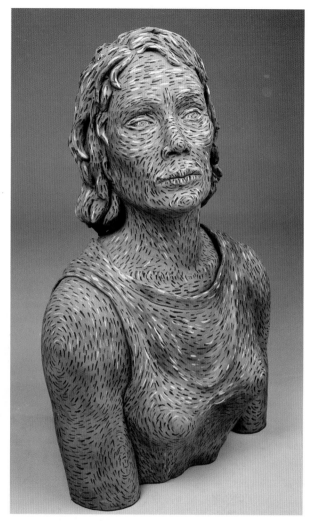

FAYE PARK
Letting Go, 1999

26 x 17 x 8 in. (66 x 43 x 20 cm)

Clay; cast body, hand building, slab
construction; low-fire stains; cone 4

Photo by Sheldon Ganstrom

JUDITH N. CONDON
Bourne, 2001

24 x 18 x 11 in. (61 x 46 x 28 cm)

Ceramic; colored slips, acrylic paints; oxidation-fired

Photo by David Andrews

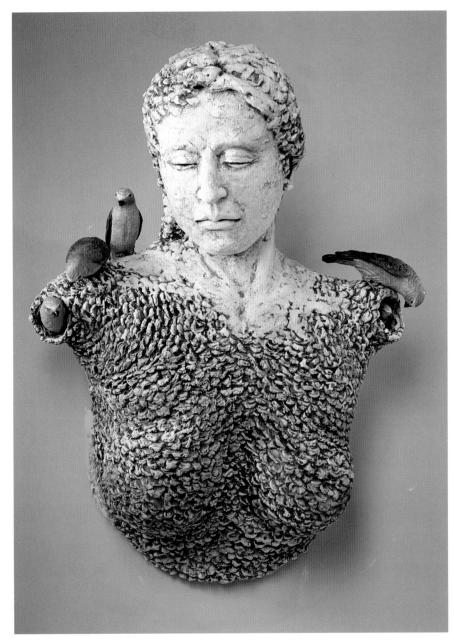

ADRIAN ARLEO
Swallow Bust, 2003

23 x 20 x 12 in. (58 x 51 x 31 cm)

Clay; hand built, coiled; glaze, wax
encaustic, added surface texture

Photo by Chris Autio
Courtesy of Ferrin Gallery

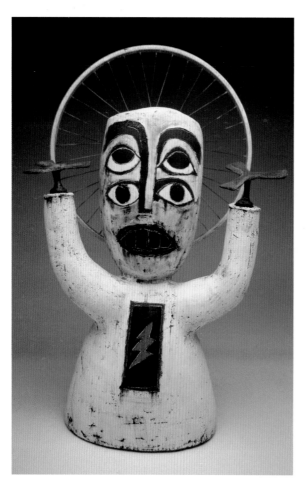

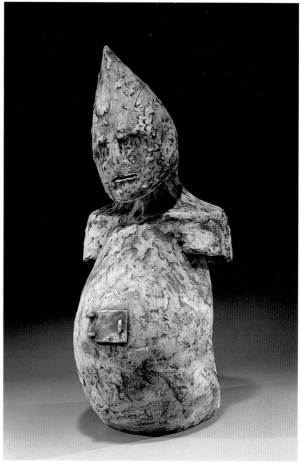

SCOTT LOSI
Drifter, 2001

38 x 24 x 23 in. (97 x 61 x 58 cm)

Coil-built earthenware; bike wheel

Photo by artist

MICHAEL A. PRATHER
Stomachache In My Head, 2003

27 x 11 x 12 in. (69 x 28 x 31 cm)

Ceramic; black iron oxide wash; cone 06

Photo by artist

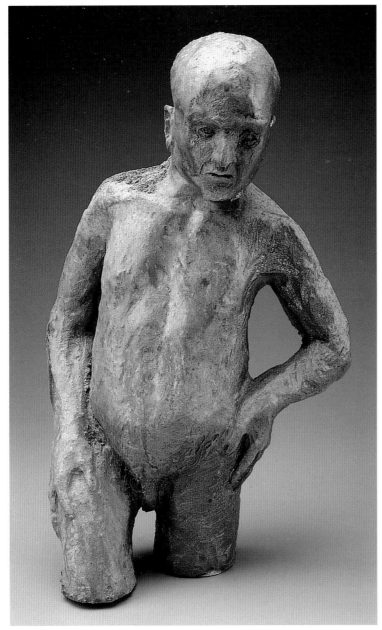

What began as a study of form and expression became something more, through à combination of luck and intention in an anagama.

BARBARA REINHART
Leaning Man, 1998
15 x 10 x 5 in. (38.1 x 25.4 x 12.7 cm)
Hand-built stoneware; wood-fired

Photo by William Lemke

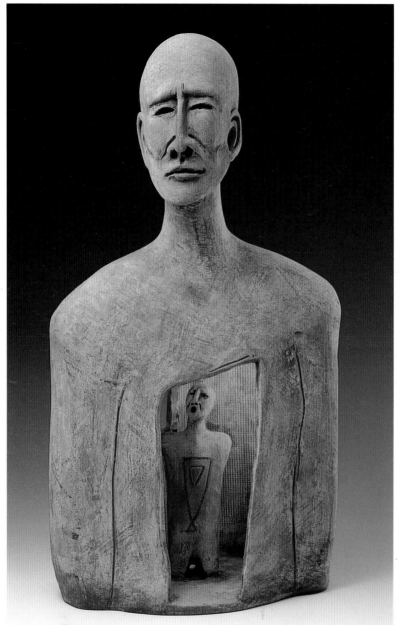

PAM SUMMERS
Reflections of the Soul, 2003

23 x 10 x 7 ½ in. (58 x 25 x 19 cm)

Coiled, slab built; layered stains; multi-fired

Photo by Jerry McCollum

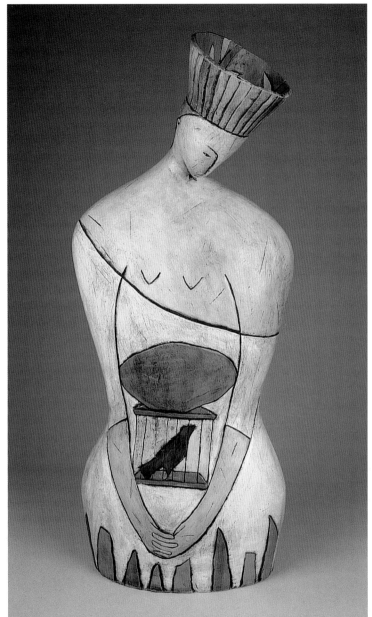

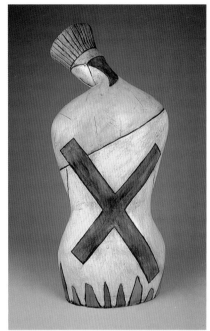

SANDRA ZEISET RICHARDSON
Exiled, 2000

23 x 10 x 7 ½ in. (58 x 25 x 19 cm)

Low-fire clay; coil built; underglazes

Photos by Stan V. Richardson

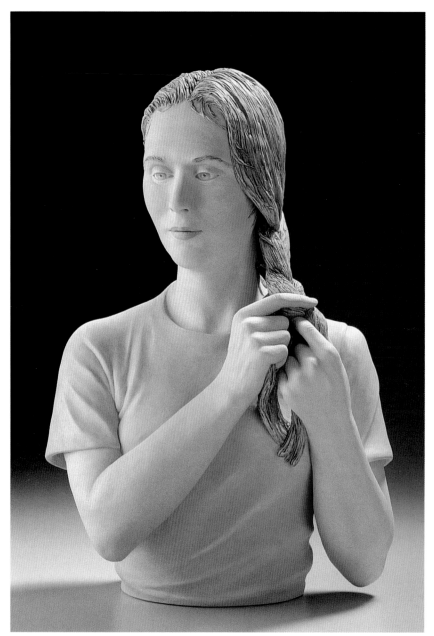

Braid is about being lost in thought—a moment of tenderness. The expression and the pale washes of color hint at emotions just below the surface.

BEVERLY MAYERI
Braid, 2003

19 x 12 x 8 in. (48 x 31 x 20 cm)

Low-fire clay; coil built on newspaper armature; acrylic paints

Photo by Lee Fatherree

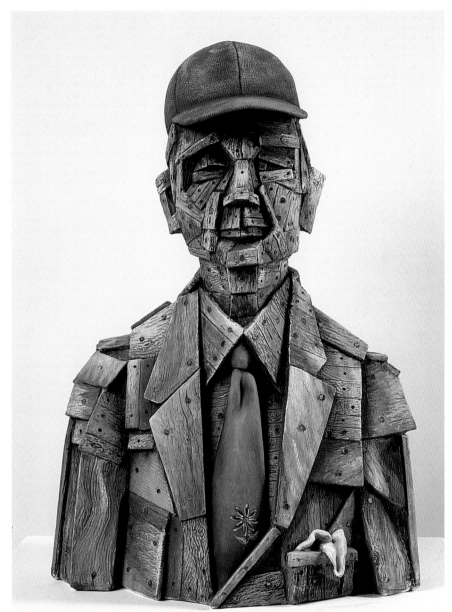

JACK EARL
Scraps & Slats, 2003

26 x 18 ½ x 11 in. (66 x 47 x 28 cm)

Ceramic

Photo by Tom Van Eynde
Courtesy of Perimeter Gallery, Chicago

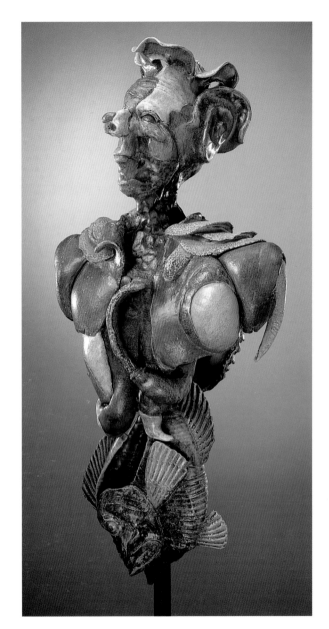
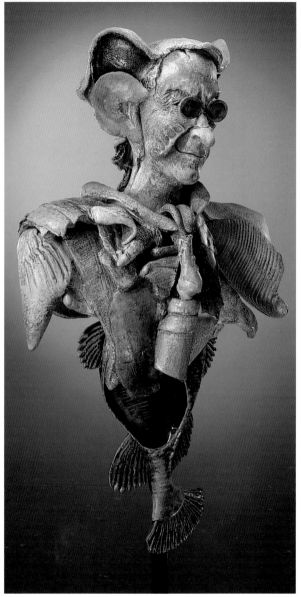

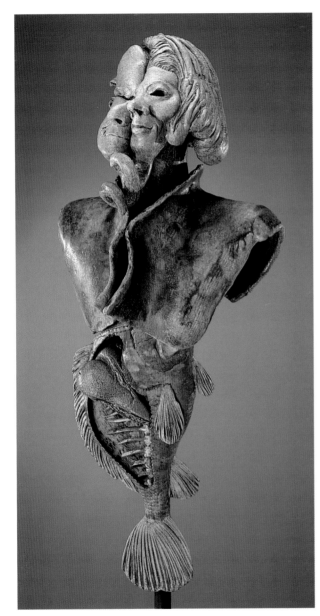

BILL ABRIGHT
OPPOSITE LEFT
The Nose I'd Choose to Lose, 2001

32 x 16 x 11 in. (81 x 41 x 28 cm)

Ceramic; post-fired construction; cone 9 soda

Photo by Charles Kennard

OPPOSITE RIGHT
All Apart Of Me, 2001

31 x 8 x 12 in. (79 x 20 x 31 cm)

Ceramic; post-fired construction; cone 9

Photo by Charles Kennard

THIS PAGE
Balance, 2001

63 x 16 x 15 in. (160 x 41 x 38 cm)

Ceramic, post-fired construction; cone 9 soda

Photo by Charles Kennard

I am drawn toward the combination of active surfaces, sometimes aggressively gouged and tooled and deeply stained, with images that are resoundingly still, meditative, and reverential in feel.

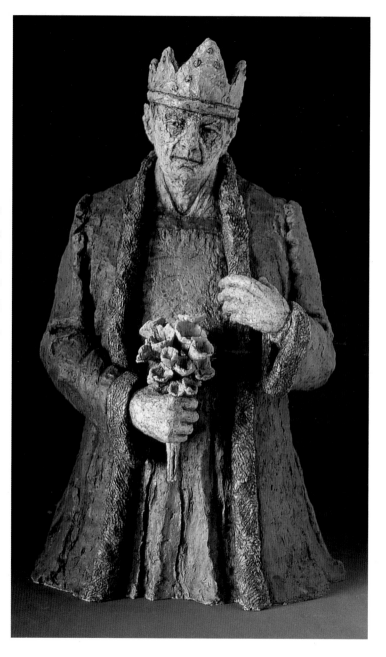

MARLENE MILLER
King with Bouquet, 2003

45 x 29 x 25 in. (114 x 74 x 66 cm)

Sculpted stoneware; ceramic stains, underglaze, acrylic; cone 6 reduction

Photo by artist

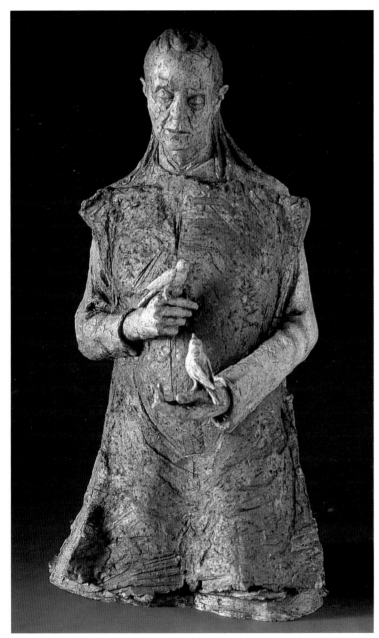

I created this piece soon after the death of one of my closest friends. The slab that emerged in front of the figure feels like a covering, a shield, a veil, a separation. This is one of the most psychologically and spiritually complex pieces I have made.

MARLENE MILLER
Witness, 2003

36 x 22 x 19 in. (91 x 56 x 48 cm)

Sculpted stoneware; ceramic stains, underglaze, acrylic; cone 6 reduction

Photo by artist

JOSHUA MARGOLIS
Torn, 2001

16 x 11 x 6 in. (41 x 28 x 15 cm)

Clay; watercolor

Photo by artist

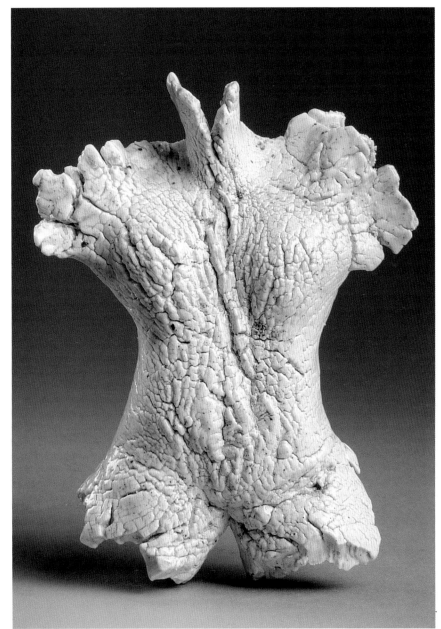

MARTA MATRAY GLOVICZKI
Blanche, 2002

8 x 6 x 2 ½ in. (20 x 15 x 6 cm)

Hand-built porcelain; salt glazed;
cone 12 wood

Photo by Peter Lee

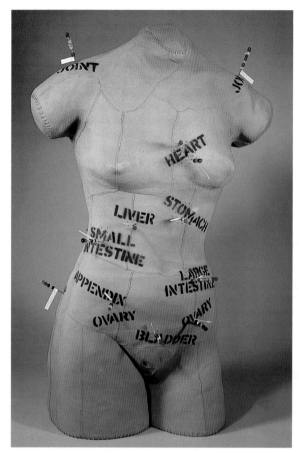 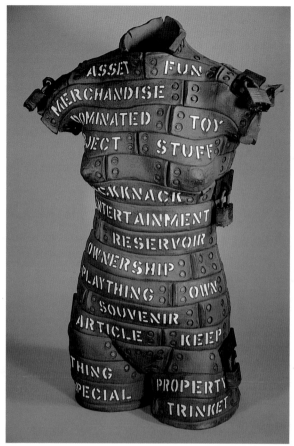

GLENN PHIFER
LEFT
Haitian Voodoo Doll, 1999

30 x 19 x 10 in. (76 x 18 x 25 cm)

Hand-built stoneware; oxide, pins, bones, beads, paints

Photo by artist

RIGHT
Possession Obsession, 1998

29 x 18 x 10 in. (74 x 46 x 25 cm)

Stoneware, steel; hand built; oxide, paints

Photo by artist

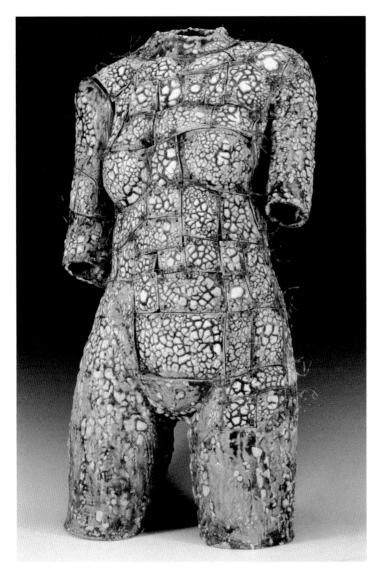

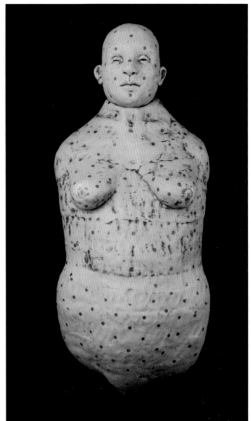

TOM BARTEL
ABOVE
Femme with Pattern, 2003

33 x 18 x 14 in. (84 x 46 x 36 cm)

Ceramic, wire; vitreous engobes; multi-fired

Photo by Geoff Carr

HELEN OTTERSON
LEFT
Fragmented, 2000

36 x 17 x 10 in. (91 x 43 x 25 cm)

Clay, wire; hand-built; cone 04 multi-fired

Photo by artist

Xiuhtechtli is the
Aztec fire lord who
resides at the heart
of Earth.

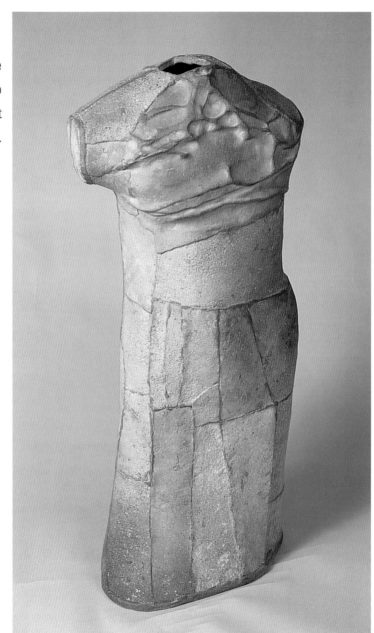

DANIEL RHODES
Xiuhtechtli, 1988

47 x 10 in. (119 x 25 cm)

Clay; wood-fired

Photo by Gary Huibregtse
In the private collection of
Marybeth Coulter

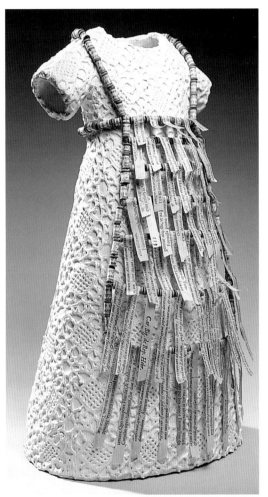

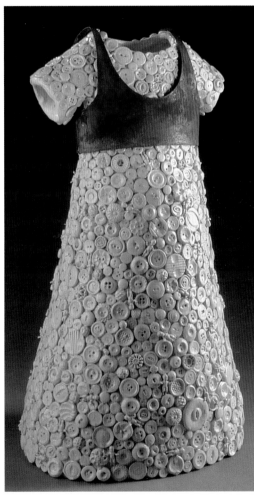

KATHLEEN HOLMES
LEFT
The Archivist, 2003

17 x 10 x 9 in.
(43 x 25 x 23 cm)

Ceramic; wood,
metal, paper

Photo by artist

RIGHT
Matriarch, 2002

17 x 11 x 10 in.
(43 x 28 x 25 cm)

Ceramic; metal, buttons,
plastic babies

Photo by artist

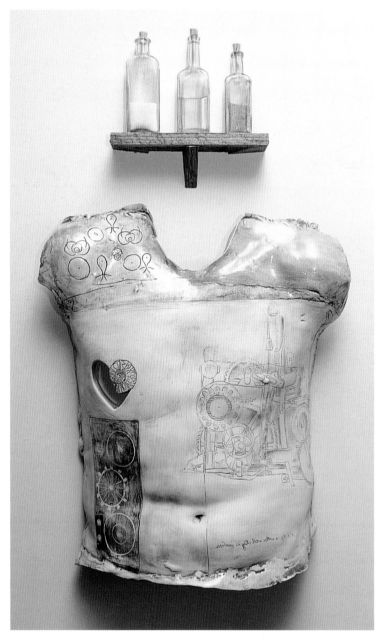

My recent work involves the exploration of surface quality, form, and the narrative . . . The torso serves as a visual journal for my experiences, both biological and emotional.

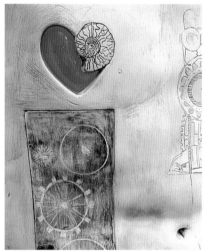

JACQUELINE SANDRO
Male with Glass Heart, 2003

28 x 16 x 6 in. (71 x 41 x 15 cm)

Clay, glass; slab built, pressed, molded; stains, underglaze

Photos by Marcos Sepulveda

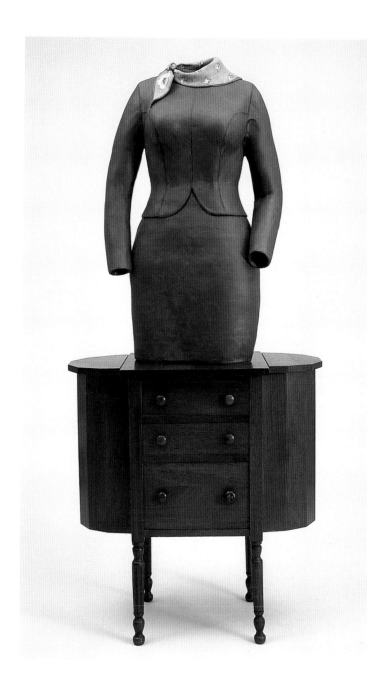

JANE SPANGLER
There Resides in Women an Element of Holiness and a Gift of Prophecy. Once Upon a Time Our Hands Held Magic, 1999

62 x 28 x 14 in. (157 x 71 x 36 cm)

Low-fire clay; coil built; wooden sewing cabinet and items crafted from sewing notions and office supplies

Photos by John Knaub

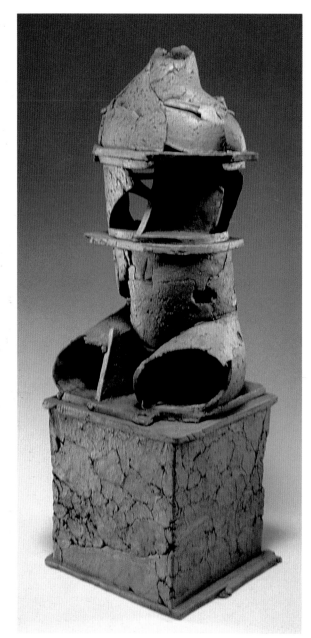

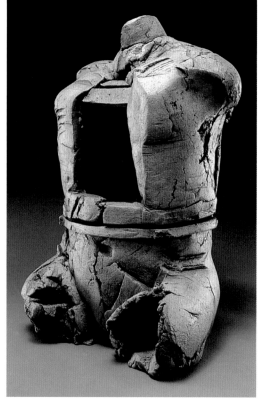

GARRETT MASTERSON
ABOVE
Grounded, 2001

24 x 15 x 13 in. (61 x 38 x 33)

Slab-built stoneware

Photo by Courtney Frisse

LEFT
Guardian—Seated, 2000

33 x 13 x 12 in. (84 x 33 x 30 cm)

Slab-built stoneware

Photo by Courtney Frisse

I have always been interested in the mythical and spiritual references associated with a winged figure. I wanted mine to look as if it has endured for ages.

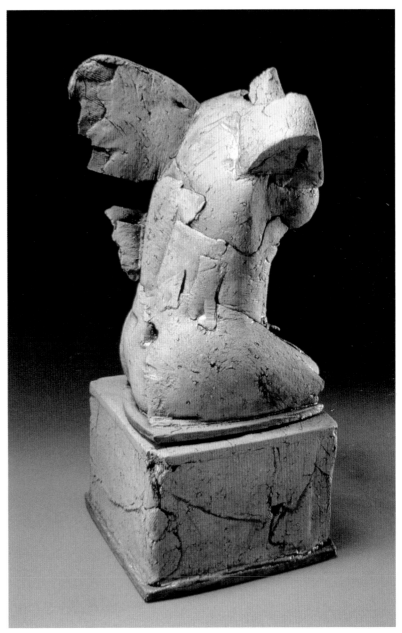

GARRETT MASTERSON
Winged Figure, 2001
22 x 10 x 11 in. (51 x 25 x 28 cm)
Slab-built stoneware
Photo by Courtney Frisse

The figure is deployed as an expressive vehicle to explore the dilemma of spirit incarnate.

KAREN LOUISE FLETCHER
Fragment II, 2000
15 ¼ x 12 ¾ x 10 ¾ in. (39 x 33 x 27 cm)
Polychromed earthenware; solid built
Photo by artist

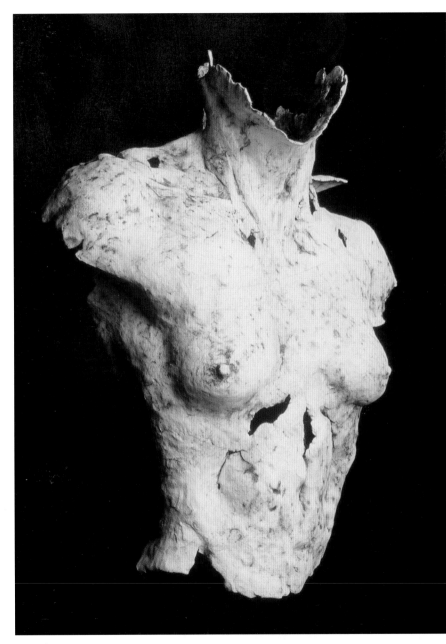

Part off a series studying
the [absent] head

SHELLEY WILSON
Female Torso '95, 1995

18 x 14 x 9 in. (46 x 36 x 23 cm)

Ceramic; hand built, pinched,
coiled; stainless steel

Photo by artist

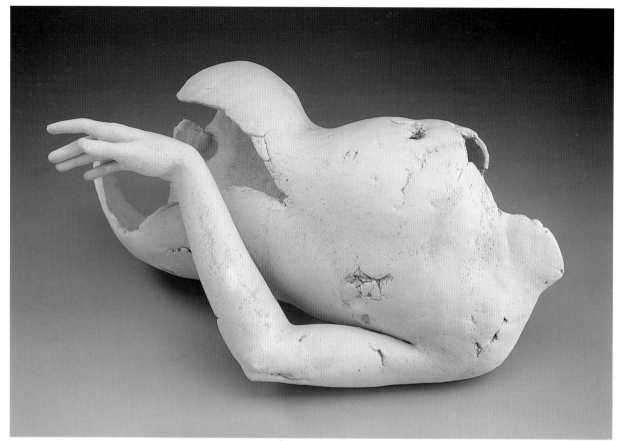

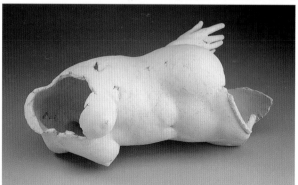

COLLEEN CAREY MCCALL
Torsion, 2001

26 x 13 x 16 in. (66 x 33 x 41 cm)

Immature stoneware

Photos by Dean Powell

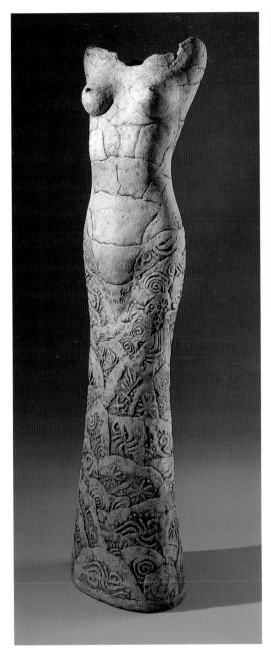

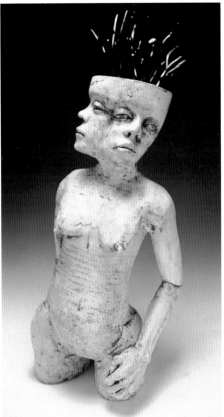

ABOVE
BRIAN K. MCCALLUM
The Parade, 2002

28 x 10 x 8 in. (71 x 25 x 20 cm)

Clay; thrown, altered; slips, glazes; multi-fired

Photo by artist

LEFT
LOUIS MENDEZ
Isis, 1998

52 x 13 x 8 in. (132 x 33 x 20 cm)

High-temperature stoneware; slab built;
stamped decorative patterns; reduction

Photo by Noel Allum

Emerging is about a leap out of the darkness into the light. I wanted to show how gesture can imply a shift in mood.

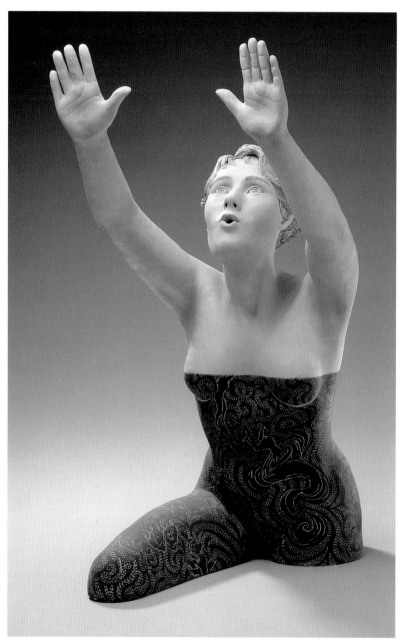

BEVERLY MAYERI
Emerging, 2001

25 x 13 x 16 in. (64 x 33 x 41 cm)

Low-fire buff clay; coiled, modeled on newspaper armature; underglaze, acrylic paint

Photo by Lee Fatherree

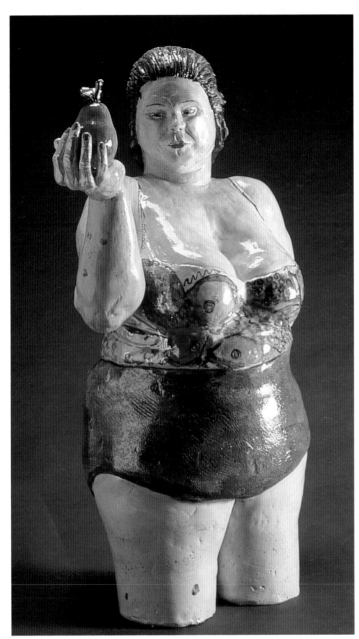

This piece represents my tension between acceptable and marketable work or artistic rejection and criticism. Both are interchangeable.

LUNDIN KUDO
Hidden Agenda, 2000
50 x 31 x 33 in. (127 x 79 x 84 cm)
Hand-built ceramic; glazed
Photo by Mark Taylor

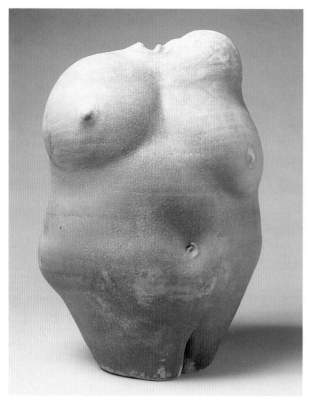

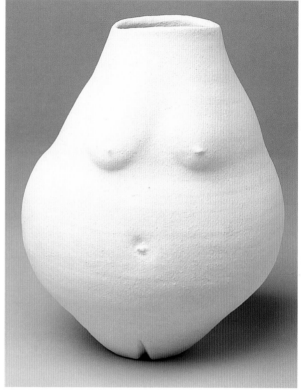

KAY YOURIST
LEFT
Blue Nude, 2003

18 x 12 x 10 in. (46 x 30 x 25 cm)

Stoneware; thrown, altered;
cone 06, cone 04, cone 02

Photo by David Myers

RIGHT
Nude, 2001

11 x 9 x 8 in. (28 x 23 x 20 cm)

Stoneware; thrown, altered; cone 02

Photo by David Myers

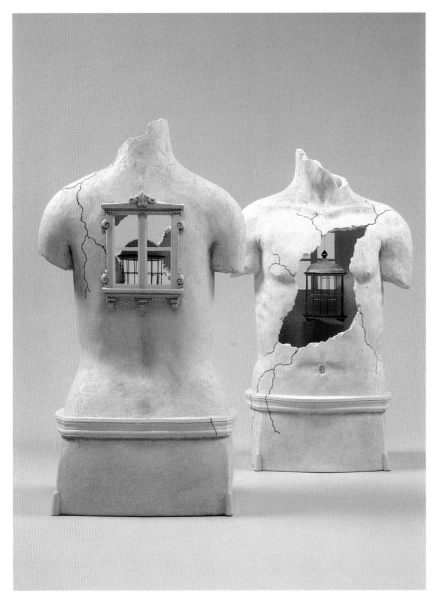

JIRI LONSKY
Cries and Whispers, 2003

Male: 33 x 19 x 11 in. (84 x 48 x 28 cm)

Female: 32 x 21 x 11 in. (81 x 53 x 28 cm)

Low-fire sculpture clay, terra sigillata; stain washes, frit washes; cages of wire and ceramic; bisque cone 04, glaze cone 04, luster cone 018

Photos by John Knaub

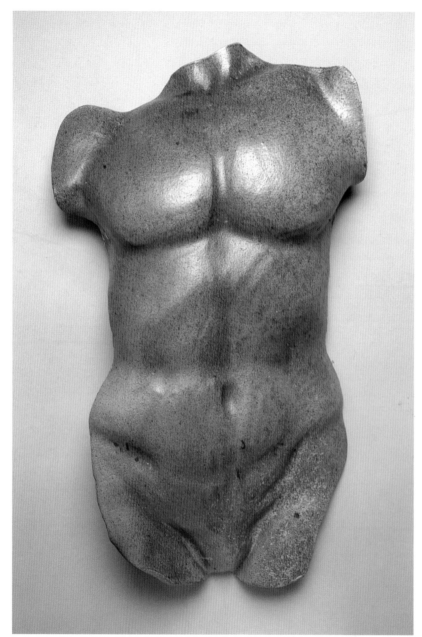

MARIANNE TEBBENS
Wood-fired Torso, 2002

26 x 15 x 5 in. (66 x 38 x 13 cm)

Slab-built stoneware; wood-fired

Photo by John J. Carlano

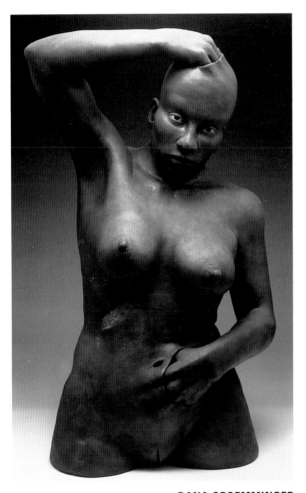

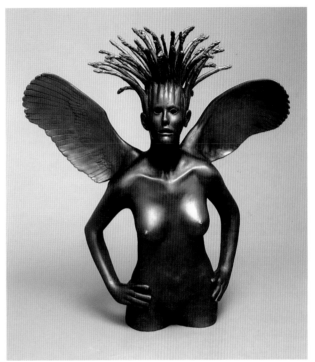

**JACK THOMPSON AKA
JUGO DE VEGETALES**
Medusa, 2003

36 x 33 x 11 in. (91 x 84 x 28 cm)

Ceramic; oil paints, graphite

Photo by John Carlano

Refers to the mythology
of various cultures,
from Italy to Japan

DANA GROEMMINGER
Blue, 2000

32 x 18 x 14 in. (81 x 46 x 36 cm)

Coiled clay; oils

Photo by artist

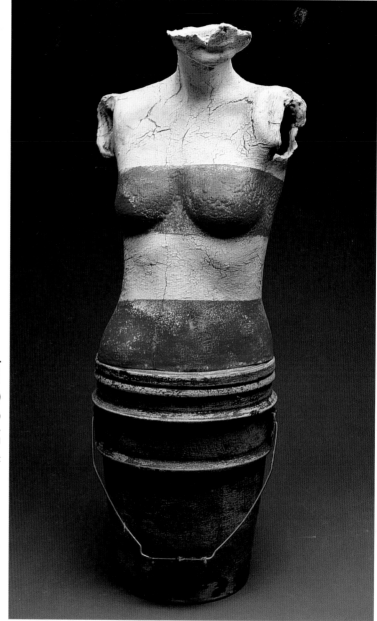

MICHAEL T. SCHMIDT
Woman and Bucket, 2001

42 x 16 x 16 in. (107 x 41 x 41 cm)

Terra cotta; press molded, coiled, slab
construction, thrown parts; multi-fired,
sandblasted after each firing

Photo by artist

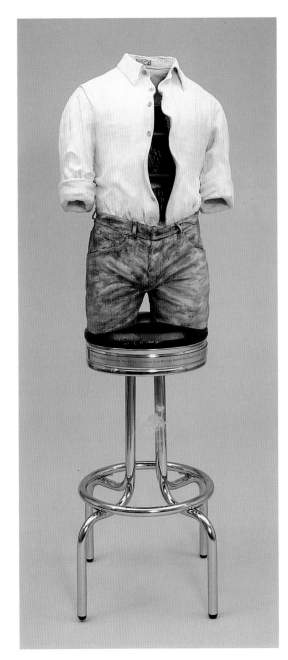

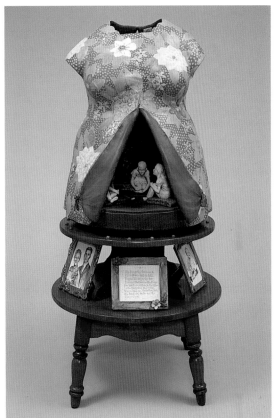

JANE SPANGLER
ABOVE
She Brings the Outdoors In.
All Is Green—Wall to Wall, 1999

56 x 28 x 28 in. (142 x 71 x 71 cm)

Low-fire clay; coil built; underglazes, clay monoprints, mixed media

Photo by John Knaub

LEFT
The Blue Comet, 1999

56 x 19 x 15 in. (142 x 48 x 38 cm)

Low-fired clay; coil built, slab elements; underglazes,
acrylic washes, mixed media

Photo by John Knaub

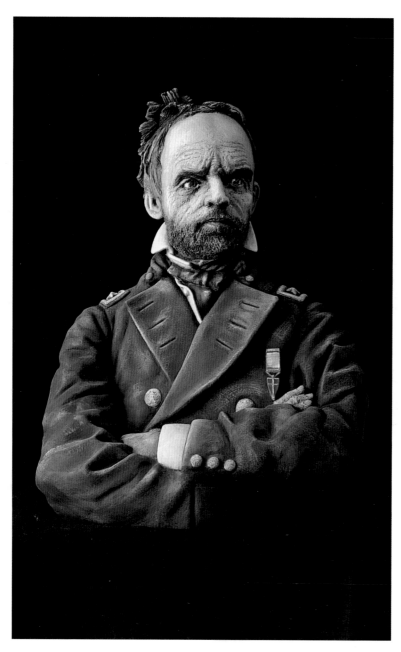

JACK EARL
William Tecumseh Sherman, 2002

28 x 20 x 15 in. (71 x 51 x 38 cm)

Ceramic; oil paint

Photo courtesy of Nancy Margolis Gallery, New York

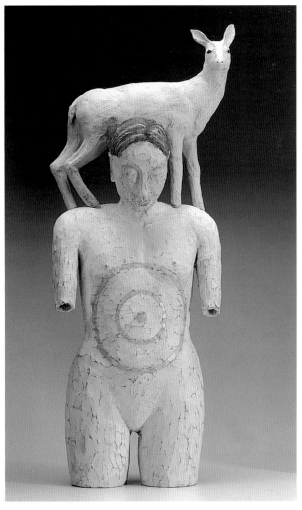

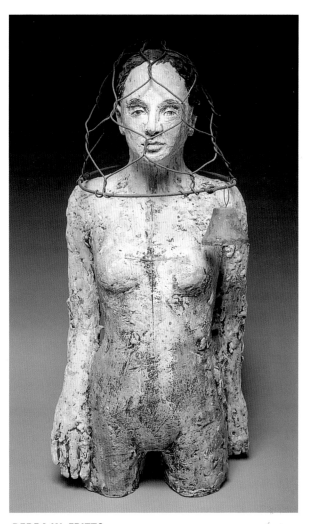

LOGAN WOOD
Invitation, 2003

33 x 14 x 9 in. (84 x 36 x 23 cm)

Hand-built ceramic; glazes

Photo by Black Cat Studio

DEBRA W. FRITTS
The Bell Carrier, 2003

26 ½ x 13 x 8 ½ in. (67 x 33 x 22 cm)

Terra cotta, metal; hand built, coiled; slips,
oxide, underglazes, glazes; multi-fired

Photo by Mike Jenson

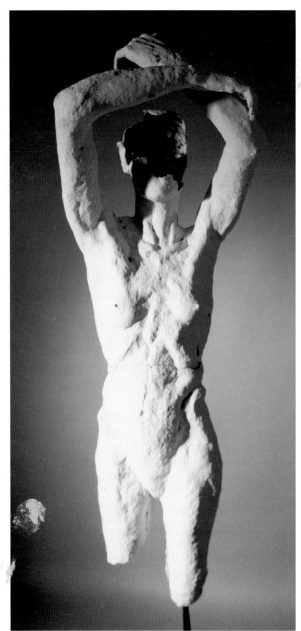

One in a series of life-size sculptures that addresses how people order, categorize, and prioritize women on the issue of the perfect body and direct relation to phrenology

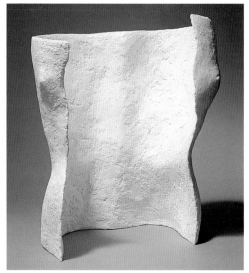

GRACE BAKST WAPNER
ABOVE
Open Torso, 2002

16 ½ x 13 x 9 in. (42 x 33 x 23 cm)

High-fire clay; plaster

Photo by Jerry Thompson

SHELLEY WILSON
LEFT
Untitled, 1996

72 x 32 x 12 (183 x 81 x 31 cm)

Ceramic; hand built, pinched, coiled; stainless steel

Photo by artist

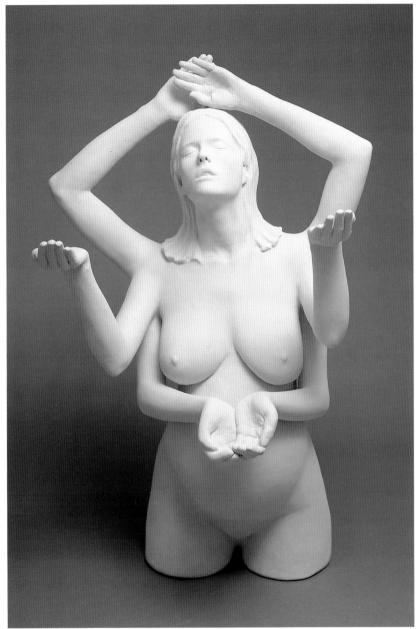

This is the creator side
of the Indian goddess
Shiva as I see her.

**JACK THOMPSON AKA
JUGO DE VEGETALES**
*Shive Embarasada
(Pregnant Shiva),* 2003
39 x 24 x 20 in. (99 x 61 x 51 cm)
Ceramic; sculpted, cast; painted

Photo by John Carlano

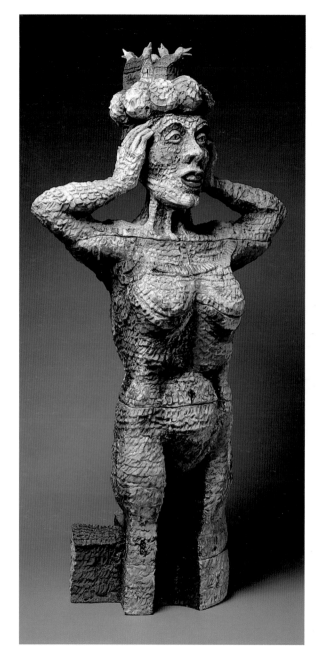

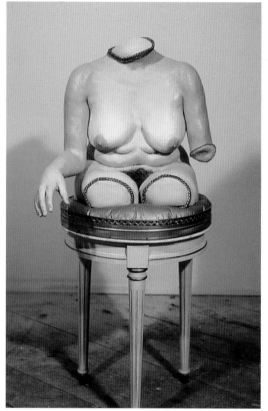

ABOVE
REBECCAH KARDONG
Animal, 2003

42 x 24 x 24 in. (107 x 61 x 61 cm)

Hand-built ceramic; mixed media

Photo by artist

LEFT
CHERYL TALL
Prima Vera, 2000

40 x 20 x 20 in. (102 x 51 x 51 cm)

Clay; coil-built in sections, fitted inner flanges; slips, oxides, glazes; electric

Photo by Mark Taylor

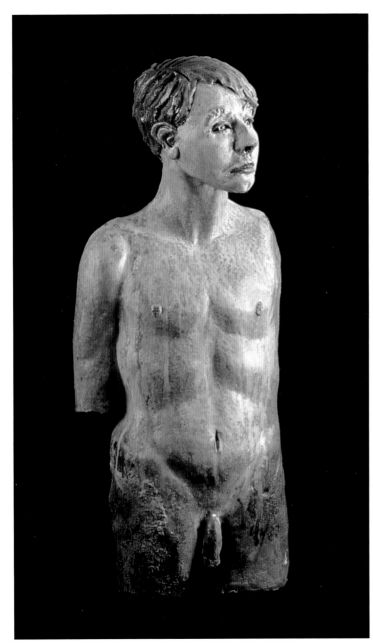

While I was constructing him, I thought and intended him to be a somewhat worldly, older man, but he transformed into almost an adolescent: very alone, apart, and beginning to worry about what life was going to bring him. There is sadness in him that I had not anticipated or expected.

MARTHA L. KEHM
Male Nude, 2003

28 x 13 x 10 in. (71 x 33 x 25 cm)

Slab-built Rudy Autio clay; porcelain slip; train kiln

Photo by Moorman Photographics

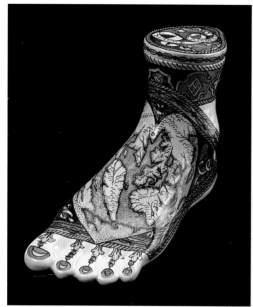

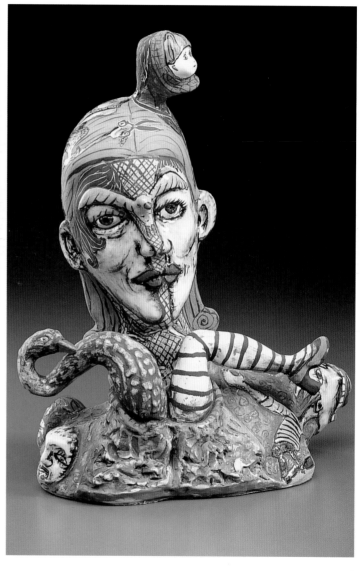

CONNIE KIENER
ABOVE
Madre Amore, 2003

6 ½ x 4 x 9 in. (17 x 10 x 23 cm)

Majolica ceramic; low-fire glaze

Photo by Bill Bachober
Courtesy of Ferrin Gallery

LAURA JEAN MCLAUGHLIN
RIGHT
Down to the River, 2003

14 x 12 x 8 in. (36 x 31 x 20 cm)

Slab-built porcelain; slips, glazes, painting,
sgraffito; cone 6

Photo by Mike Ray

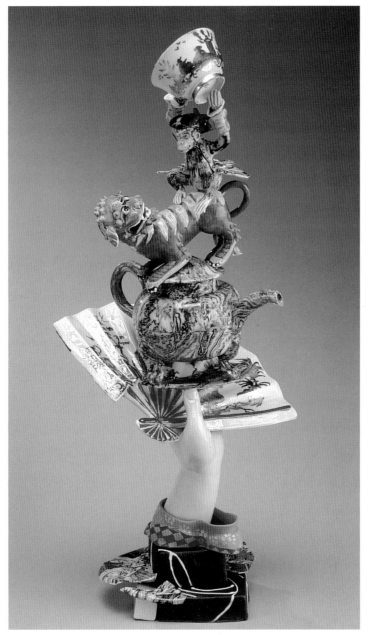

All the slip-cast elements in this work are taken from molds of my own original artwork.

MICHELLE ERICKSON
Taste in High Life, 2003

22 x 9 x 8 in. (56 x 23 x 20)

White and colored porcelains, colored earthenware, red stoneware; thrown, hand built, press molded, slip cast; laid agate enamel on bisque, overglaze enamel, underglaze oxides, decal

Photo by Gavin Ashworth, New York

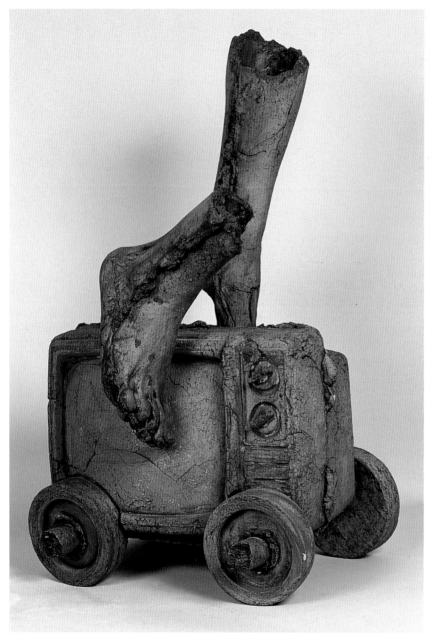

BRETT COPPINS
Dependence, 2001

27 x 18 x 13 in. (69 x 46 x 33 cm)

Earthenware; press molded, wheel thrown

Photo by artist

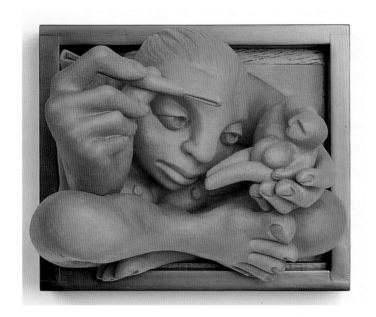

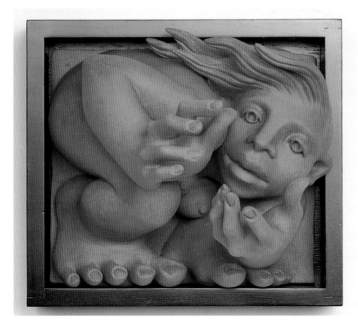

LEE STOLIAR
TOP
Venus, 2003

9 ½ x 11 ¼ x 11 in. (24 x 29 x 28 cm)

Hand-built terra cotta; wood, wax

Photo by Manfred Weidemann

BOTTOM
Empty Hands II, 2003

11 ½ x 13 x 12 in. (29 x 33 x 31 cm)

Hand-built terra cotta; wood, wax

Photo by Manfred Weidemann

This two-figure ceramic work reflects the dualism in us all, and the strength of our inner wisdom . . . The strength of the smaller figure, and the focus of each on the toes and feet, is not only about being grounded to the Earth and our bodies, but is deeply connected to the vulnerability symbolized by "clay feet."

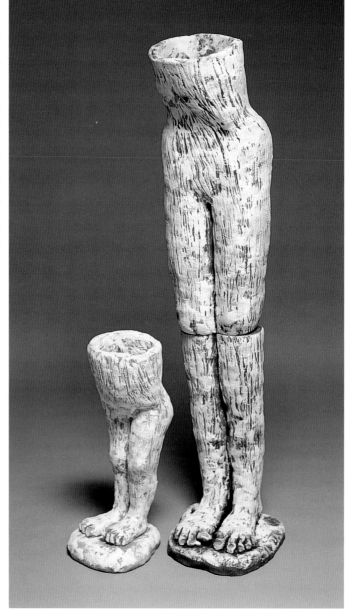

DALE FERGUSON
Looking Within: Mother & Child, 2002
Mother: 36 x 9 x 6 in. (91 x 23 x 15 cm)
Child: 16 x 6 x 5 in. (41 x 15 x 13 cm)
Terra cotta; layered excel, underglazes

Photo by Mike Noa

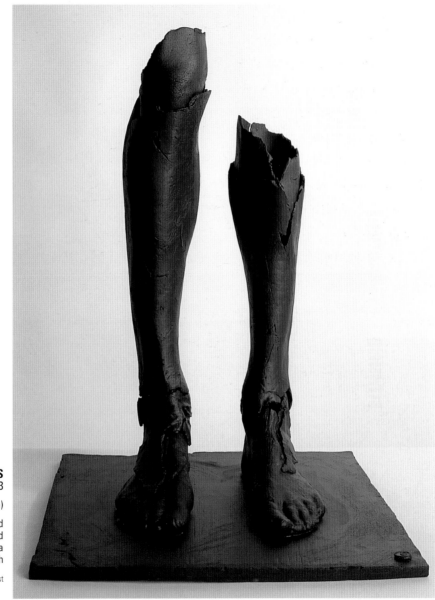

HAYLEY-JAY DANIELS
Inner Steps, 2003

23 ½ x 17 ¾ x 17 ¾ in. (60 x 45 x 45 cm)

Porcelain, stoneware; press molded
from plaster casts, hand-sculpted
additions, slab base; high-fired terra
sigillata finish

Photo by artist

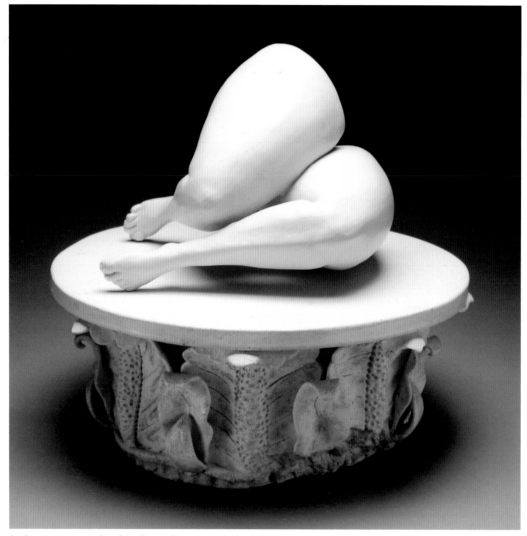

I choose to work with the voluptuous female figure. I am completely captivated by the way the rolls of the body move and stack upon each other. I find this undulating movement hypnotic.

KELLI R. DAMRON
Legs on Pedestal, 2002

10 x 10 x 10 in. (25 x 25 x 25 cm)

Low-fire ceramic; slab built; glaze, terra sigillata

Photo by artist

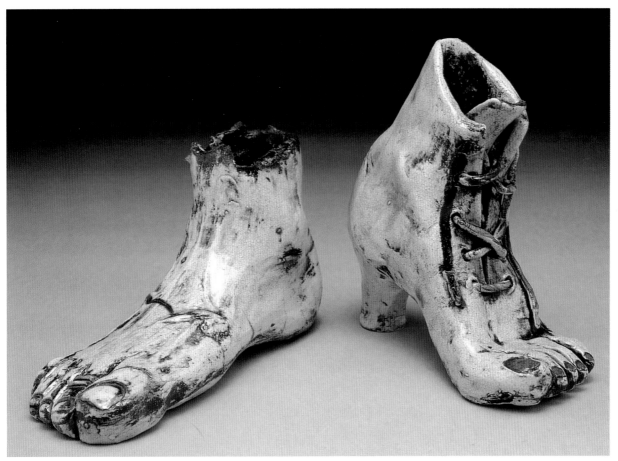

SALLY SMITH
Pied, 2003

Left: 4 ½ x 3 x 7 ½ in. (11 x 8 x 19 cm)

Right: 7 x 3 x 6 in. (18 x 8 x 15 cm)

Raku clay; oxides, crackle glaze

Photo by Michael Noa

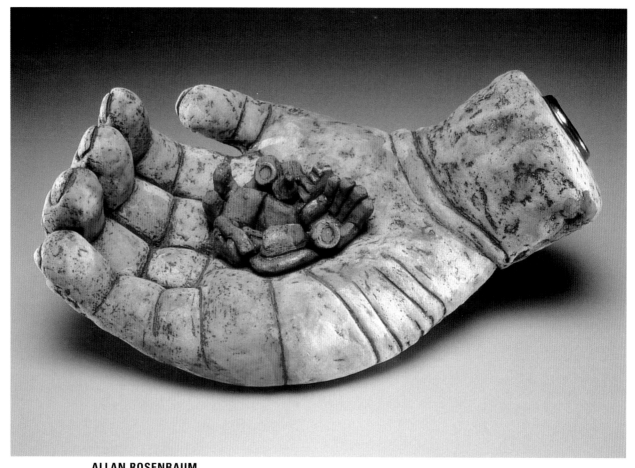

ALLAN ROSENBAUM
Collector's Hand, 2002

7 x 18 x 10 in. (18 x 46 x 25 cm)

Hand-built earthenware; stain, glaze

Photo by Katherine Wetzel

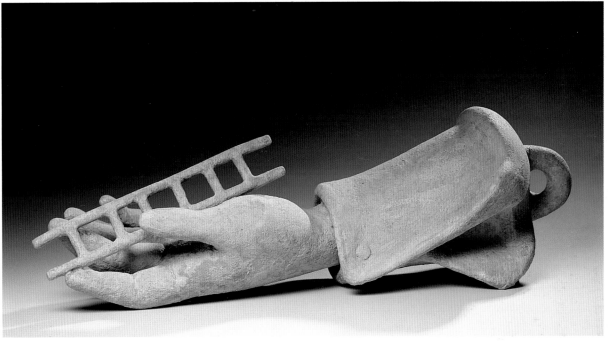

VON ALLEN
Ladder of Success Achiever's Charm, 2003

10 x 26 x 10 in. (25 x 66 x 25 cm)

Clay; pinched, carved; low-fire glazes; multi-fired

Photo by Hawkinson Photography

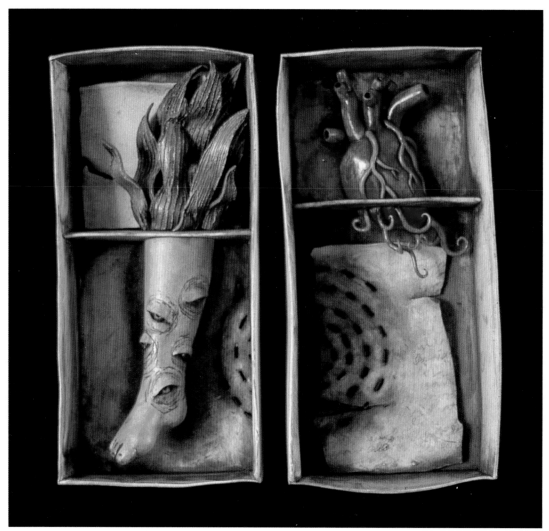

LEAH HARDY
Duet, 2003

8 x 8 x 2 in. (20 x 20 x 5 cm)

Stoneware; slab built, hand modeled

Photo by artist

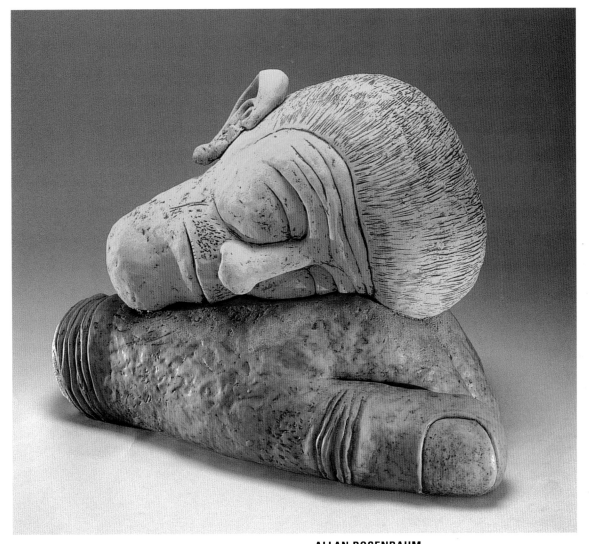

ALLAN ROSENBAUM
Rester, 2003

22 x 29 x 22 in. (56 x 74 x 56 cm)

Hand-built earthenware; stain, glaze

Photo by Katherine Wetzel

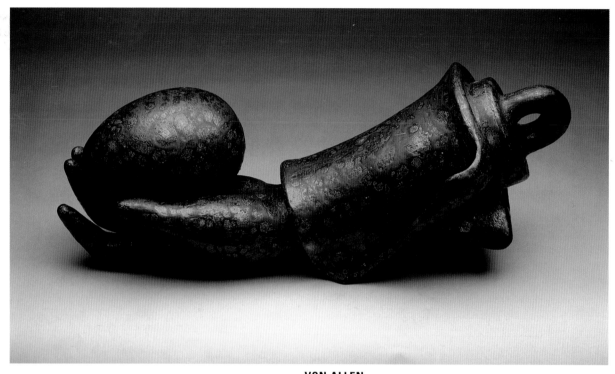

VON ALLEN
Egg Fertility Charm, 2003

11 x 25 x 8 in. (28 x 64 x 20 cm)

Clay; pinched, hand formed, carved;
low-fire glazes; multi-fired

Photo by Utah State University

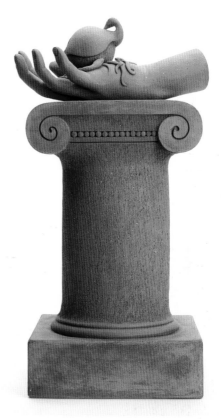

STEPHEN PATT
RIGHT
Peace and Safety, 1997

16 x 10 x 8 in. (41 x 25 x 20 cm)

Stoneware; iron oxide stain

Photo by Gary Resnick

HAYLEY-JAY DANIELS
BELOW
Armoured, 2003

13 ¾ x 41 ⅓ x 7 ¼ in. (35 x 105 x 18 cm)

Ceramic, porcelain, stoneware; press molded from
plaster casts, hand-sculpted additions, acrylic and
wood base; high-fired terra sigillata finish

Photo by artist

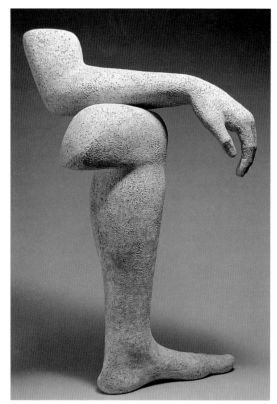

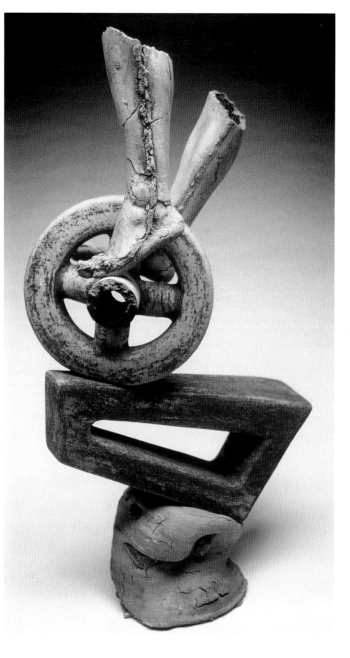

PETER MEYER
ABOVE
Ray at Rest, 2002

34 x 28 x 20 in. (86 x 71 x 51 cm)

Coil-built earthenware; colored
slips; single-fired

Photo by artist

BRETT COPPINS
RIGHT
Finding Common Ground, 2002

60 x 30 x 25 in. (152 x 76 x 64 cm)

Earthenware; wheel thrown,
altered, press molded

Photo by artist

BONNIE HARTFORD PRICE
*Down the Nile III (warrior
woman series),* 2003

18 x 9 x 8 ½ in. (46 x 23 x 22 cm)

Clay; slab built, molded, stamped;
bisque cone 06, glaze cone 5

Photo by Paula Smith

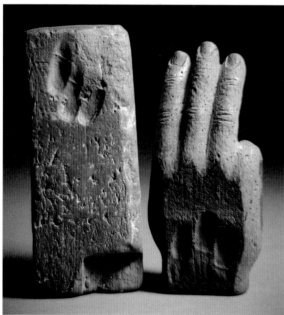

CHRIS BERTI
ABOVE
Relief, 2002

3 ½ x 8 x 2 ½ in. (9 x 20 x 6 cm)

19th-century earthenware brick; carved

Photo by artist

LEFT
Of My Blood, 2003

8 x 9 x 3 in. (20 x 23 x 8 cm)

19th-century earthenware brick; carved

Photo by artist

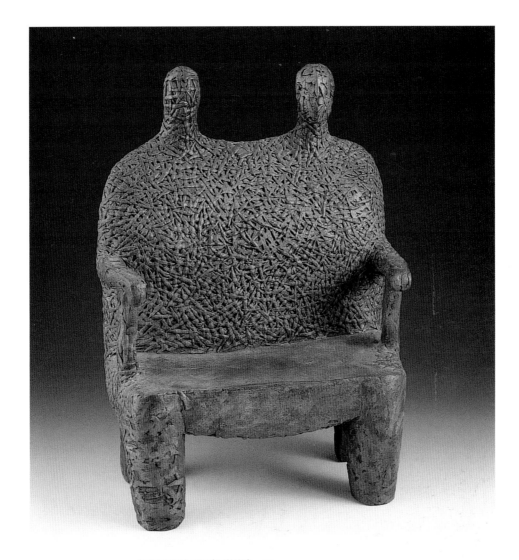

KESTUTIS MUSTEIKIS
Double Chair, 1996

11 x 8 x 5 in. (28 x 20 x 13 cm)

Hand-built stoneware; iron oxide wash;
cone 10 reduction

Photo by Rimas VisGirda

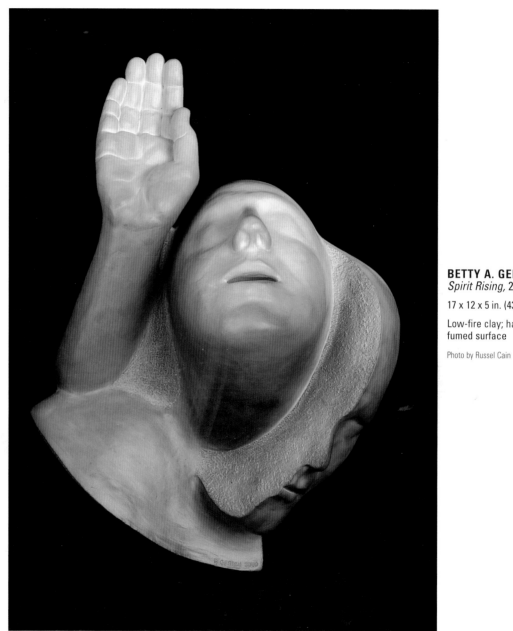

BETTY A. GERICH
Spirit Rising, 2002

17 x 12 x 5 in. (43 x 31 x 13 cm)

Low-fire clay; hand built;
fumed surface

Photo by Russel Cain

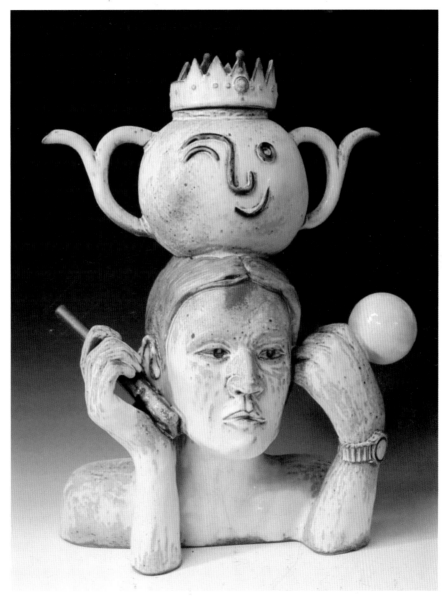

JIMMY LIU
Teapot on Teapot, 2003

17 ½ x 15 x 4 in. (45 x 38 x 10 cm)

Hand-built stoneware; cone 10

Photo by artist

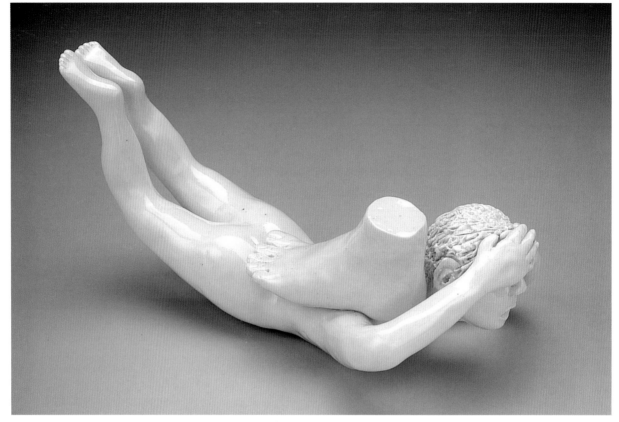

COILLE McLAUGHLIN HOOVEN
Cracked Under Pressure, 2003

4 x 9 x 5 in. (10 x 23 x 13 cm)

Hand-formed porcelain; cone 11

Photo by Charles Frizzell

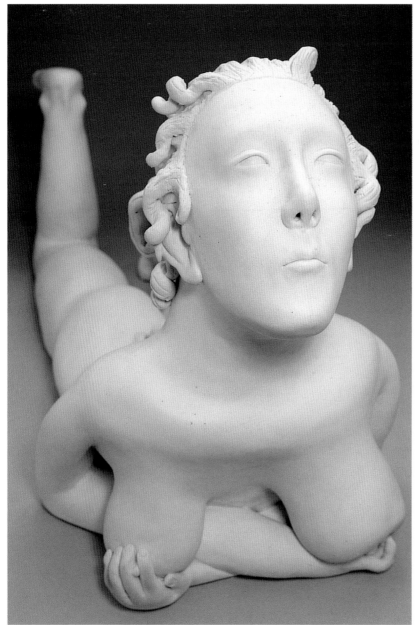

NOBUHITO NISHIGAWARA
Nobuism, 2001

17 x 13 x 28 in. (43 x 33 x 71 cm)

Hand-built porcelain; polished

Photo by artist

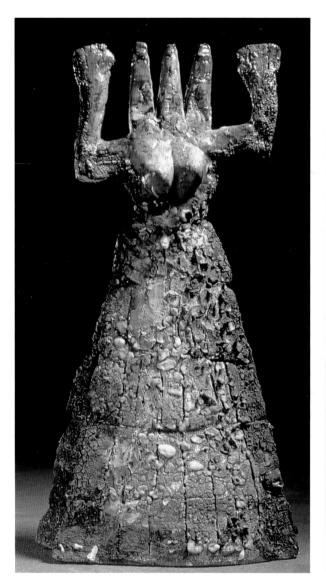 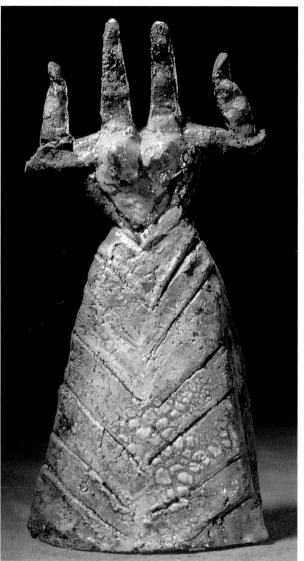

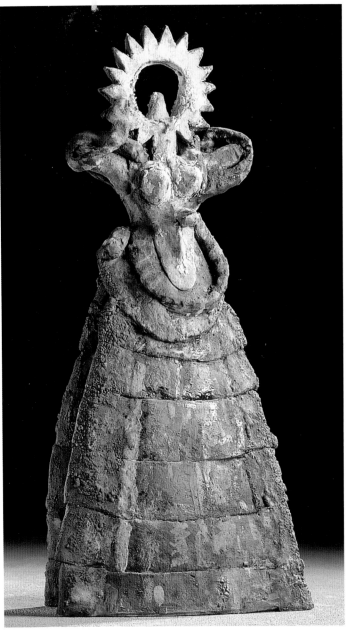

NINA HOLE
OPPOSITE PAGE LEFT
Pythia, 1992

12 ¾ x 8 x 2 ¾ in. (32 x 20 x 7 cm)

Hand-built earthenware; low-fired oxidation

Photo by Kristian Krogh

OPPOSITE PAGE RIGHT
Goddess, 1997

8 x 6 x 2 ¾ in. (20 x 15 x 7 cm)

Hand-built earthenware; low-fired oxidation

Photo by Kristian Krogh

LEFT
Snake Goddess, 1992

17 ½ x 11 ¼ x 6 in. (45 x 28 x 15 cm)

Hand-built earthenware; low-fired oxidation

Photo by Kristian Krogh

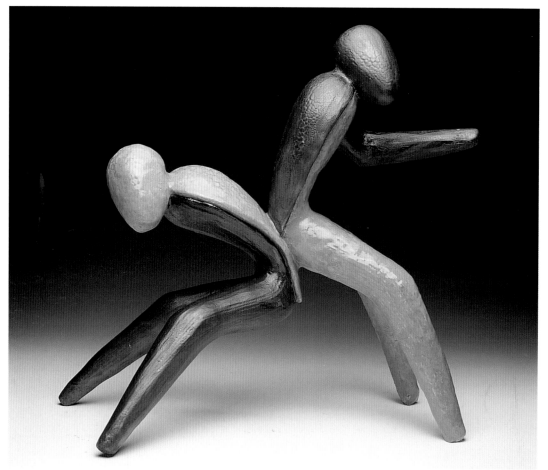

My figurative work emphasizes a variety of design principles through abstraction. I am particularly interested in visual and worked textures, juxtaposition of primary and secondary contours, and the invention of a coded vocabulary of color within each piece.

BRYAN HIVELEY
Blue/Graphite Figures, 2003
16 x 16 x 8 in. (41 x 41 x 20 cm)
Hand-built earthenware; glaze; cone 04
Photo by artist

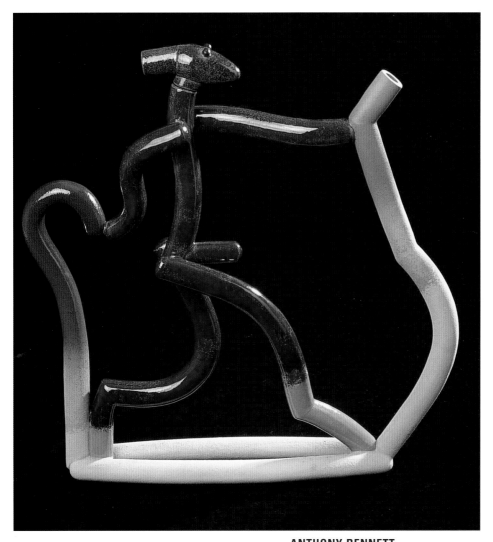

ANTHONY BENNETT
Mr. Tube Takes a Hike, 2002

16 x 15 in. (41 x 38 cm)

White earthenware; slip-cast
sections; colored glazes

Photo by Peter Greenhalf

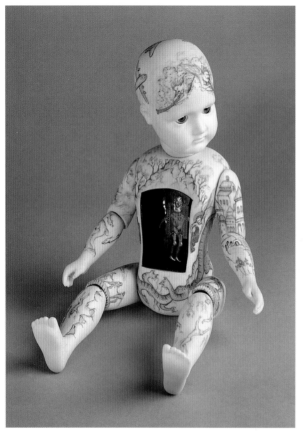

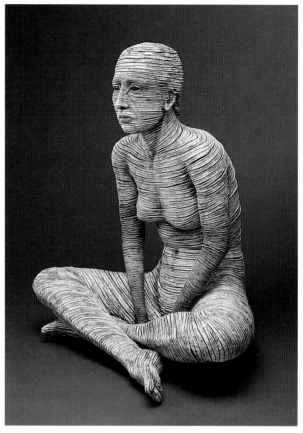

MARYANN WEBSTER
Host Figure With Apocalyptic Tattoos, 2001

Reclining: 18 x 5 x 6 in. (46 x 13 x 15 cm)

Seated: 9 x 7 x 5 in. (23 x 18 x 13 cm)

Porcelain; milagro charms, China paint

Photo by Jan Schou

ADRIAN ARLEO
Pretending, 2000

30 x 27 x 23 in. (76 x 69 x 58 cm)

Clay; hand built, coiled; glaze, scored texture

Photo by Chris Autio

Courtesy of Ferrin Gallery

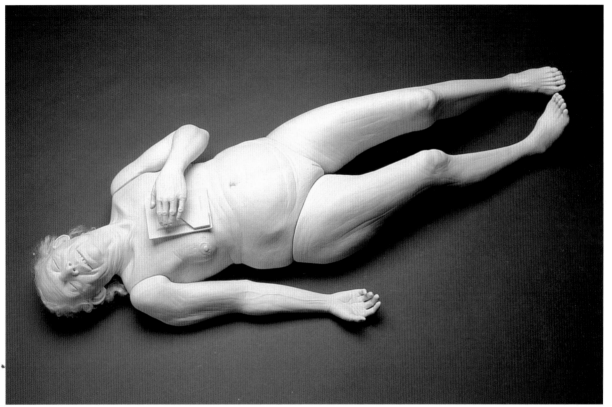

TIP TOLAND
Rapture, 2002

12 x 36 x 20 in. (31 x 91 x 51 cm)

Porcelain; wool

Photo courtesy of Nancy Margolis Gallery, New York

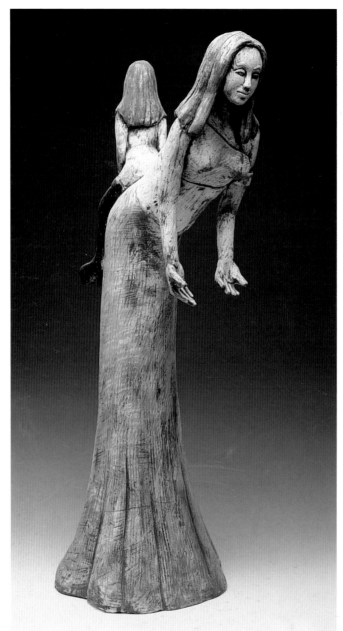

SHANNON CALHOUN
Alter Ego, 2003

18 x 5 x 5 in. (46 x 13 x 13 cm)

Hand-built ceramic; low-fire stains, low-fire washes

Photo by artist

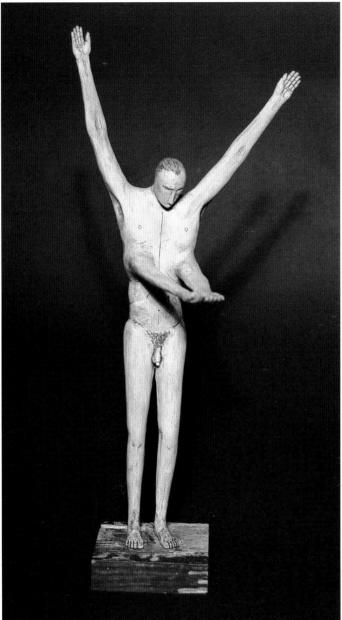

I am acutely interested in the possible conceptual constructs formed by the combination of the object/image (image in this case as it pertains to figurative sculpture) and the different meanings that may be arrived at with the title of the work.

STEVEN P. BRADFORD
Clean, 1999

13 x 4 ½ x 4 in. (33 x 11 x 10 cm)

Earthenware

Photo by artist
In the permanent collection of the Everson Museum,
Syracuse, New York

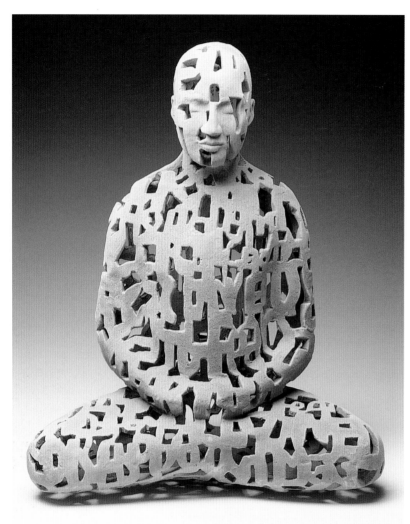

ROB KIRSCH
TV Blue Buddha, 2002

22 x 12 x 10 in. (56 x 31 x 25 cm)

Hand-built stoneware

Photo by John Carlano
Courtesy of The Clay Studio, Philadelphia

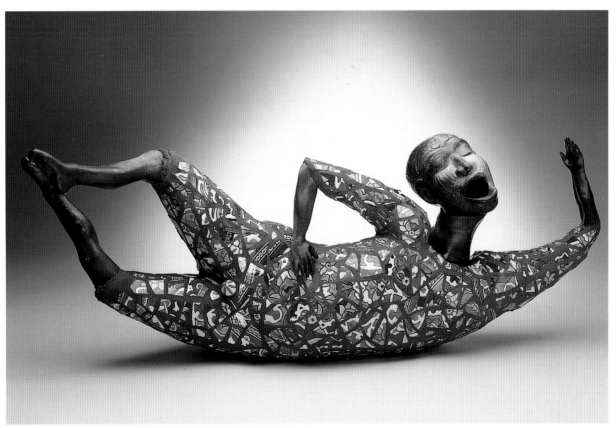

This piece includes Turkish pottery shards.

RONNA NEUENSCHWANDER
Minal Jinnati Wan-nassi (Among Jinns and Men), 1997

11 x 26 x 7 in. (28 x 66 x 18 cm)

Earthenware; grout, terra sigillata

Photo by Dale Montgomery

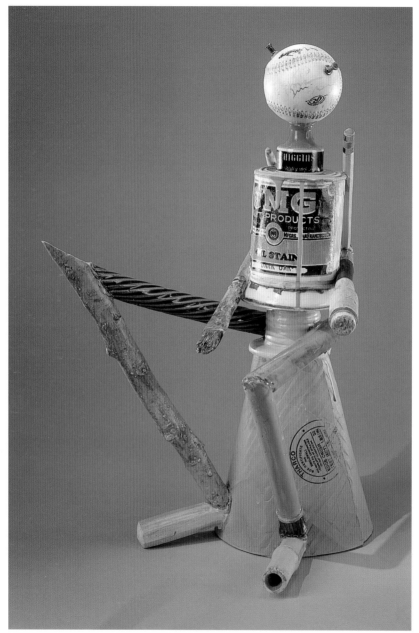

RICHARD SHAW
Get Ready, 2003

22 x 12 ½ x 7 in. (56 x 32 x 18 cm)

Porcelain; overglazes, decals

Photo by Joseph Schopplein

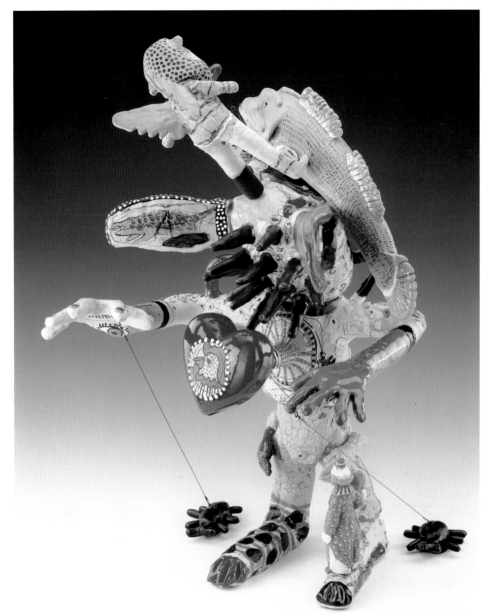

BILL STEWART
Walking My Bugs and Checking Out Where I've Been, 2002

30 x 29 x 17 in. (76 x 74 x 43 cm)

Hand-built terra cotta; glaze, engobes; multi-fired

Photo by artist

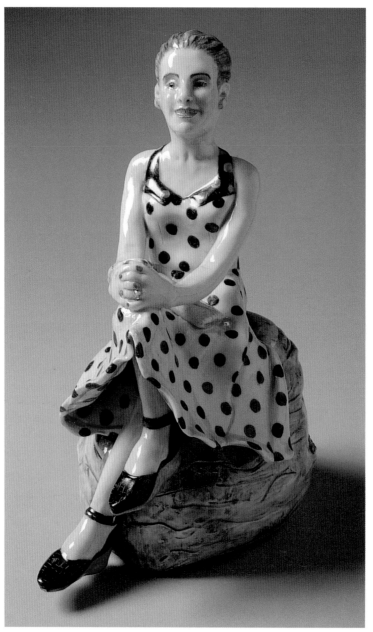

LAURA WILENSKY
Summer 1958, 2002

8 ½ x 4 x 7 in. (22 x 10 x 18 cm)

Hand-built porcelain; underglazes,
China paints; cone 10, cone 018

Photo by Storm Photo

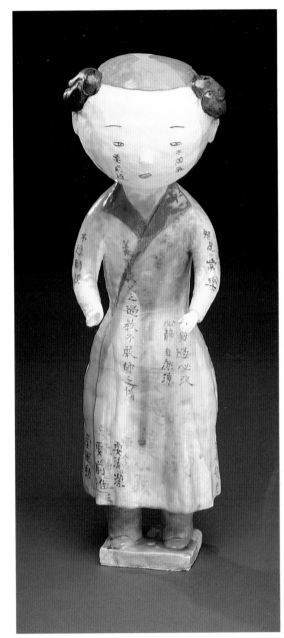

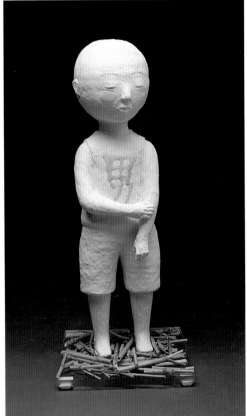

BETH LO
ABOVE
Boy, 2002

19 x 7 x 7 in. (48 x 18 x 18 cm)

Coil-built porcelain; bamboo, Plexiglas, epoxy

Photo by Chris Autio

LEFT
Only One Child, 1999

18 x 6 x 5 in. (46 x 15 x 13 cm)

Coil-built porcelain; underglazes, glazes, China paint

Photo by Chris Autio

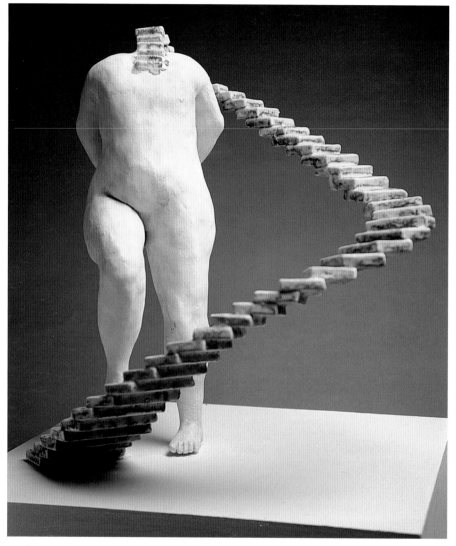

YELENA SHEYNIN
Leads Straight to My Head, 2003

18 x 13 x 12 in. (46 x 33 x 31 cm)

Hand-built ceramic; low-fire glaze

Photo by artist

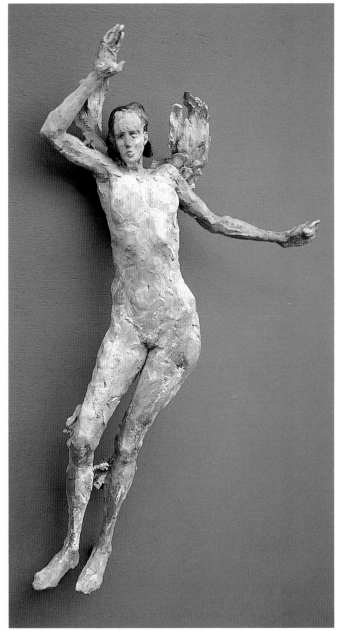

KAREN SWENHOLT
Forgiving Kennedy, 2003

18 x 10 x 2 in. (46 x 25 x 5 cm)

Terra cotta; paint, wax; fired

Photo by artist

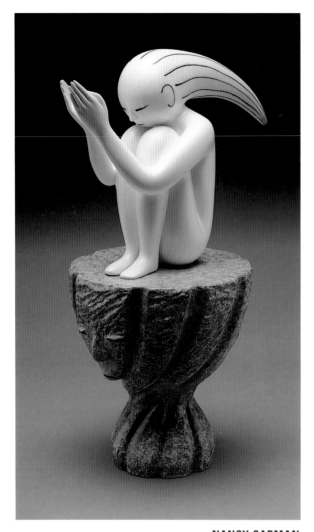

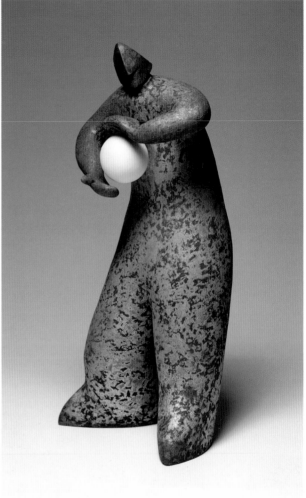

NANCY CARMAN
Pour Me Out, 2001

17 x 13 x 9 in. (43 x 33 x 23 cm)

Low-fire white earthenware;
hand built; underglazes, glazes

Photo by Joseph Painter

FRED YOKEL
Just Let Go, 1999

22 x 10 x 10 in. (56 x 25 x 25 cm)

Raku clay with porcelain ball; coil built;
sponged, dry copper matte glaze

Photo by Roger Dunn

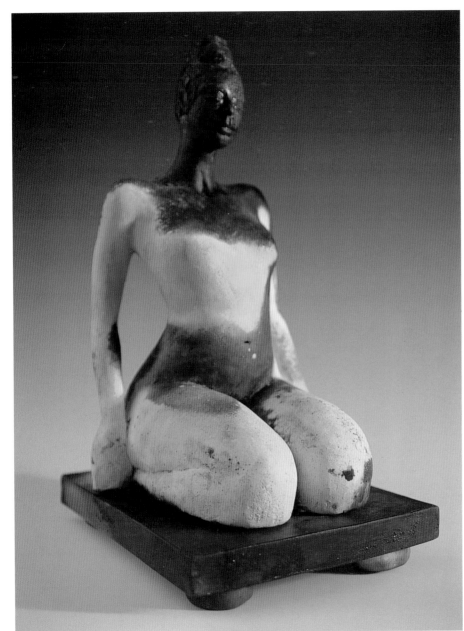

NANCY FARRELL
Kneeling Woman, 2003

13 ½ x 6 ¾ x 9 in. (34 x 17 x 23 cm)

Porcelain; smoke-fired

Photo by artist

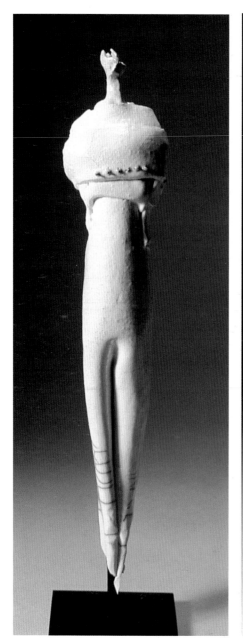

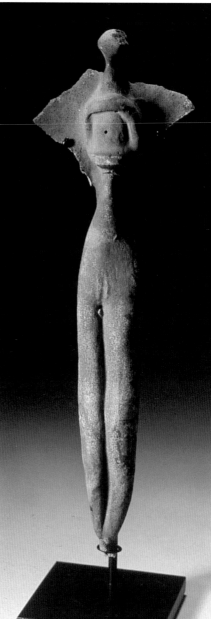

NANCY LEGGE
FAR LEFT
Penelope, 2002

15 x 2 ¾ x 2 in. (38 x 7 x 5 cm)

Clay, iron; raku-fired

Photo by Gugger Petter

LEFT
Torquil, 2002

11 ½ x 3 ¼ x 1 ½ in. (29 x 8 x 4 cm)

Clay; raku-fired

Photo by Gugger Petter

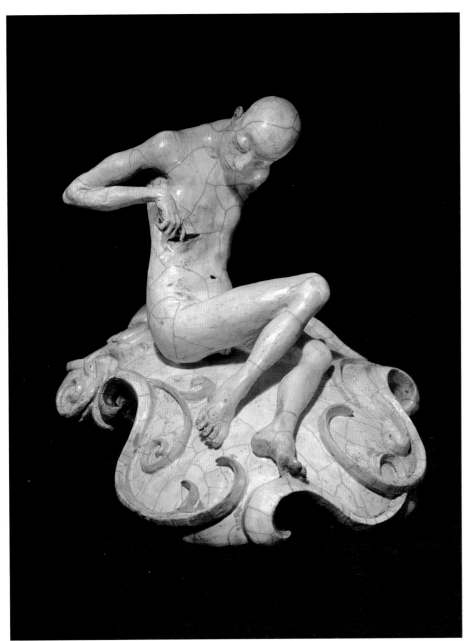

JUSTIN NOVAK
Disfigurine #24, 2001

12 x 12 x 12 in. (31 x 31 x 31 cm)

Ceramic; raku-fired

Photo by artist

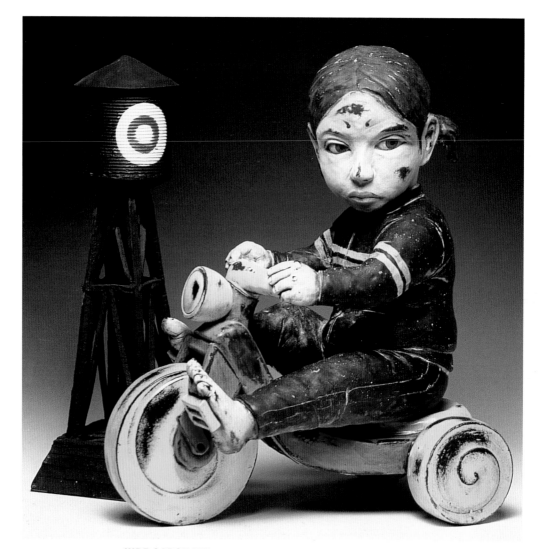

HIDE SADOHARA
Untitled, 2003

18 x 14 x 9 in. (46 x 36 x 23 cm)

Hand-built stoneware

Photo by artist
Courtesy of The Clay Studio, Philadelphia

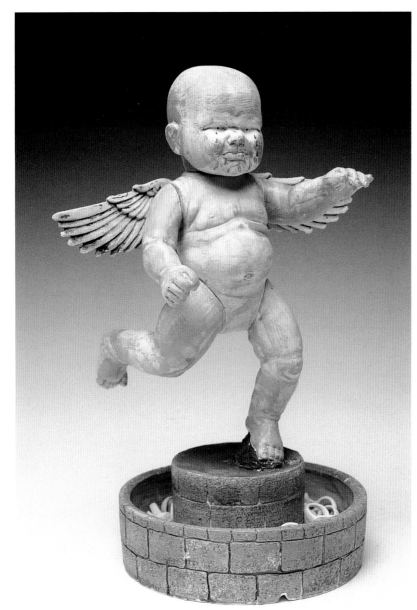

JEFFREY LANFEAR
Out of Arrows, 2002

15 x 8 x 6 in. (38 x 20 x 15 cm)

Porcelain, stoneware; thrown, slip cast

Photo by artist

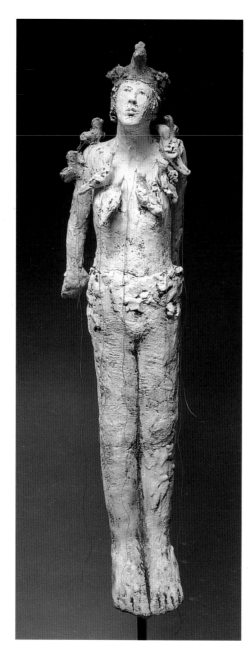

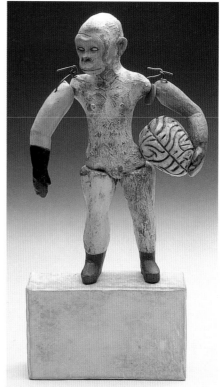

ABOVE
MICHAELENE WALSH
Aggressive Primitive, 2001

12 x 6 x 4 in. (31 x 15 x 10 cm)

Hand-built earthenware; glazes, rubber, steel wire

Photo by Eduardo Calderon

LEFT
DEBRA W. FRITTS
Connected, 2003

30 x 7 ½ x 6 ½ in. (76 x 18 x 17 cm)

Terra cotta, metal armature; hand built, coiled, modeled;
red thread, oxide, slips, underglazes; multi-fired

Photo by Mike Jenson

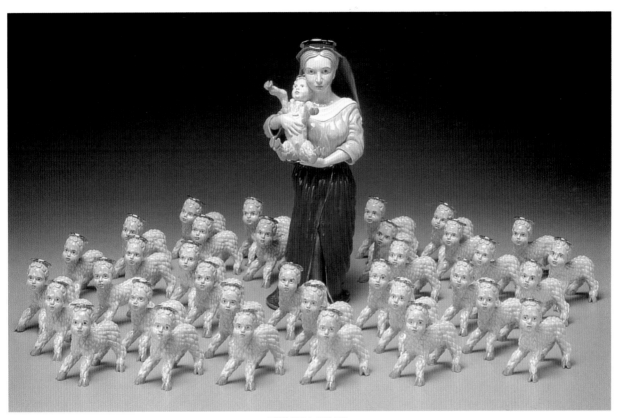

RUSSELL BILES
Mary Had A Little Lamb (The Second Coming), 2002

Mary: 14 x 5 ½ x 5 ½ in. (36 x 14 x 14 cm)

Lambs: 3 ½ x 3 ¼ x 2 ¼ in. (9 x 8 x 6 cm)

Earthenware; coil built, slip cast; underglaze

Photo by Tim Barnwell
Courtesy of Ferrin Gallery

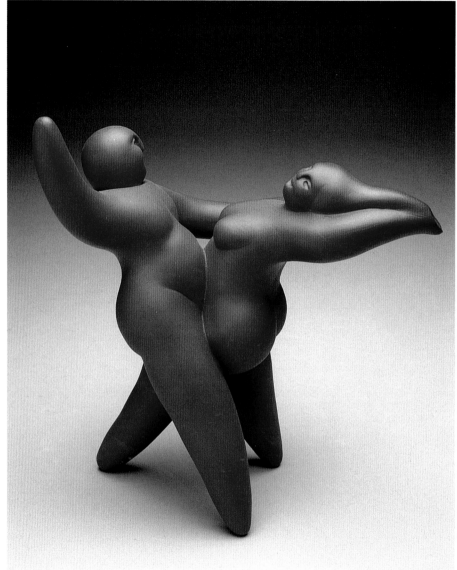

RICHARD SWANSON
Tango Teapot, 2002

10 x 9 x 6 in. (25 x 23 x 15 cm)

High-iron clay; slip cast; bisque
cone 06, fired until vitreous,
cone 54, sanded after each firing

Photo by artist

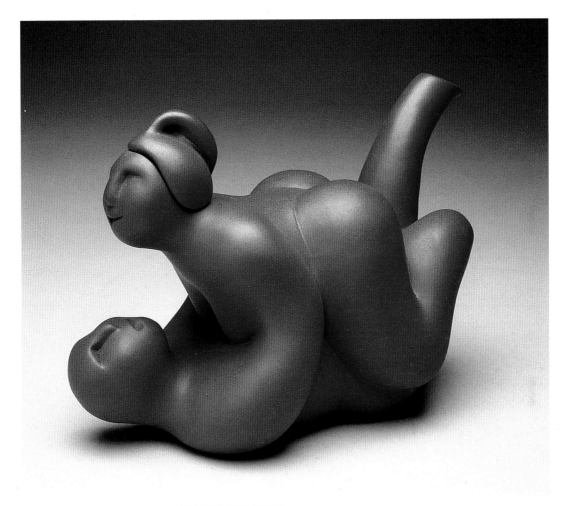

RICHARD SWANSON
Pleasure That Burns Teapot, 2002

9 ½ x 6 x 4 in. (24 x 15 x 10 cm)

High-iron clay; slip cast; bisque cone 06, fired until vitreous, cone 54, sanded after each firing

Photo by artist

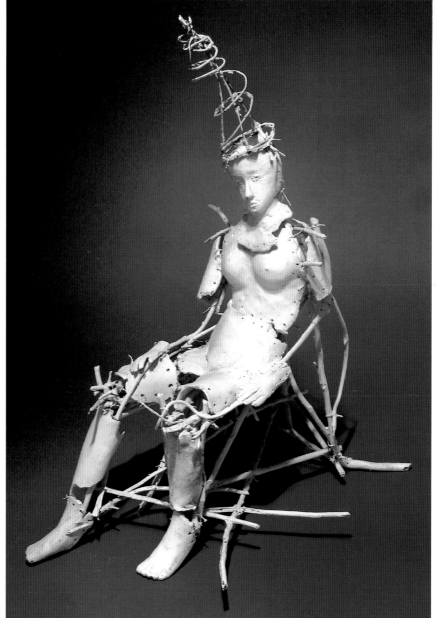

JAYE LAWRENCE
Small Seated Figure, 2003

14 x 8 x 19 in. (36 x 20 x 48 cm)

Press-molded clay; wood, wire, paint

Photo by Les Lawrence

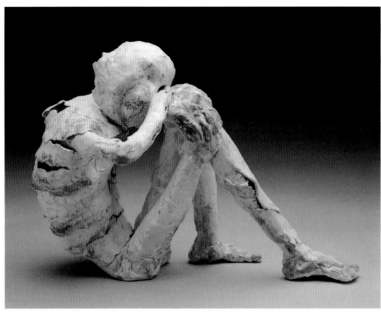

These are two in a series of seven figures based on a poem by Keats, also titled *La Belle Dame Sans Merci.*

ANDI SILVER
LEFT
La Belle Dame Sans Merci #7, 2002

18 x 30 x 7 in. (46 x 76 x 18 cm)

Cone 10 paper clay slip poured on plaster bat; cone 6

Photo by artist

BELOW
La Belle Dame Sans Merci #4, 2002

2 x 18 x 5 in. (5 x 46 x 13 cm)

Cone 10 paper clay slip poured on plaster bat; glaze; cone 6

Photo by artist

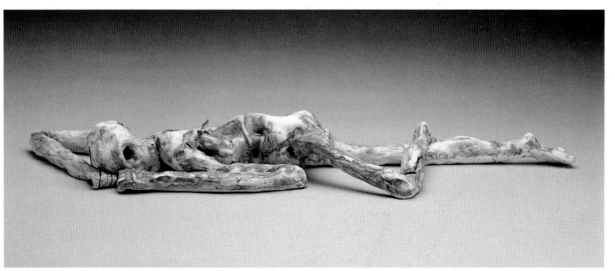

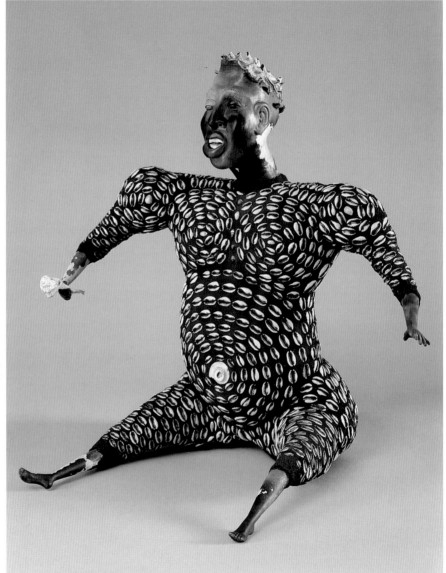

RONNA NEUENSCHWANDER
Kolon Tigi, 2003

18 x 17 x 12 in. (46 x 43 x 31 cm)

Earthenware; shells, grout,
terra sigillata

Photo by Aaron Johanson
In the collection of Monroe Klein

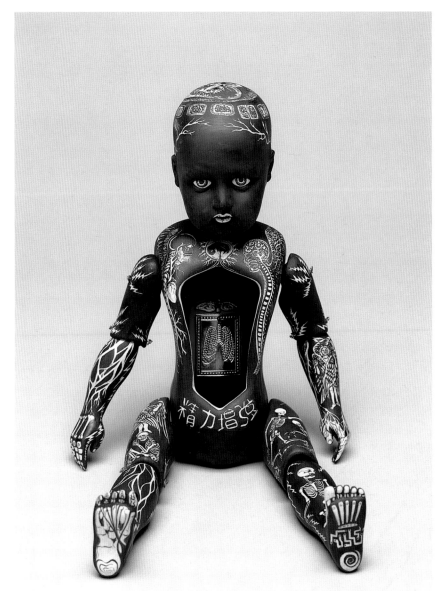

MARYANN WEBSTER
Lazarus Figure, 2003

Reclining: 20 x 9 x 4 in. (51 x 23 x 10 cm)

Seated: 10 x 9 x 6 in. (25 x 23 x 15 cm)

Porcelain; terra sigillata, sgraffito, milagro lung charm, movable joints

Photo by Dennis Mecham

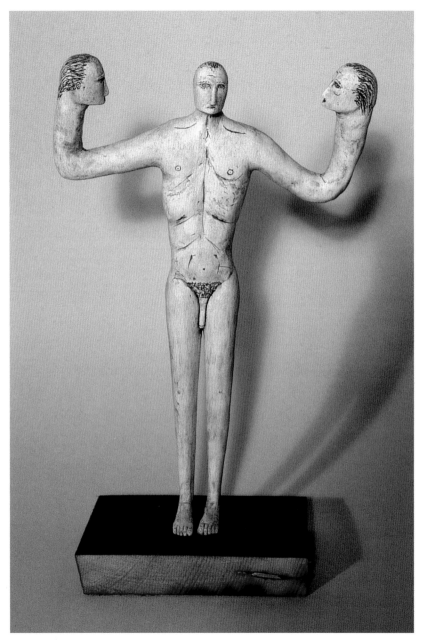

In most cases the title of my work has many possible definitions/meanings that I want the viewer to consider when interpreting the work.

STEVEN P. BRADFORD
Voices, 1999
8 x 6 x 3 in. (20 x 15 x 8 cm)
Earthenware
Photo by artist

After traveling throughout France and spending time in Paris, I began seeing the figure in Impressionist terms. I wanted to try to capture the feeling of youth, health, and joy in my sculpture.

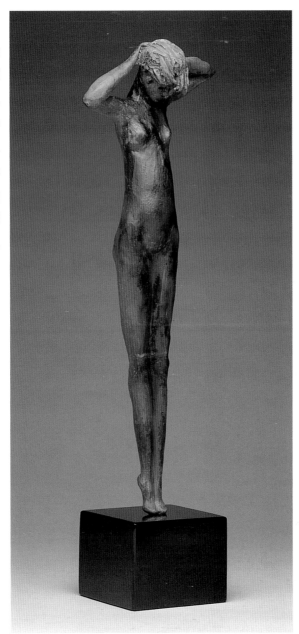

LINDA HANSEN MAU
Jeune Fille, 2000

17 x 6 x 3 in. (43 x 15 x 8 cm)

Paper clay, stoneware; hand built; red terra sigillata; electric-fired, smoked in open tub with newspaper

Photo by Lynn Hunton

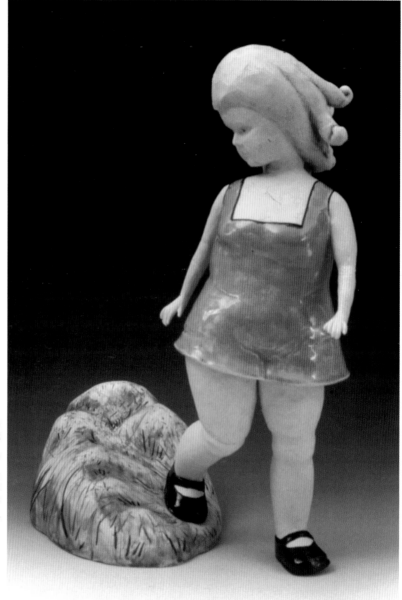

KRISTA GRECCO
Last Glance, 2003

13 x 12 x 7 in. (33 x 31 x 18 cm)

Porcelain; hand built, with
some press molded parts;
custom-made glazes and washes

Photo courtesy of Ann Nathan Gallery

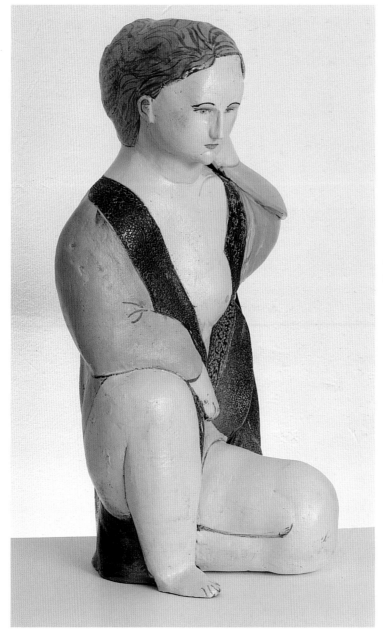

MICHAEL KAY
Odelisque, 2001

17 ¾ x 11 ¼ x 8 ¾ in. (45 x 28 x 22 cm)

Hand-built white earthenware; colored slips, oxides

Photo by artist

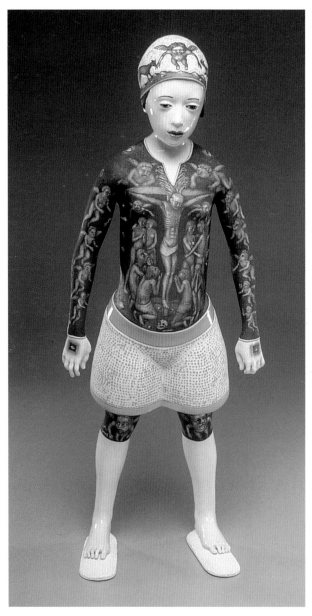
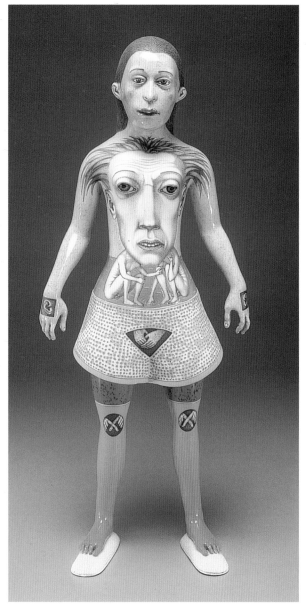

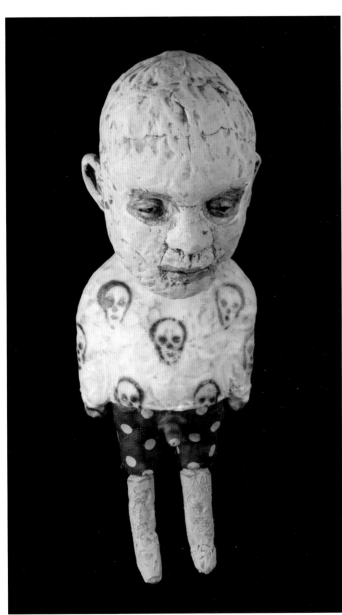

SERGEI ISUPOV
OPPOSITE PAGE LEFT
Broken Heart, 2003

21 x 6 ½ x 6 in. (53 x 16 x 15 cm)

Porcelain; glaze

Photo courtesy of Ferrin Gallery

OPPOSITE PAGE RIGHT
Moody, 2003

22 x 9 x 4 in. (56 x 23 x 10 cm)

Porcelain; glaze

Photo courtesy of Ferrin Gallery

TOM BARTEL
LEFT
Life and Death Figure, 2003

18 x 12 x 18 in. (46 x 31 x 46 cm)

Ceramic, wire; vitreous engobes; multi-fired

Photo by Geoff Carr

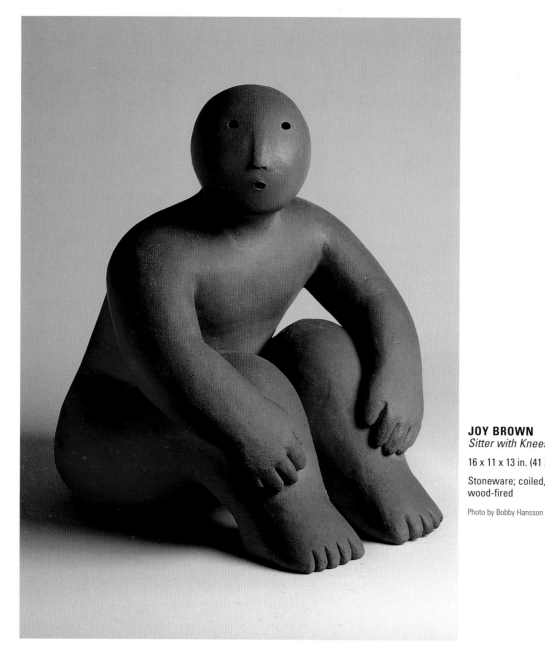

JOY BROWN
Sitter with Knees Up, 2000

16 x 11 x 13 in. (41 x 28 x 33 cm)

Stoneware; coiled, paddled;
wood-fired

Photo by Bobby Hansson

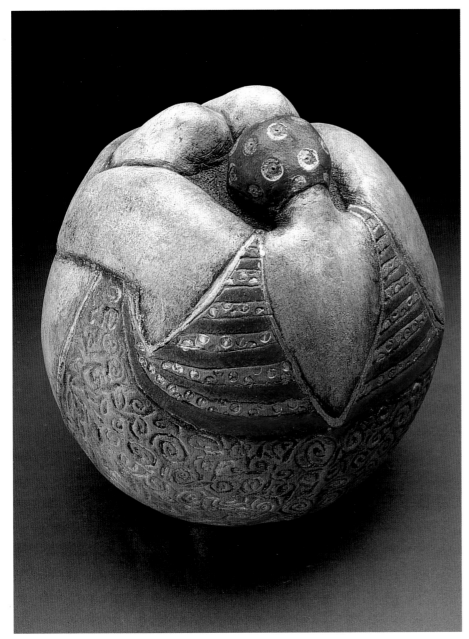

MARIE E.V.B. GIBBONS
Orange Suited Swimmer, 2003

7 x 7 x 8 in. (18 x 18 x 20 cm)

Hand built, pinched; low-fire, cold finishes, acrylic paints, washes, 22k-gold leaf

Photo by Maddog Studio

JENNY MENDES
Black or White?, 2003

7 x 4 ½ x 3 in. (18 x 11 x 8 cm)

Terra cotta; terra sigillata; cone 03

Photo by Heather Protz

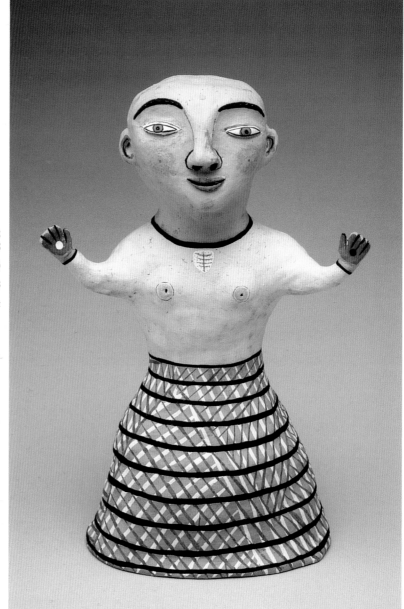

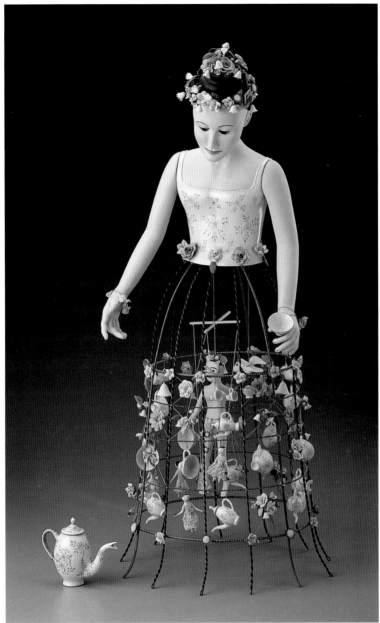

LIA ZULALIAN
Doll #4, 2003

24 x 10 in. (61 x 25 cm)

Porcelain; slip cast, hand built, assembled; China paints, wire

Photo by John Polak
Courtesy of Ferrin Gallery

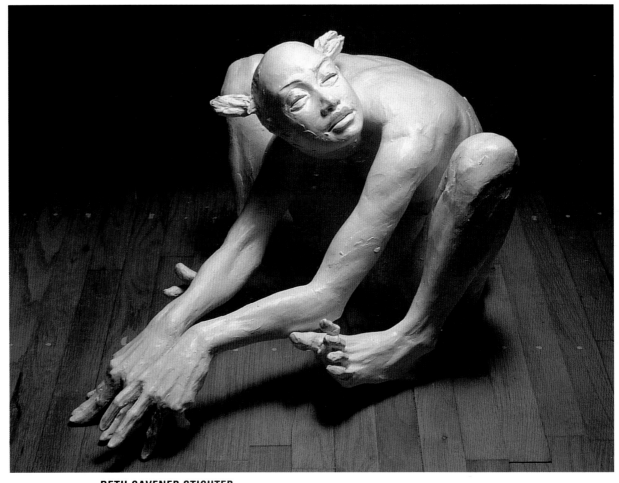

BETH CAVENER STICHTER
Play, 2002

18 x 29 x 21 in. (46 x 74 x 53 cm)

Built solid from 600 lb. (273 kg) of
stoneware: cut, hollowed, reassembled;
terra sigillata; fired

Photo by artist

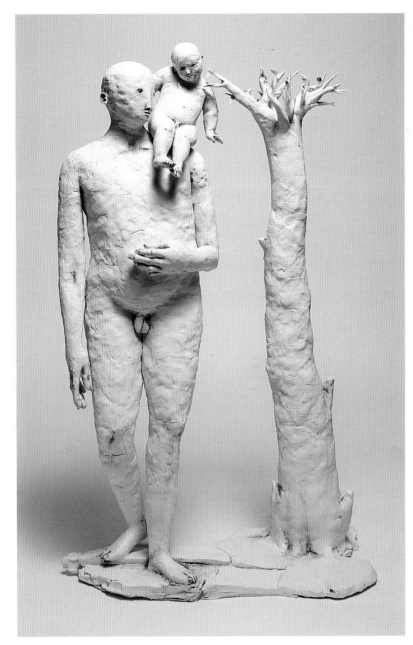

CLAIRE CURNEEN
St. Christopher, 2003

31 ½ x 13 ¾ x 7 ¾ in. (80 x 35 x 20 cm)

Hand-built porcelain; gold decals

Photo by artist

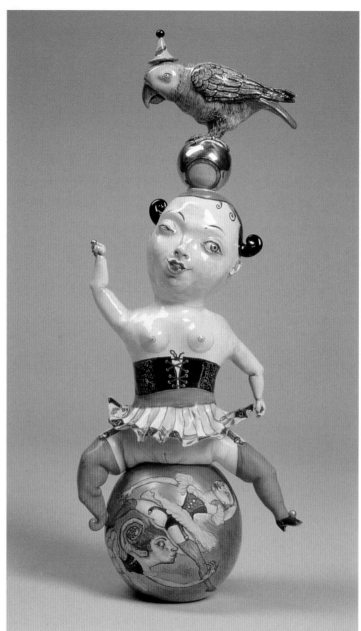

IRINA S. ZAYTCEVA
Little Red Riding Sock, 2001

19 x 8 in. (48 x 20 cm)

Hand-built porcelain; overglazes,
underglazes, 24k-gold paint; high-fired

Photo by artist

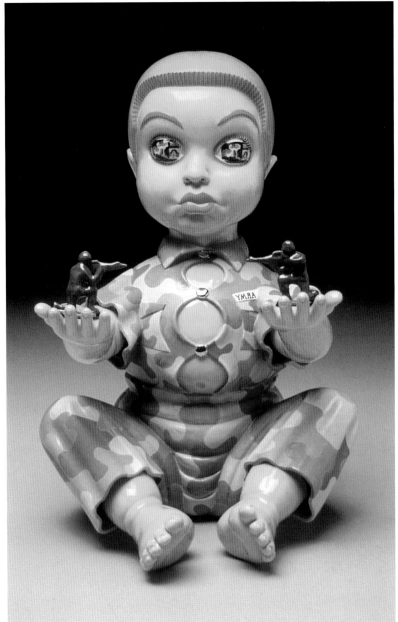

RUSSELL BILES
Raw Recruit (Basic Training), 2003

12 ½ x 8 ½ x 9 ½ in. (32 x 21 x 24 cm)

Coil-built porcelain; underglaze

Photo by Tim Barnwell
Courtesy of Ferrin Gallery

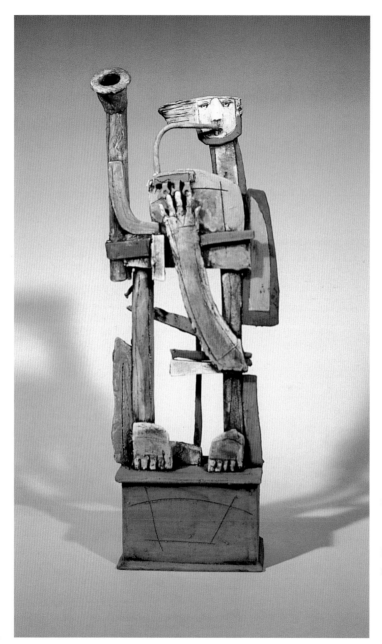

CHRISTY KEENEY
Pipe Player, 2003

16 x 7 x 5 in. (41 x 18 x 13 cm)

Raku crank clay; hand built; kiln-fired

Photo by artist

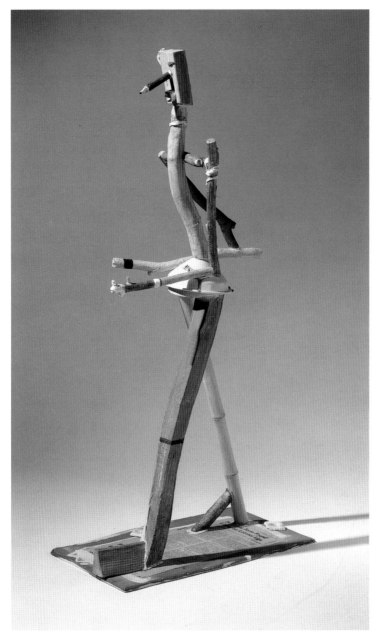

RICHARD SHAW
Double Dishes, 1997

22 x 14 x 7 ½ in. (56 x 36 x 19 cm)

Porcelain; decals, overglazes

Photo by Joseph Schopplein

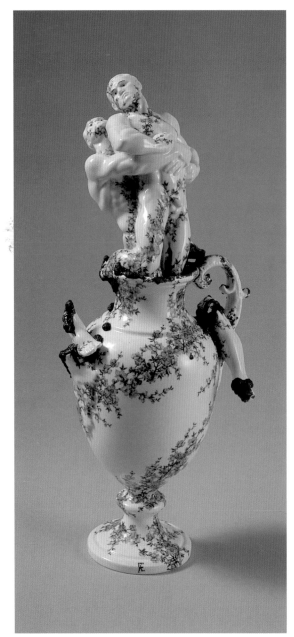

LASZLO FEKETE
ABOVE
The Thief from Bagdad, 2002-2003

14 ¼ x 7 x 17 in. (36 x 18 x 43 cm)

Constructed of fired pieces from Herend Porcelain Factory, Hungary

Photo by Gyula Tahin

LEFT
Fight to Death and Life, 2003

25 ¼ x 10 in. (64 x 25 cm)

Constructed of fired pieces from Herend Porcelain Factory, Hungary

Photo by Gyula Tahin

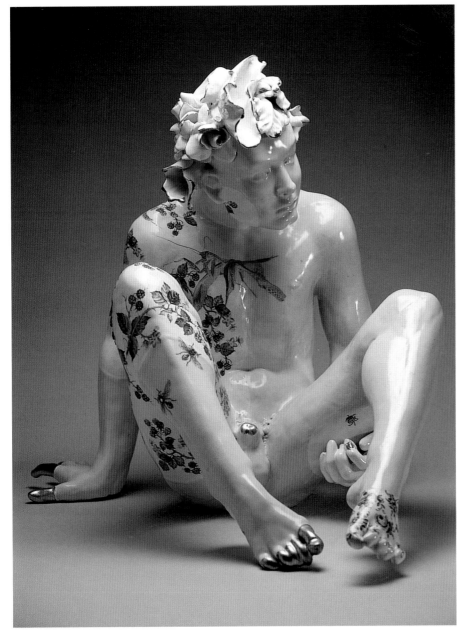

CHRISTYL BOGER
Untitled, 2001

30 x 26 x 26 in. (76 x 66 x 66 cm)

Hand-built ceramic; decals, lusters

Photo courtesy of The Clay Studio, Philadelphia

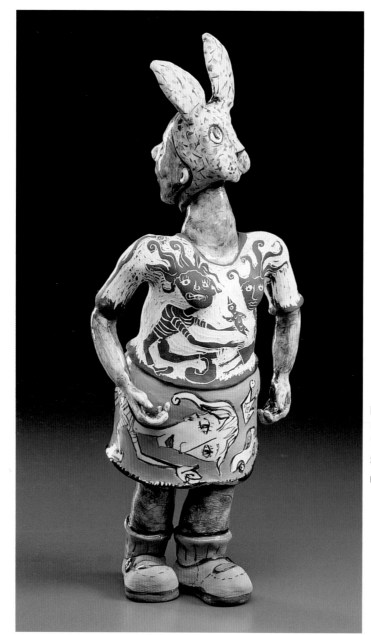

LAURA JEAN MCLAUGHLIN
Mary Jane, 2003

16 x 8 x 6 in. (41 x 20 x 15 cm)

Slab-built porcelain; slips, glaze, sgraffito

Photo by Mike Ray

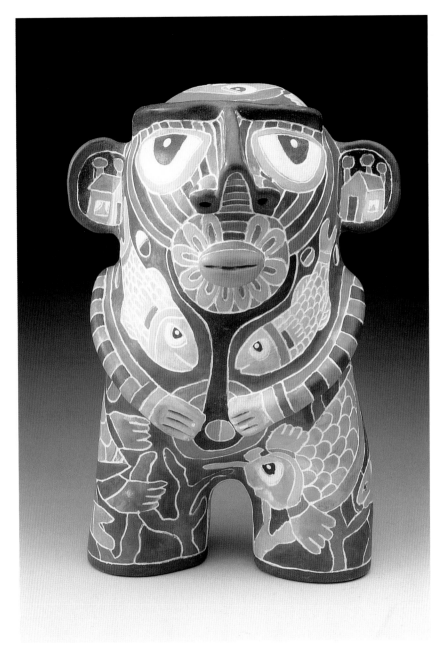

WASHINGTON LEDESMA
Leo, 2003

10 x 6 ³/₄ x 6 in. (25 x 17 x 15 cm)

White stoneware clay; multi-color underglazes, sgraffito, matte finish; cone 02 electric oxidation

Photo by Jerry Anthony

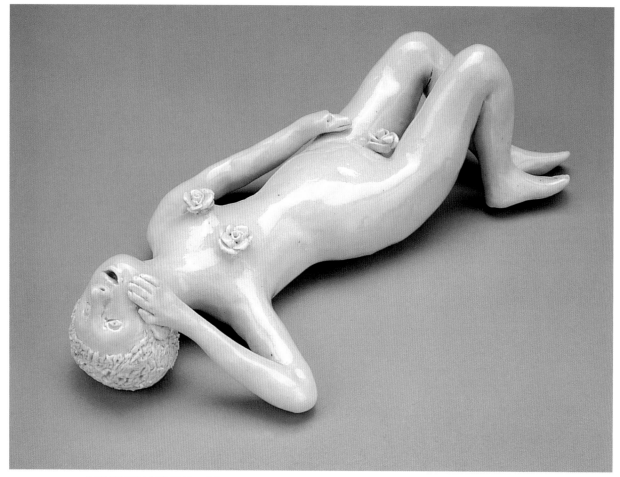

COILLE MCLAUGHLIN HOOVEN
Rosebud, 2003

4 x 9 x 5 in. (10 x 23 x 13 cm)

Hand-formed porcelain; cone 11

Photo by Charles Frizzell

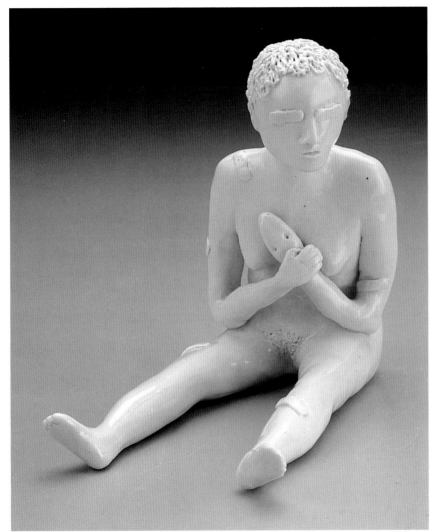

COILLE MCLAUGHLIN HOOVEN
World Series: Planetary Vision, 2003

5 x 5 x 5 in. (13 x 13 x 13 cm)

Hand-formed porcelain; cone 11

Photo by Charles Frizzell

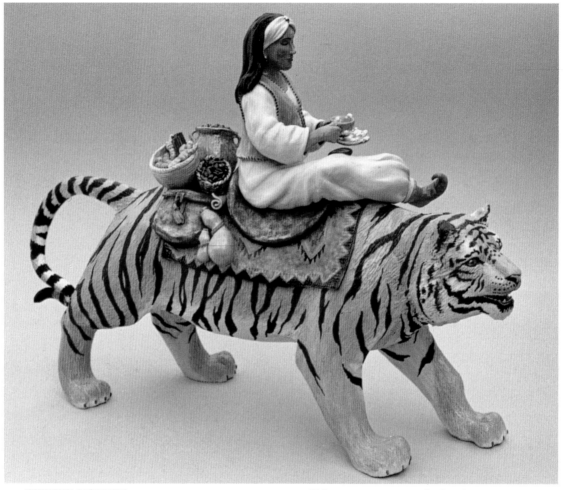

KATHRYN MCBRIDE
Bengal Spice Teapot, 1997

10 x 15 x 6 in. (25 x 38 x 15 cm)

Hand-built porcelain; engobe; cone 8 oxidation

Photo by artist
Courtesy of Ferrin Gallery

This teapot was made for the 1997 Celestial Seasonings Teapot Exhibition, using imagery from the Bengal Spice Tea packaging.

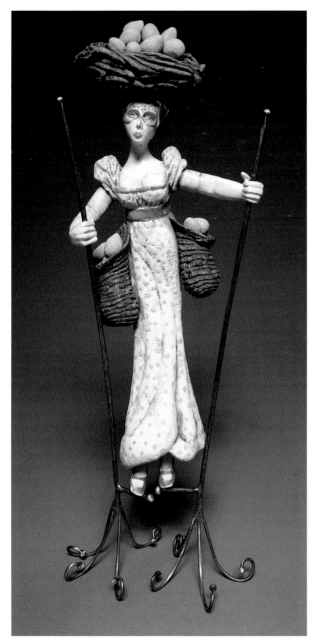

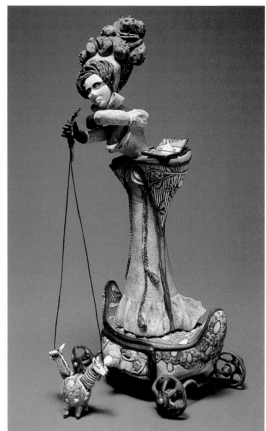

JOHN AND ROBIN GUMAELIUS
ABOVE
Hipstory, 2003

15 x 8 x 6 in. (38 x 20 x 15 cm)

Ceramic; hand built, carved; string, paper, steel

Photo by artists

LEFT
Egg Snatcher, 2003

15 x 7 x 5 in. (38 x 18 x 13 cm)

Ceramic, steel; hand built, carved; China paint; cone 6 glaze

Photo by artists

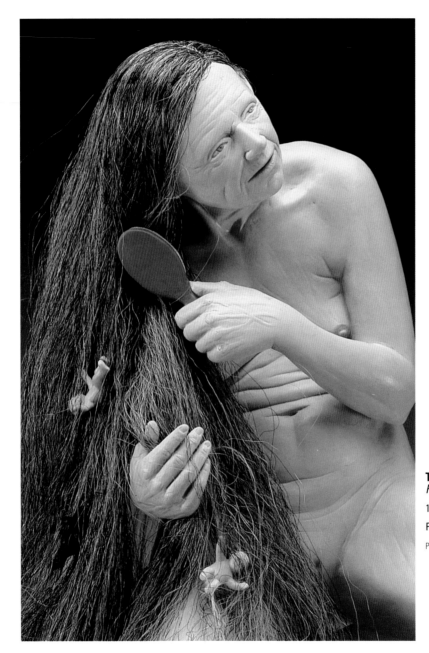

TIP TOLAND
River of Patience, 2002

15 x 20 x 12 in. (38 x 51 x 31 cm)

Porcelain; synthetic hair, wax, paint

Photo courtesy of Nancy Margolis Gallery, New York

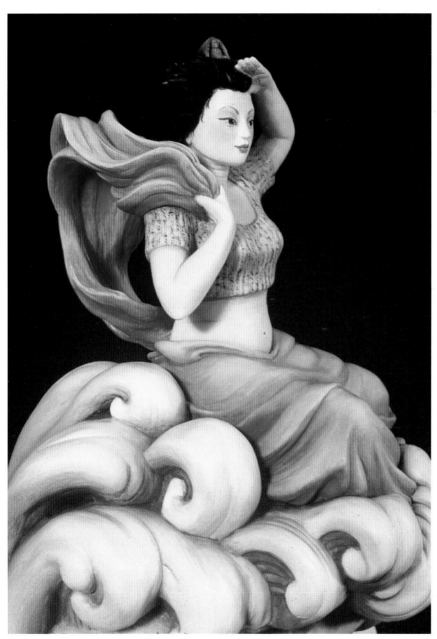

MIRIAM DAVIS
Kuan Yin, 2001

17 x 8 x 8 in. (43 x 20 x 20 cm)

Hand-modeled porcelain; oil paint; cone 4

Photo by Anita Frimkess-Fein

I tried to create a narrative that taps the viewers' imaginations and transports them into the window that both contains and reveals … My focus here is with a description of a voyeur as "a person who derives exaggerated or unseemly enjoyment from being an observer." I think that there is a voyeur in each of us.

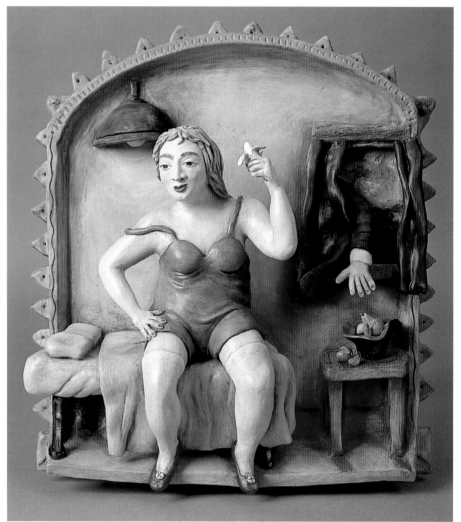

MARCIA SMITH
The Succulent Juices Remain on My Lips, 2002

13 x 12 x 4 in. (33 x 31 x 10 cm)

Hand-built white ceramic; glazes, stains, oil paints, wax; cone 5

Photo by David Furnas

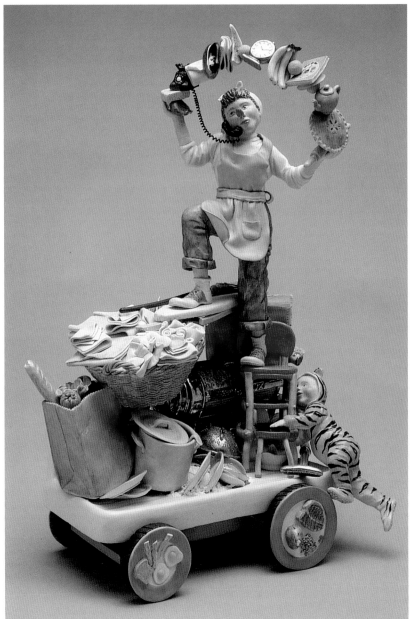

KATHRYN MCBRIDE
Mother's Balancing Act, 2003

17 x 12 x 6 in. (43 x 31 x 15 cm)

Hand-built porcelain; engobe, glaze decoration, stainless-steel wire; cone 8 oxidation

Photo by Tony Grant
Courtesy of Ferrin Gallery

This is the first in a series of tea sets casting the working mother as a circus performer.

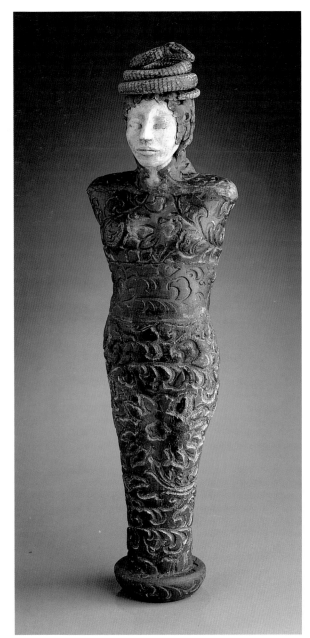

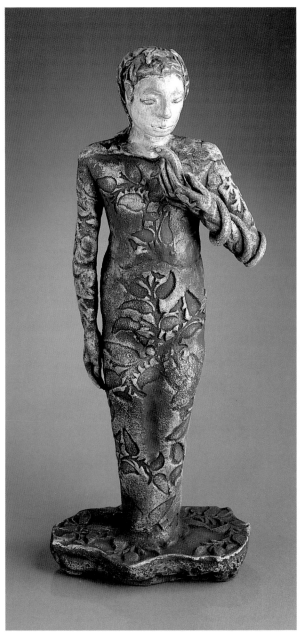

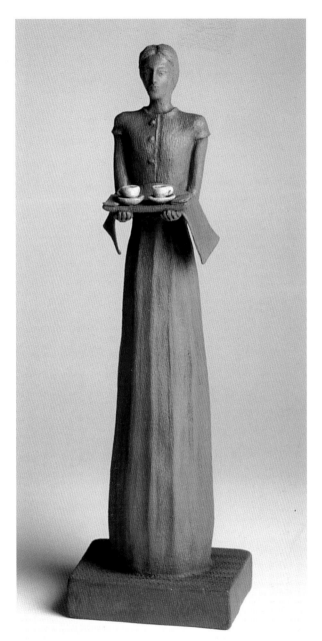

CAROL TRIGG
OPPOSITE PAGE LEFT
Primordial Spirit, 2003

25 ½ x 7 x 4 in. (65 x 18 x 10 cm)

Low-fire stoneware; slab built; engobes, stains, frit wash

Photo by Wendy McEahern

OPPOSITE PAGE RIGHT
Eve's Garden, 2003

21 x 8 x 5 ½ in. (53 x 20 x 14 cm)

Low-fire stoneware; slab built; engobes, stains, frit wash

Photo by Wendy McEahern

HOLDEN MCCURRY
LEFT
High Tea for Two, 2002

16 x 3 x 3 in. (41 x 8 x 8 cm)

Red sculpture clay; hand built, slab built; white slip, oxide wash; cone 4

Photo by Ralph Anderson

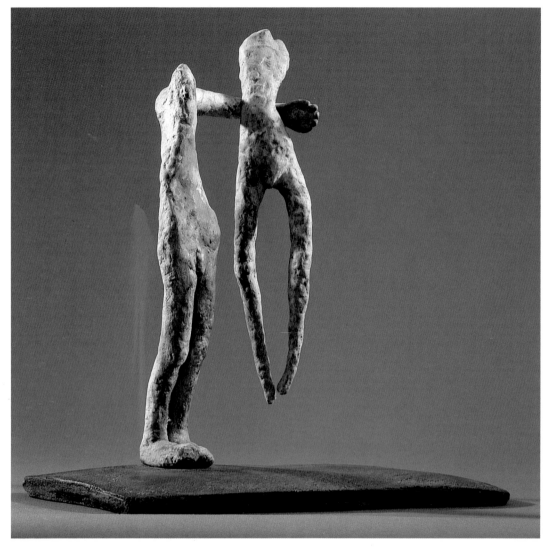

GRACE BAKST WAPNER
Self-Portrait, 1994

15 x 15 x 8 ½ in. (38 x 38 x 22 cm)

Clay; saggar-fired

Photo by Jerry Thompson

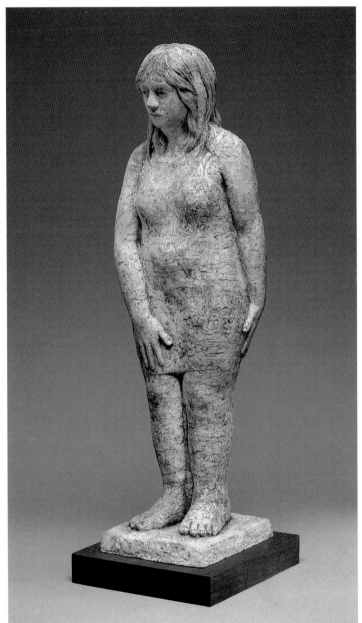

NORMAN D. HOLEN
Woman In A Summer Dress, 2002

26 x 8 ¼ x 9 ⅛ in. (66 x 21 x 23 cm)

Cast stoneware

Photo by Peter Lee

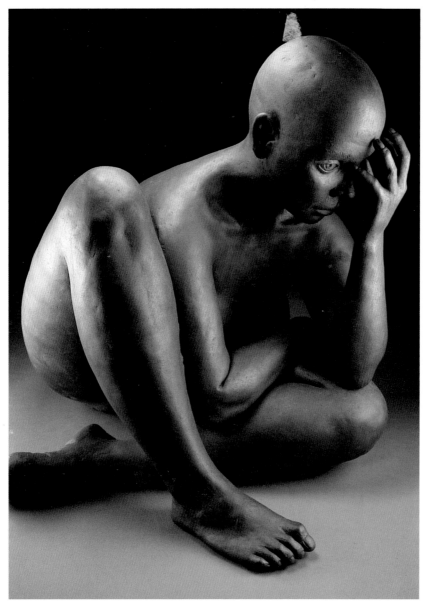

LIZ BRYANT
Under the Surface, 2003

23 x 25 x 27 in. (58 x 64 x 69 cm)

Ceramic; hand built, slab
constructed; collage

Photo by artist

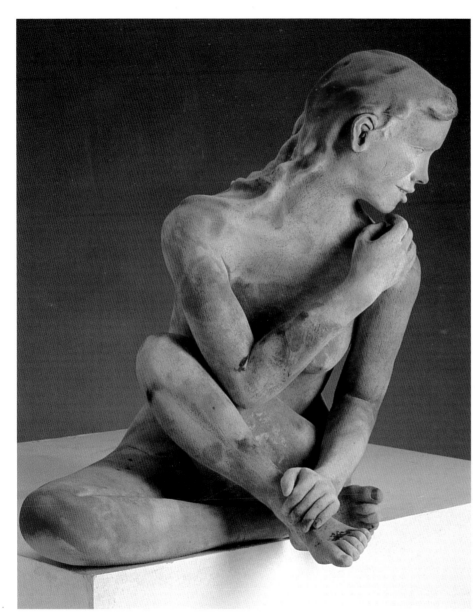

CECILIA ISRAEL-BRADFIELD
Beneath the Surface, 2001

25 x 23 x 22 in. (64 x 58 x 56 cm)

Slab built; saggar-fired

Photo by Steve Drimmel

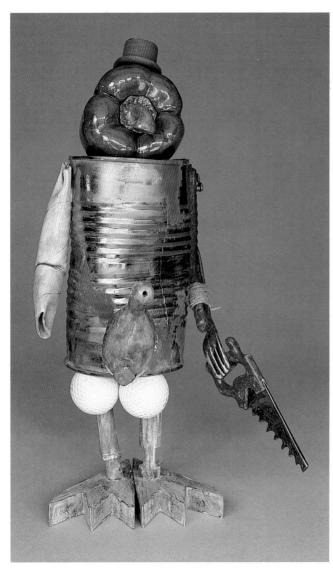

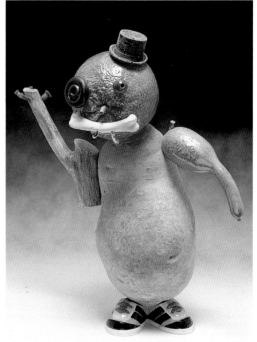

ROBIN CAMPO
ABOVE
Orange You Glad to See Me?, 2003

13 x 10 x 4 in. (33 x 25 x 10 cm)

Ceramic; assembled, slip cast; multi-fired

Photo by artist

LEFT
Pepper Head, 2003

15 x 8 x 9 in. (38 x 20 x 23 cm)

Altered, assembled, slip cast; multi-fired

Photo by artist

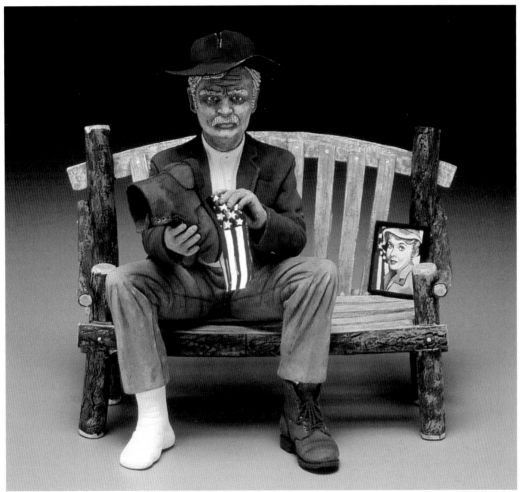

RUSSELL BILES
Beverly Hillbillies 9.11 (Jed), 2002

11 x 11 ½ x 9 in. (28 x 29 x 23 cm)

Coil-built earthenware; underglaze

Photo by Tim Barnwell
Courtesy of Ferrin Gallery

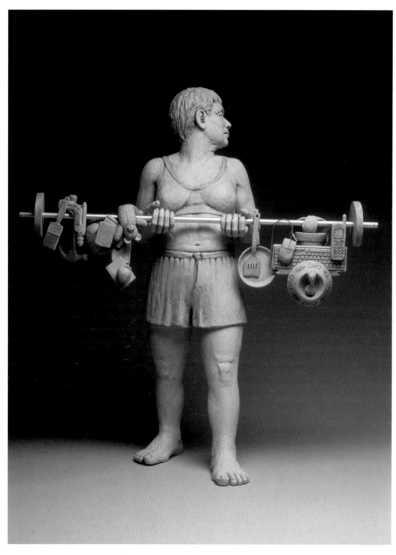

This piece, although not a self-portrait, is an expression of personal experience. Being an artist, wife, mother, cook, dog walker, organizer, and communicator all at once can sometimes become a heavy weight to carry … with motivation, strength, and a good sense of balance, the jobs get done.

CLAUDIA OLDS GOLDIE
A Weight-Bearing Exercise, 2002
25 x 24 x 10 in. (64 x 61 x 25 cm)
Hollow-built stoneware; India ink stain
Photo by David Caras

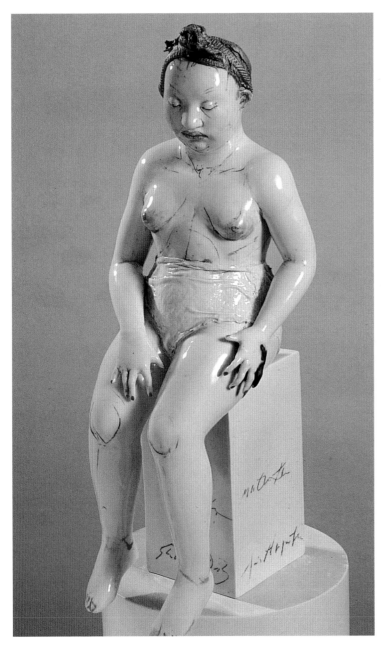

I approach the soft, white China clay with a particular picture in my mind's eye. During the process of working, the piece gradually changes; it is formed, broken, and revived.

GUNDI DIETZ
Sitting Women with Golden Hair-bow, 2001

17 ¾ x 9 ¾ x 9 ¾ in. (45 x 25 x 25 cm)

Modeled porcelain; underglaze, burnished gold; 2516°F (1380°C)

Photo by Tina Dietz

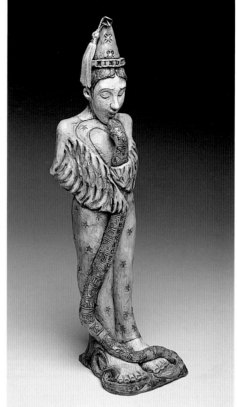

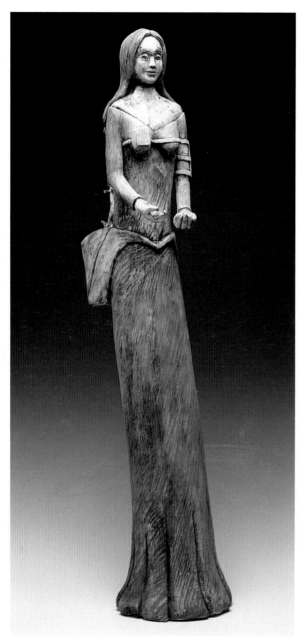

JANIE PACKER
ABOVE
Mindful Embrace, 2003

20 x 6 x 6 in. (51 x 15 x 15 cm)

White stoneware; slab built, coiled; acrylic paints, found objects

Photo by Gerhard Heidersberger

SHANNON CALHOUN
LEFT
Contemplation, 2003

24 x 4 x 4 in. (61 x 10 x 10 cm)

Hand-built ceramic; low-fire stains, low-fire underglazes

Photo by artist

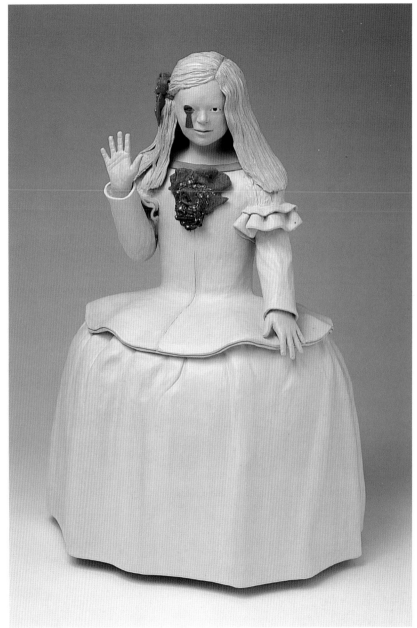

TIM N. TAUNTON
La Menina Espiana, 2002

23 x 16 x 16 in. (58 x 41 x 41 cm)

Hand-built earthenware; terra
sigillata, underglaze

Photo by artist

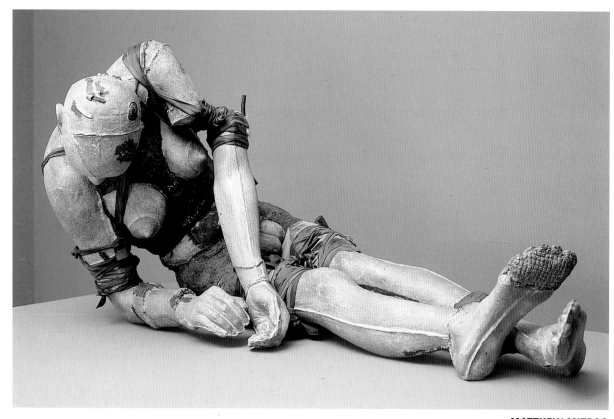

MATTHEW MITROS
Human, 2003

24 x 40 x 20 in. (61 x 102 x 51 cm)

Hand-built stoneware; rubber; salt-fired cone 6,
sandblasted

Photo by artist

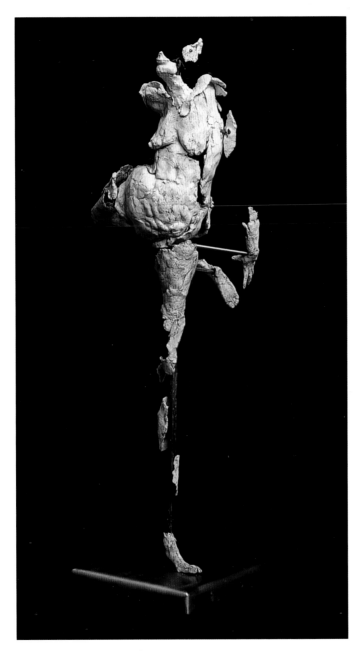

EMMA RODGERS
Re-Constructed Figure, 2003

27 ½ x 11 ¾ x 11 ¾ in. (70 x 30 x 30 cm)

Porcelain, white stoneware; hand built on steel armature

Photo by Peter Raymond

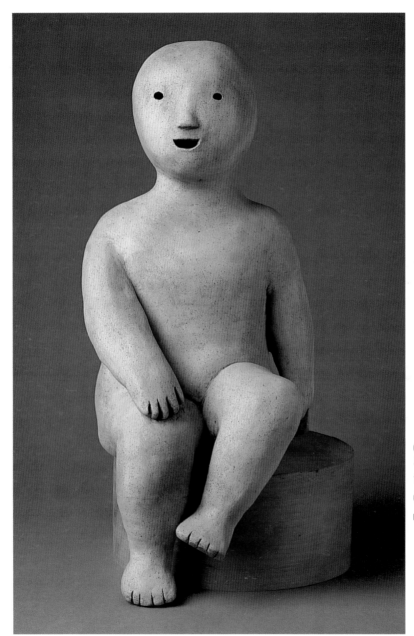

CAROL VAN DE WALL-BACA
Homage to Joy Brown, 2003
19 ½ x 12 x 12 ½ in. (50 x 30 x 32 cm)

Clay; stains; gas-fired

Photo by Bruce Blank

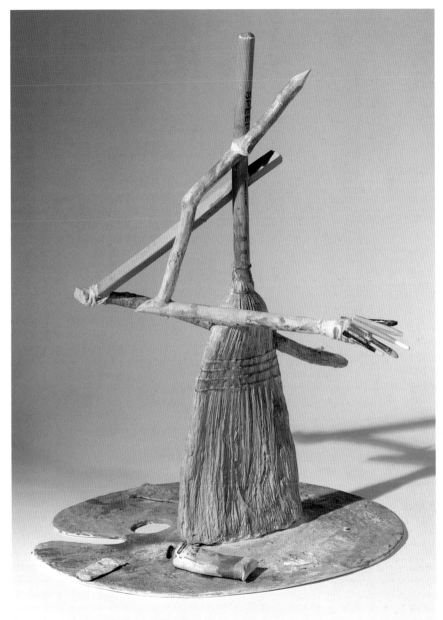

RICHARD SHAW
Speeding, 1994

27 x 21 x 13 in. (67 x 53 x 33 cm)

Porcelain; decals, overglazes

Photo by Joseph Schopplein

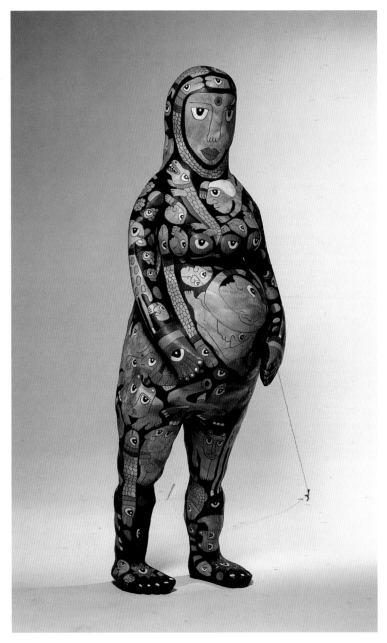

WASHINGTON LEDESMA
*Flor de Lis Standing Figure
(Goddess Flower),* 2002

38 x 12 x 11 in. (97 x 31 x 28 cm)

Terra cotta; multi-color underglazes,
sgraffito, matte finish; cone 02
oxidation electric

Photo by Bob Gothard

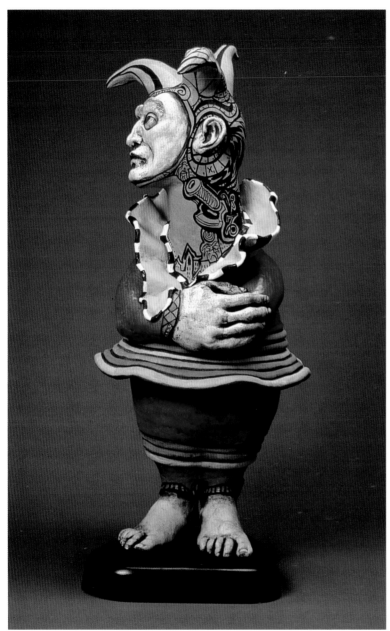

Using humor to tell my stories seems to be a natural approach for me, and I use it as a carrot to entice the audience into the work ... I am hopeful that people will find their own interpretations and relate to the work on their own terms.

JEAN CAPPADONNA NICHOLS
Space Harlequin with Two Left Feet, 2003

34 x 16 x 14 in. (86 x 41 x 36 cm)

Whiteware; hand built, coils on slabs; glazes, underglazes

Photo by Karen Harmon, Ft. Myers, Florida
Courtesy of Carol Robinson Gallery, New Orleans; Del Mano Gallery, Los Angeles; Matsumoto Gallery, Sanibel Island, Florida

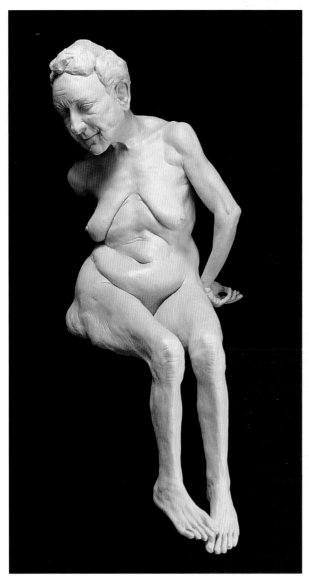 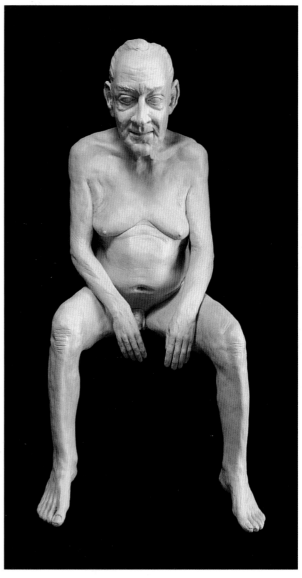

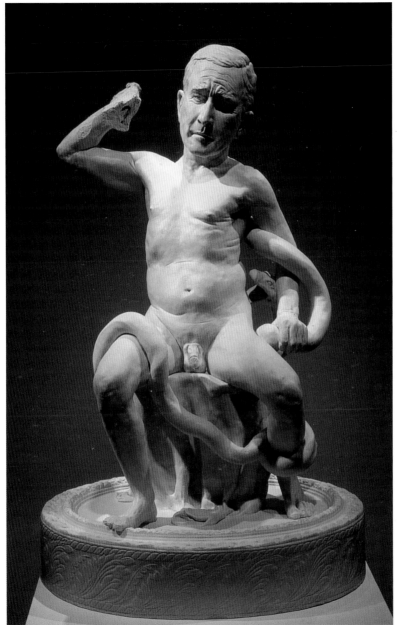

DIRK STASCHKE
OPPOSITE PAGE LEFT
Old Woman, 2002

33 x 11 x 20 in. (84 x 28 x 51 cm)

Hand-built ceramic

Photo by artist

OPPOSITE PAGE RIGHT
Old Man, 2002

34 x 16 x 16 in. (86 x 41 x 41 cm)

Hand-built ceramic

Photo by artist

LEFT
After Laocoön, 2003

38 x 25 x 20 in. (97 x 64 x 51 cm)

Hand-built ceramic

Photo by artist

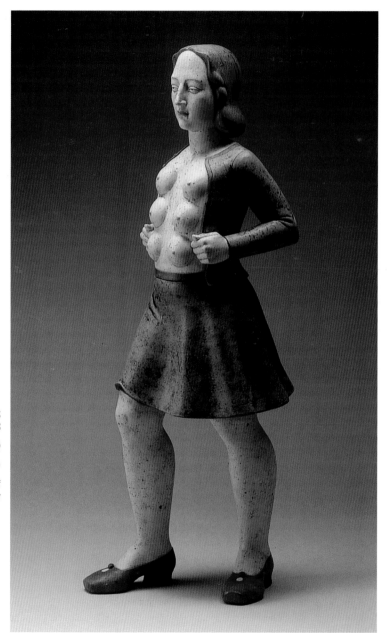

LAURA DE ANGELIS
Sphinx, 2003

34 x 11 x 11 in. (86 x 28 x 28 cm)

Ceramic; layered engobes, wood-ash glaze

Photo by E. G. Schempf
Courtesy of Ferrin Gallery

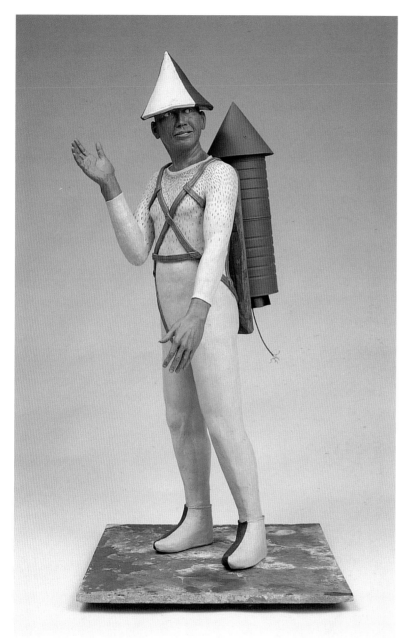

TIM N. TAUNTON
Rocketman, 1995

36 x 14 x 17 in. (91 x 36 x 43 cm)

Earthenware, slate base; hand built;
terra sigillata, wood, metal, wire

Photo by artist

This piece explores
childhood realities.

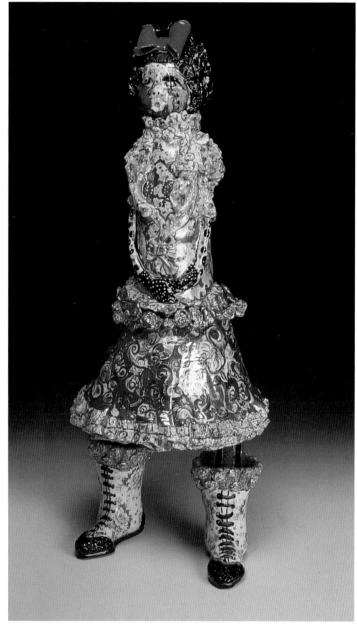

LANEY K. OXMAN
Camouflaged Innocence, 2003

60 x 25 x 25 in. (152 x 64 x 64 cm)

Red earthenware; underglazes, glazes,
enamels, 24k-gold; multi-fired

Photo by artist

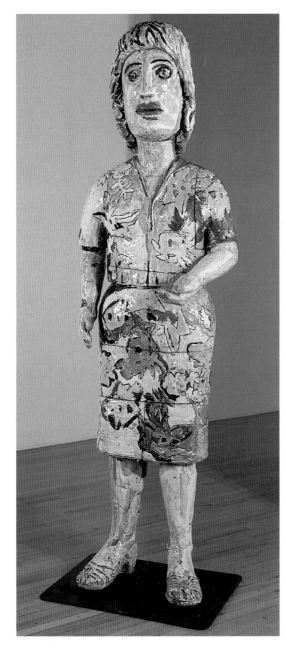

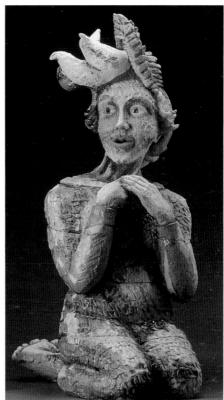

CHERYL TALL
ABOVE
Tallulah, 2003

38 x 18 x 27 in. (97 x 46 x 69 cm)

Clay; coil built in sections, fitted inner flanges; terra sigillata, oxides, glazes

Photo by Dennis Cobey

VIOLA FREY
LEFT
Reflective Woman I, 2002

94 ½ x 29 x 24 in. (240 x 74 x 61 cm)

Ceramic

Photo by artist
Courtesy of Nancy Hoffman Gallery, New York

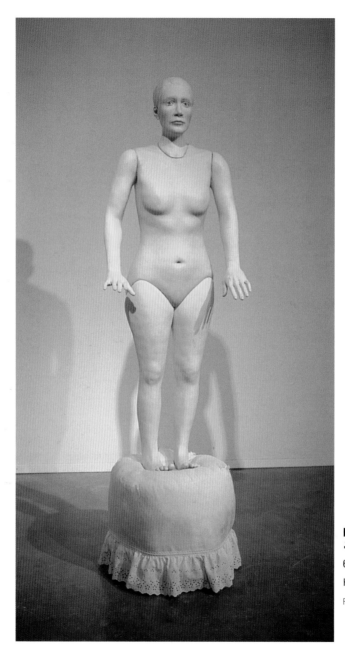

REBECCAH KARDONG
Stand, 2001

65 x 23 x 17 in. (165 x 58 x 43 cm)

Hand-built ceramic; mixed media

Photo by artist

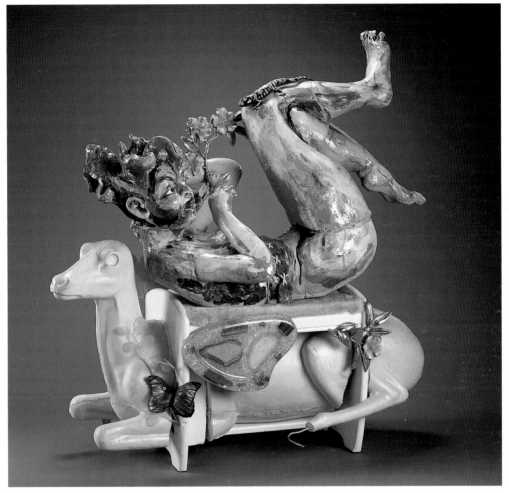

ANNE PERRIGO
Jane Doe, 2000

47 x 42 x 17 in. (119 x 107 x 43 cm)

Low-fire clay; hand built; low-fire glaze,
China paints, wood, plastic, taxidermy form,
found objects

Photo by Roger Schreiber

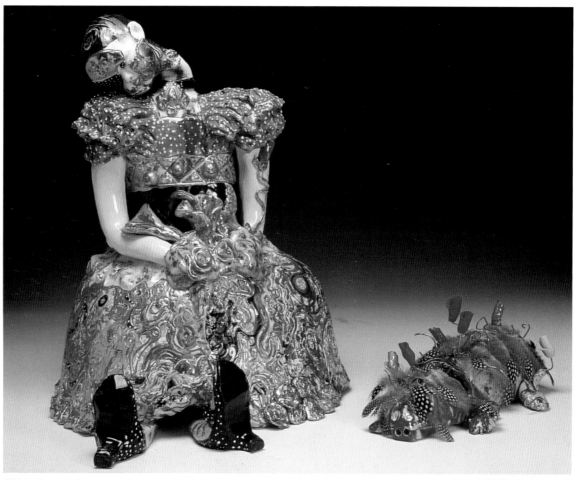

This piece addresses issues of
childhood molestation.

LANEY K. OXMAN
Sadness Among Opulence, 2003
36 x 20 x 20 in. (91 x 51 x 51 cm)
Hand-built white earthenware; glazed, 24k gold; multi-fired

Photo by artist

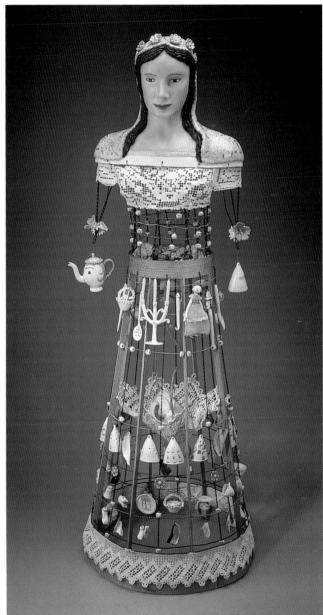

LIA ZULALIAN
Life's Crossroads, 2001

38 x 14 x 13 in. (97 x 36 x 33 cm)

Porcelain; slip cast, hand built; encaustic,
China paints, wood, wire, lace, wax

Photo by John Polak
Courtesy of Ferrin Gallery

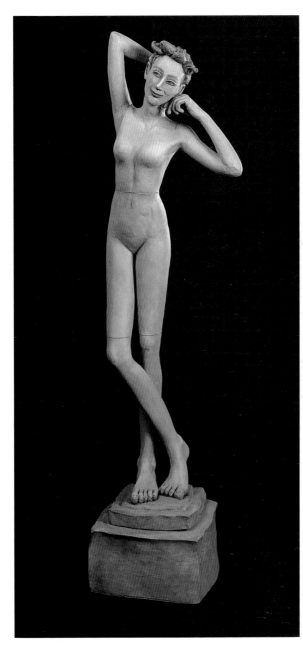

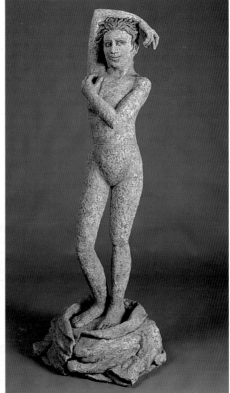

JULIE MACKIE
ABOVE
Fallen Robe, 2003

64 ¼ x 25 x 22 ½ in. (163 x 64 x 57 cm)

Stoneware; hand-built seven-section construction, textured; multi-layer underglaze; bisque cone 06, glaze cone 6 oxidation

Photo by Tony Grant

LEFT
All Angles, 2003

69 x 19 x 16 ½ in. (175 x 48 x 42 cm)

Stoneware; hand-built four-section construction; engobe, underglaze; bisque cone 06, glaze cone 6 oxidation

Photo by Tony Grant

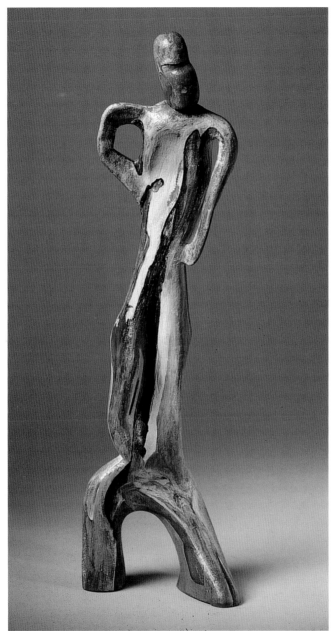

RON GALLAS
John Francis, 2001

42 x 10 x 5 in. (107 x 25 x 13 cm)

Hand built

Photo by Peter Lee

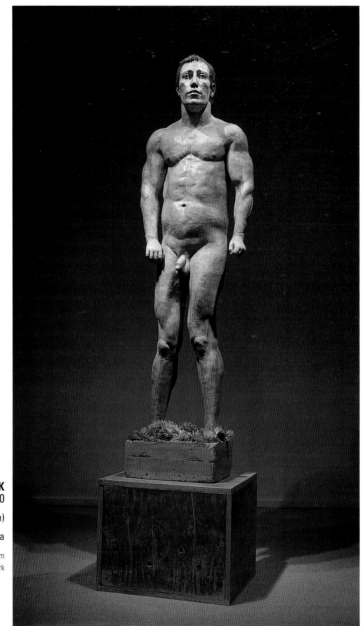

DOUG JECK
Cain and Abel, 2000

77 x 20 in. (196 x 51 cm)

Ceramic; mixed media

Photo by Noel Allum
Courtesy of Garth Clark Gallery, New York

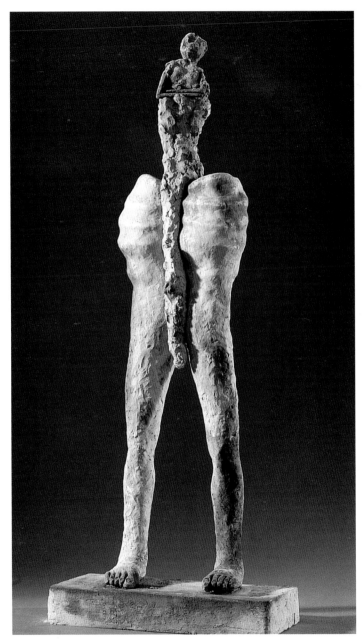

GRACE BAKST WAPNER
BC/AD, 2000

36 x 15 x 6 in. (91 x 38 x 15 cm)

Clay; saggar-fired

Photo by Jerry Thompson

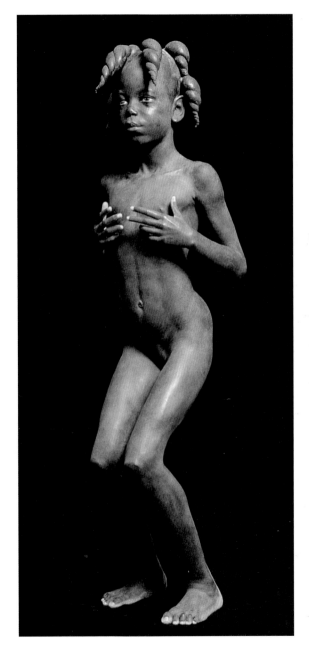

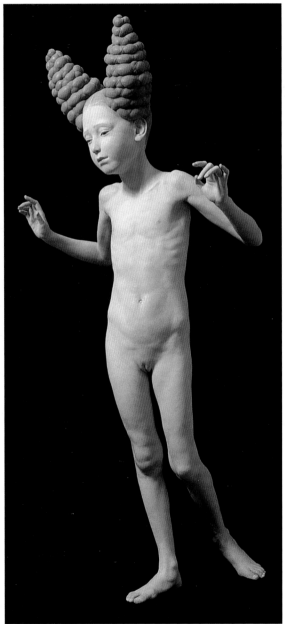

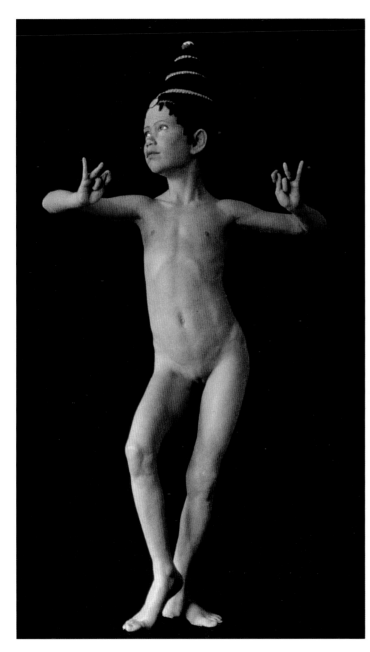

JUDY FOX
OPPOSITE PAGE LEFT
Onile (edition of 3 hydrastone casts), 1998

50 x 15 ½ x 14 in. (127 x 38 x 36 cm)

Terra cotta; casein paint

Photo courtesy of PPOW Gallery, New York

OPPOSITE PAGE RIGHT
Rapunzel (edition of 4 hydrastone casts), 1999

56 ½ x 26 ½ x 18 in. (144 x 67 x 46 cm)

Terra cotta; casein paint

Photo courtesy of PPOW Gallery, New York

LEFT
Lakshmi (edition of 4 hydrastone casts), 1999

50 x 26 x 14 in. (127 x 66 x 36 cm)

Terra cotta; casein paint

Photo courtesy of PPOW Gallery, New York

My pieces may be seen as ludicrous, surrealist, erotic, or even menacing. I play with space and ask the viewer to fill in what's missing. As Umberto Eco wrote in *Opera Aperta,* the spectator has a right to give his own significance to a work of art. By encouraging this, my work is both an aesthetic contribution to sculpture and a joyful, lively opportunity to interact with art.

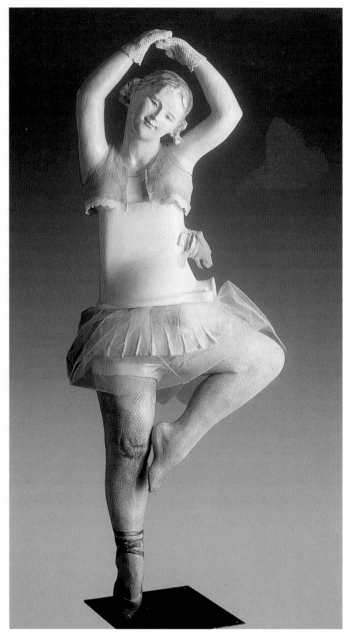

VILMA VILLAVERDE
Dancer, 2001

74 ¾ x 31 ½ x 19 ¾ in. (190 x 80 x 50 cm)

Clay; modeled, assembled to lavatory fitting; glaze, bathroom fitting, pigments; 2102°F (1100°C)

Photo by Jose Cristelli

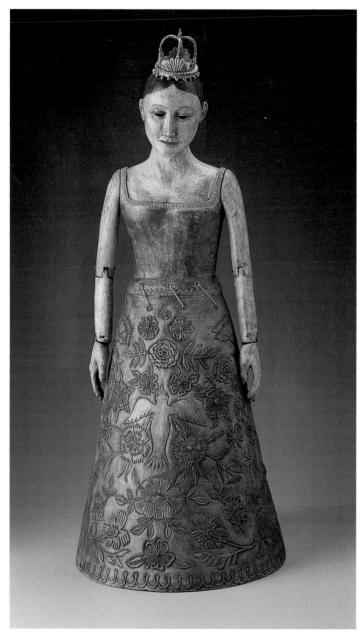

LIA ZULALIAN
The Bride, 2002

36 x 13 x 12 in. (91 x 33 x 31 cm)

Stoneware; hand built, carved; stains

Photo by John Polak
Courtesy of Ferrin Gallery

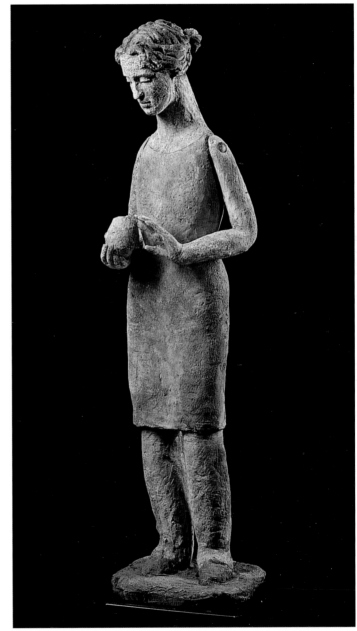

MARGARET KEELAN
Soul Catcher, 2003

38 x 10 x 10 in. (97 x 25 x 25 cm)

Clay; engobes, stains

Photo by Scott McCue

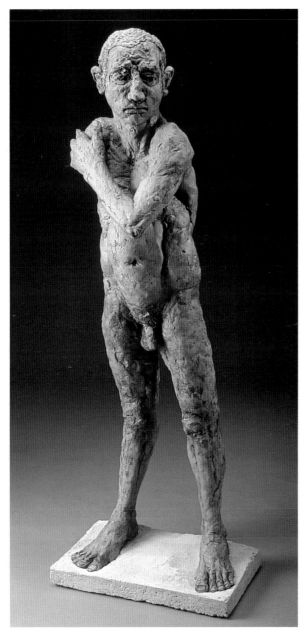

PAVEL G. AMROMIN
Missing Limbs, 2002

46 x 19 x 11 in. (117 x 21 x 28 cm)

Slab-built stoneware; oxide stains; cone 10

Photo by Jeff Bruce

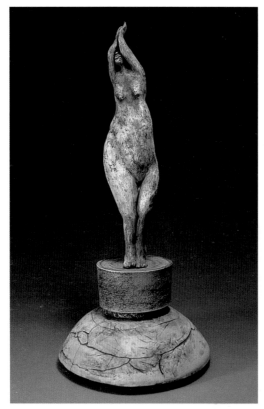

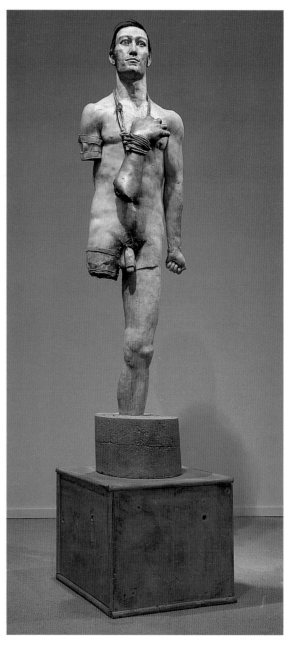

MEGAN DULL
ABOVE
Flame Woman: Guardian Of Earthspirit Rising, 1998

39 ½ x 18 x 18 in. (100 x 46 x 46 cm)

Hand-built stoneware; terra sigillata; cone 04 oxidation

Photo by artist

DOUG JECK
RIGHT
Heirloom, 2000

73 x 17 in. (185 x 43 cm)

Ceramic; mixed media

Photo by Noel Allum
Courtesy of Garth Clark Gallery, New York

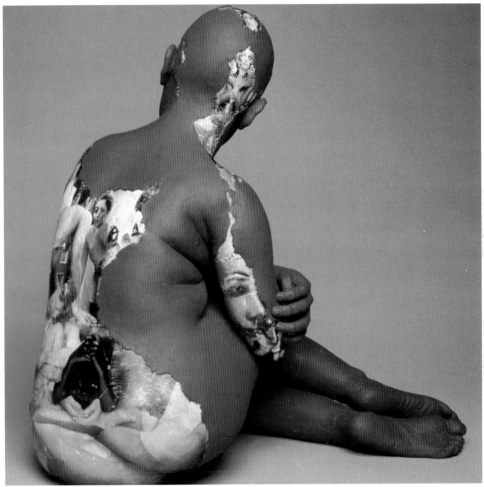

LIZ BRYANT
Reveallation, 2002

32 x 30 x 22 in. (81 x 76 x 56 cm)

Ceramic; hand built, slab constructed; collage, acrylic

Photo by artist

I was working on the assumption
that morphic fields exist. This
explains how you know someone
is staring at you from behind.
The seer is aware of all that
is around her.

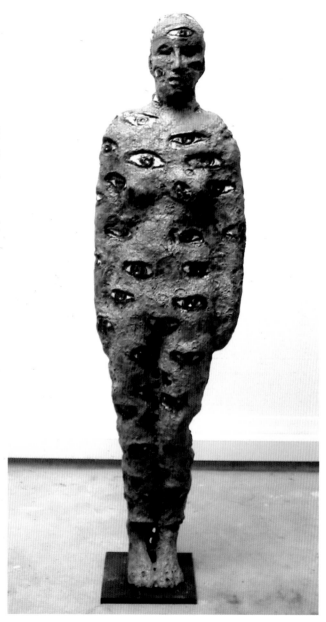

MARK CHATTERLEY
Seer, 2003
68 x 18 x 12 in. (173 x 46 x 31 cm)
Slab-built clay; crater glaze; cone 6
Photo by artist

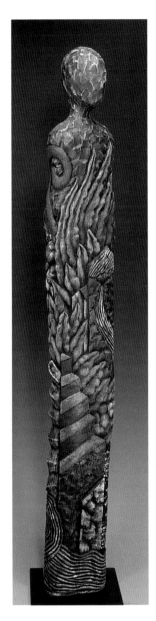

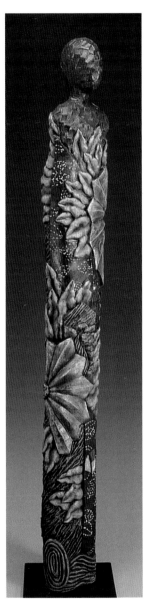

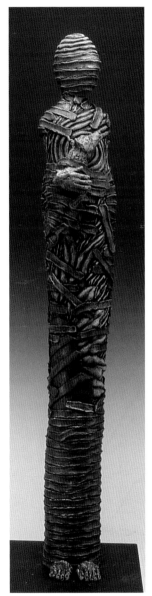

These particular pieces are a type of personal journal, with my evolving symbolism wrapping and encircling the figure form.

CHRISTINE FEDERIGHI
LEFT
River Wrap Down, 2002

70 x 7 x 6 in. (178 x 18 x 15 cm)

Ceramic; carved, coiled; oil patina; cone 04

Photo by Seeman

CENTER
Double Fan, 2002

70 x 7 x 6 in. (178 x 18 x 15 cm)

Ceramic; coiled, carved; oil patina; cone 04

Photo by Seeman

RIGHT
Wrapped and Protected (With Dog), 2003

50 x 4 x 3 in. (127 x 10 x 8 cm)

Ceramic; coiled, carved; applied clay, oil patina; cone 04

Photo by Seeman

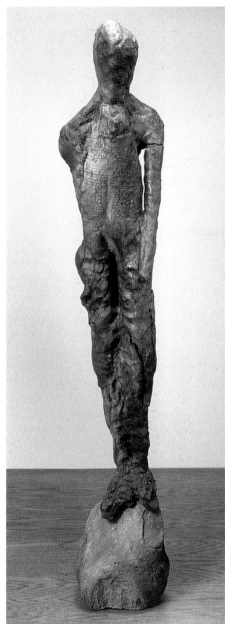

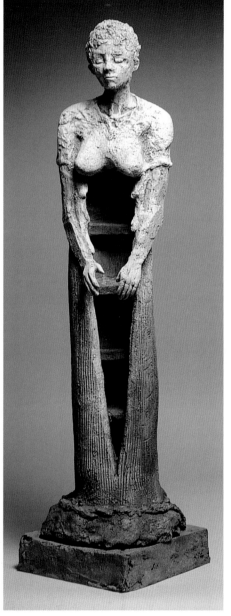

JIM JANSMA
LEFT
Figure on Rock, 1997

65 x 12 x 8 in. (165 x 31 x 20 cm)

Stoneware; anagama, wood-fired

Photo by Shirley A. Koehler

LAURA O'DONNELL
RIGHT
Vahnya, 1999

34 x 12 x 12 in. (86 x 30 x 30 cm)

Earthenware; hand built, modeled;
slips, underglaze, stains, glaze;
cone 02 oxidation

Photo by Chris Berti

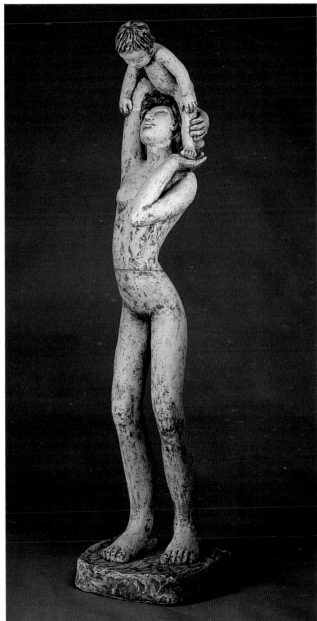

JULIE MACKIE
Counterpoise, 2003

41 ¼ x 10 ½ x 11 ¾ in. (105 x 27 x 30 cm)

Stoneware; hand-built two-section
construction, textured; underglaze;
bisque cone 06, glaze cone 6 oxidation

Photo by Tony Grant

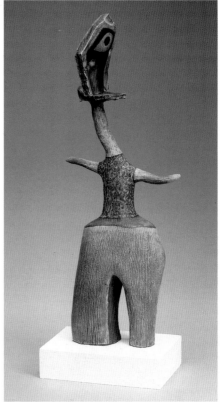

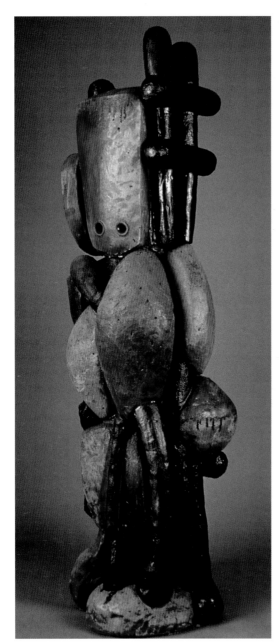

RON GALLAS
Above
Big Legs, 2003

35 x 12 x 6 in. (89 x 30 x 15 cm)

Ceramic

Photo by Peter Lee

JOHN BALISTRERI
Left
Neocubic Figure #4, 2000

78 x 24 x 27 in. (198 x 61 x 69 cm)

Ceramic stoneware; slips; wood-fired

Photo by artist

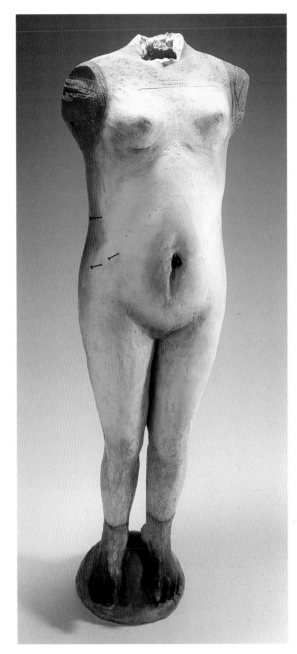

CHARLENE DOIRON REINHART
Dress Form, 2003

37 x 12 x 9 in. (94 x 31 x 23 cm)

Clay, nails; coil built; underglazes, oxides; cone 06, cone 04

Photo by artist

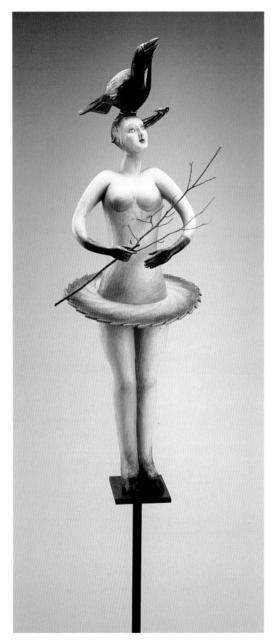
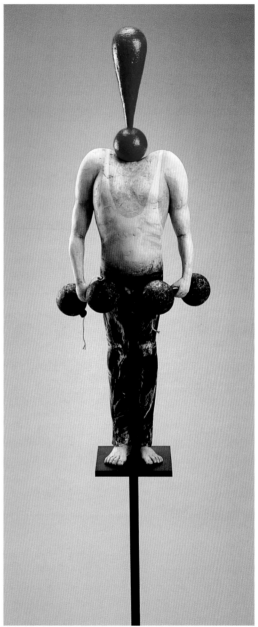

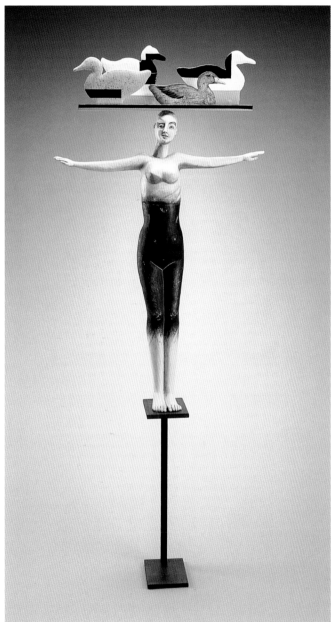

These three figures are part of the Real Politique Series.

PATTI WARASHINA
OPPOSITE PAGE LEFT
Crow Whisper, 2003

71 x 16 x 14 in. (180 x 41 x 36 cm)

Hand-built clay; glaze; low-fired

Photo by R. Vinnedge

OPPOSITE PAGE RIGHT
Strong Man, 2003

68 x 17 x 9 in. (173 x 43 x 23 cm)

Hand-built porcelain; glaze

Photo by R. Vinnedge

LEFT
Sitting Duck, 2003

75 x 30 x 8 in. (110 x 76 x 20 cm)

Hand-built clay; glaze; low-fired

Photo by R. Vinnedge

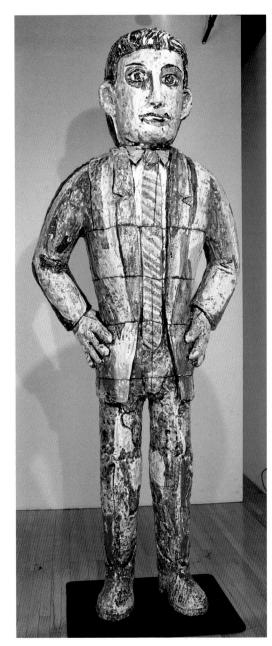

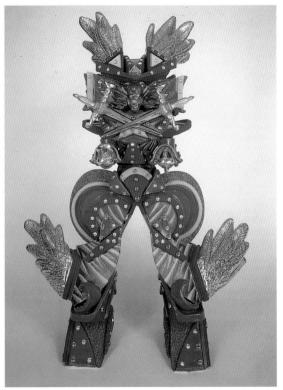

TOBY BUONAGURIO
ABOVE
Winged Tiger Robot, 1990

32 ½ x 24 ½ x 8 ½ in. (83 x 62 x 21 cm)

Ceramic; hand-constructed, cast; multi-fired and non-fired surfaces

Photo by Edgar Buonagurio

VIOLA FREY
LEFT
Authoritative Man, 2002

120 x 46 x 22 in. (305 x 117 x 56 cm)

Ceramic

Photo by artist
Courtesy of Nancy Hoffman Gallery, New York

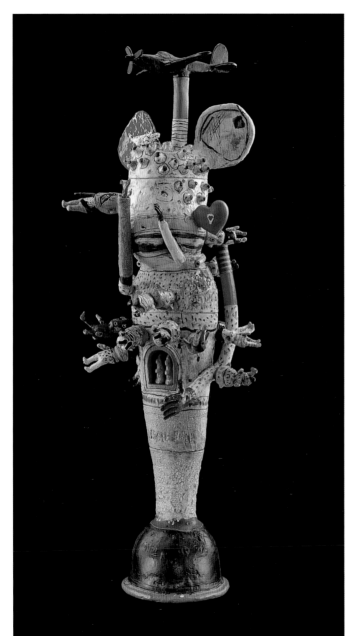

BILL STEWART
*Rabbits In My Stomach and a
Plane on My Head,* 2001

81 x 29 x 28 in. (206 x 74 x 71 cm)

Hand-built terra cotta; glaze, engobes,
multi-fired

Photo by artist

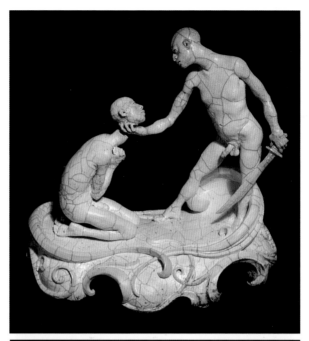

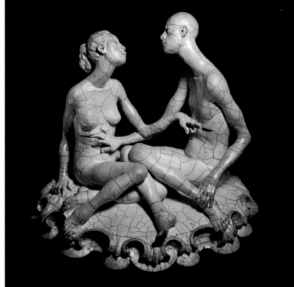

JUSTIN NOVAK
ABOVE
Apology (For A Killing) #2, 2002

14 x 15 x 10 in. (36 x 38 x 25 cm)

Hand-built ceramic; raku-fired

Photo by artist

BELOW
Disfigurine #25, 2002

14 x 13 x 11 in. (36 x 33 x 28 cm)

Hand-built ceramic; raku-fired

Photo by artist

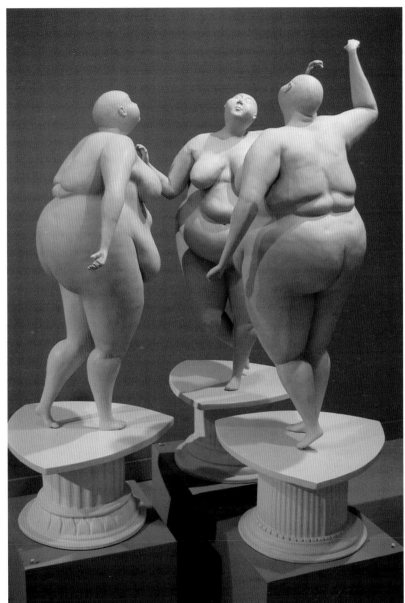

My own views on the female figure and beauty challenge those of the culture that surrounds me. I am completely captivated by the way the rolls of the body stack upon each other in the ebb and flow of the waves of flesh.

KELLI R. DAMRON
3 Muses, 2002

48 x 40 x 40 in. (122 x 102 x 102 cm)

Low-fire ceramics; soft slab/stiff slab construction; acrylic paint, wax

Photo by artist

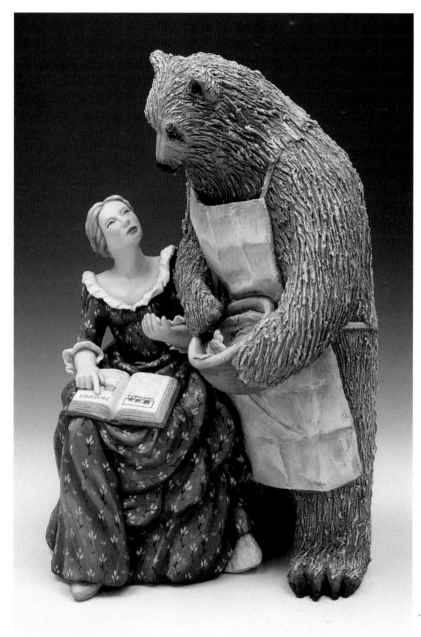

MIRIAM DAVIS
Just Right, 1998

15 x 11 x 9 in. (38 x 28 x 23 cm)

Porcelain; hand modeled, hollowed, detailed; underglaze stains, oil paint; cone 4

Photo by Greg Kinder

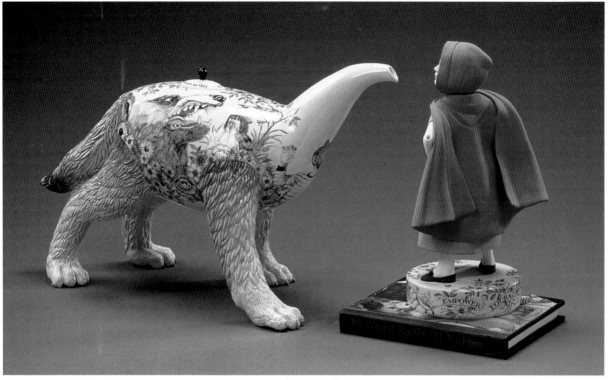

These are autobiographical, figurative teapots.

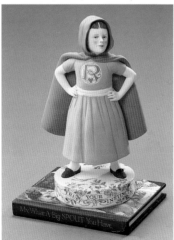

RED WELDON SANDLIN
My, What a Big Spout You Have, 2003

12 x 24 x 6 in. (31 x 61 x 15 cm)

Ceramic; slab built, carved

Wolf: Chinese blue one stroke underglaze, majolica, clear glaze,

Red Riding Hood: underglaze, matte spray finish

Photos by Charlie Akers
Courtesy of Ferrin Gallery

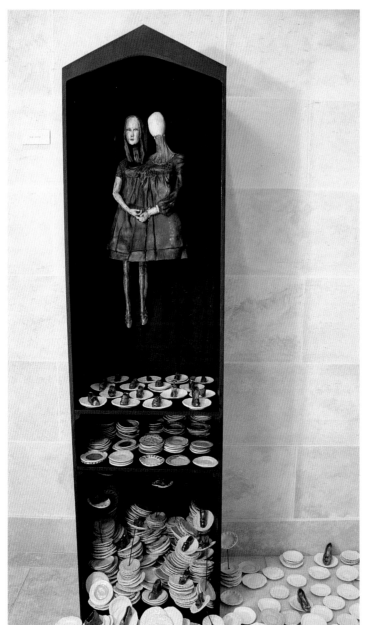

This piece began as a poem—one of six poems I transformed into ceramic figures. I felt as if each medium gave the character a different kind of fullness. It made it exciting and daunting to work on them. I felt as if I had to make sure I was true to their characters—that I couldn't just make haphazard decisions that might misrepresent them.

ROBIN GUMAELIUS
Someone New Moved into Martha's Dress, 2000

72 x 24 x 24 in. (183 x 61 x 61 cm)

Ceramic; coiled, press molded, slab built; wood, wax, paint

Photo by artist

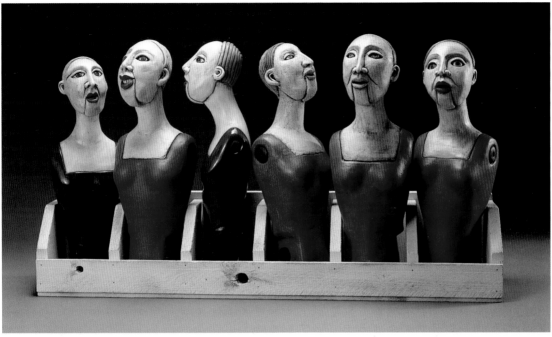

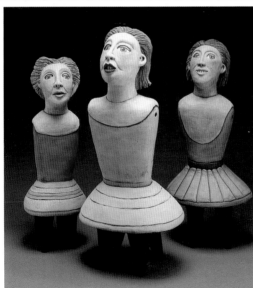

BARB DOLL
ABOVE
Embodied Series #8, 2000

Individual: 18 x 5 x 5 in. (46 x 13 x 13 cm)

Total: 18 x 36 x 6 in. (46 x 91 x 15 cm)

Hand-built clay; wood

Photo by Bart Kasten

LEFT
Dollings, 2002

18 x 18 x 6 in. (46 x 46 x 15 cm)

Hand-built clay

Photo by Bart Kasten

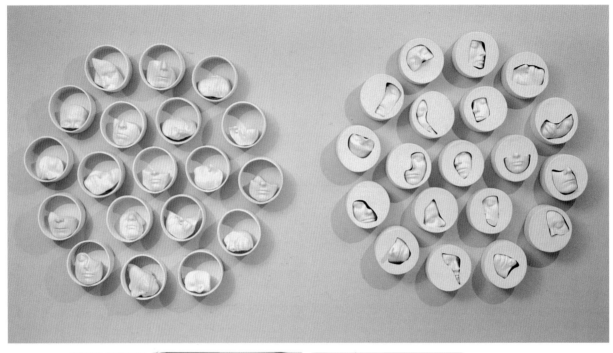

HOLLY GORING
*Twice I Was Hiding When
You Came To See Me,* 2002

42 x 92 x 6 in. (107 x 234 x 15 cm)

White earthenware; press molded,
hand built; white terra sigillata

Photo by Peter Lee

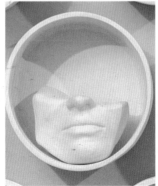
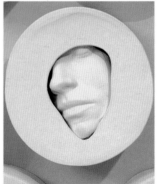

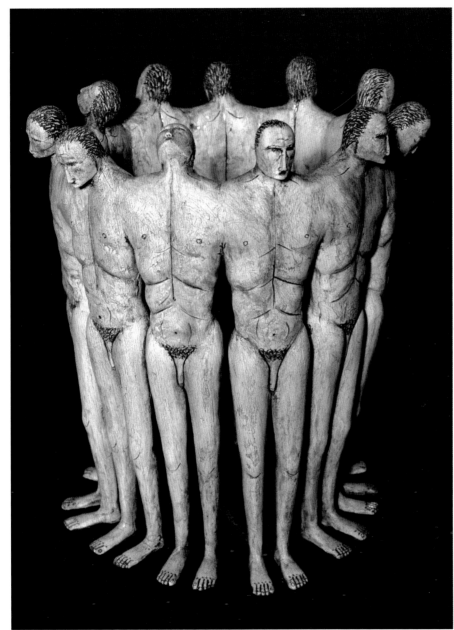

STEVEN P. BRADFORD
Zero, 1999

9 x 8 x 8 in. (23 x 20 x 20 cm)

Earthenware

Photo by artist
Private collection

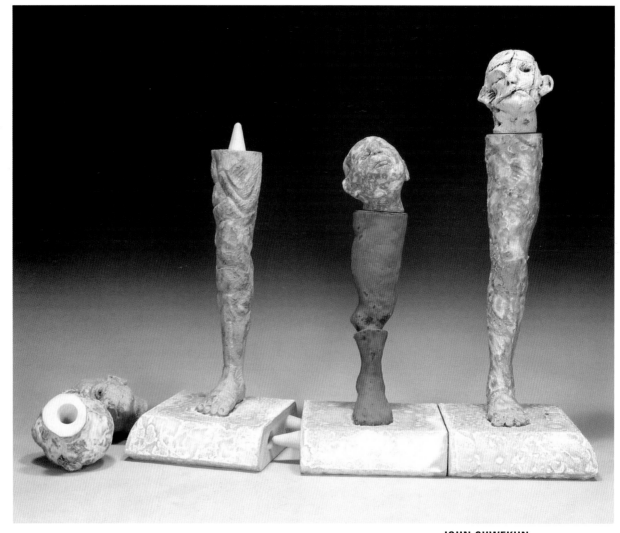

JOHN CHWEKUN
A Possibility That Happened, 2003
22 x 27 x 8 in. (56 x 69 x 20 cm)
Hand-built earthenware; glaze

Photo by artist

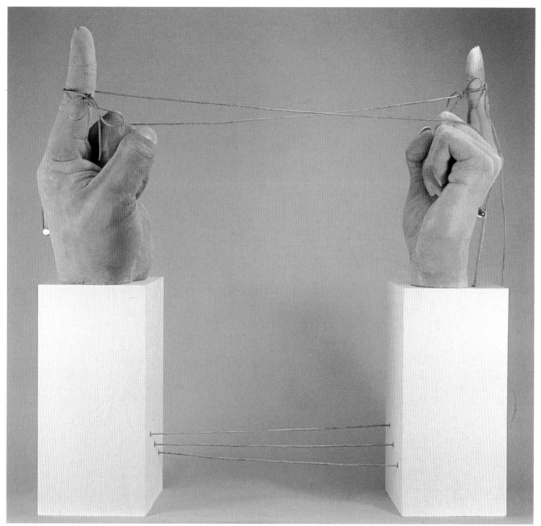

KEITH WALLACE SMITH
The Ties That Bind, 2002

66 x 22 x 93 in. (168 x 56 x 236 cm)

Coil-built stoneware; rope, latex, pulleys

Photo by artist

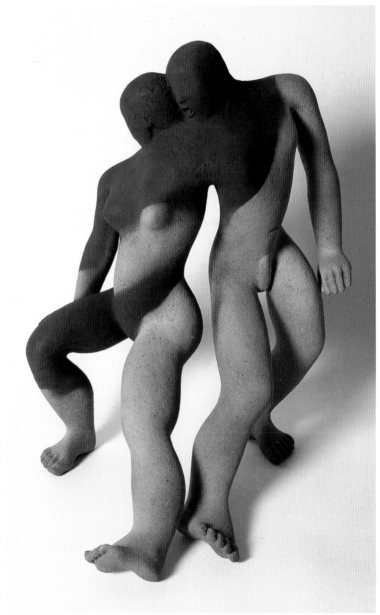

LINDA KIEFT
Etch, 2002

21 ½ x 17 x 15 ¼ in. (55 x 43 x 39 cm)

Stoneware, red clay mix; surface-
applied porcelain, slip, manganese
and red iron oxide mix; 2228°F (1220°C)

Photo by Tim Brett

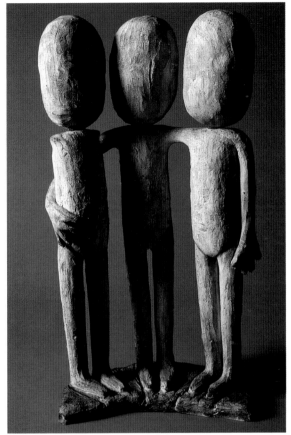
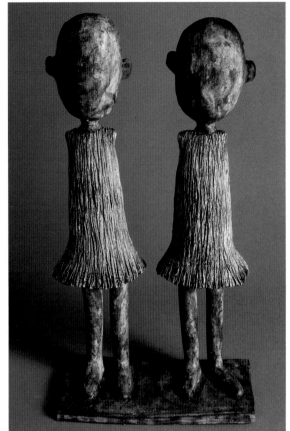

I work from my gut, in a very unintellectual way. I start pieces by thinking of a color or memory or a street sign. I like to make objects that stir up memories, memories that we all have—of school, childhood, and growing up … I am constantly amazed by the push and pull of feelings that people have. My hope is that my sculptures help open the door to the viewer's memory and elicit a story.

MELISSA STERN
LEFT
Three Friends, 2003
21 x 11 x 5 in. (53 x 28 x 13 cm)
Hand-built clay; graphite, pastel
Photo by Garry McLeod

RIGHT
Sisters, 2003
22 x 11 ½ x 5 in. (56 x 29 x 13 cm)
Hand-built clay; paint, ink
Photo by Garry McLeod

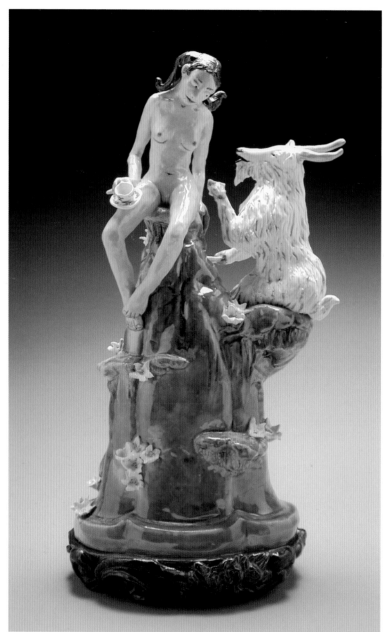

CHRIS ANTEMANN
Poppy Field, 2003

18 x 11 x 10 in. (46 x 28 x 25 cm)

Porcelain; enamels, decals, luster;
cone 10 oxidation, cone 018 enamel
and decal fired

Photo by artist

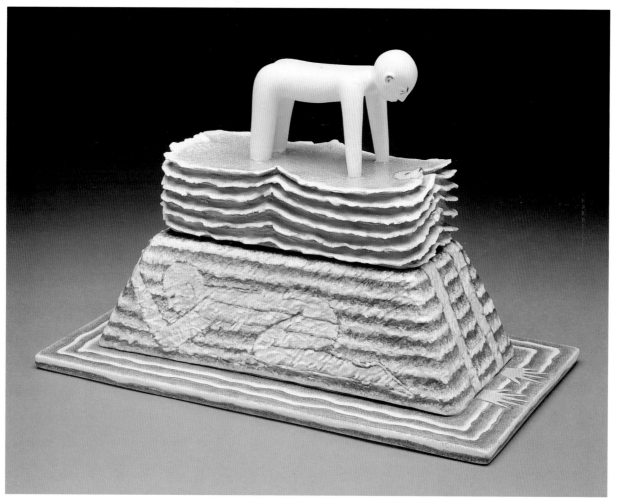

NANCY CARMAN
Forward, 2001

9 ½ x 16 x 8 ½ in. (24 x 41 x 21 cm)

Low-fire white earthenware; hand built; underglazes, glazes

Photo by Joseph Painter

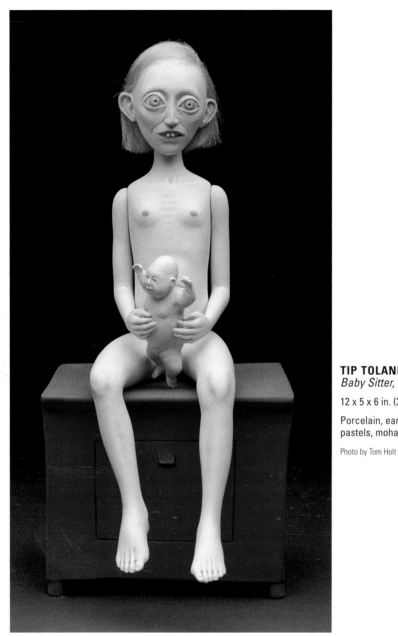

TIP TOLAND
Baby Sitter, 2001

12 x 5 x 6 in. (31 x 13 x 15 cm)

Porcelain, earthenware; slip,
pastels, mohair

Photo by Tom Holt

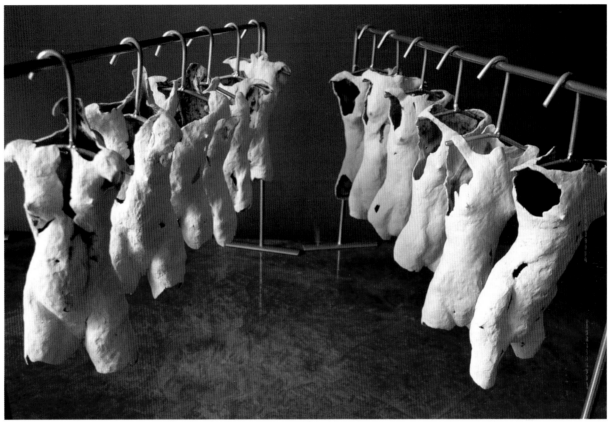

This installation deals with the clinical and psychological
aspects of anorexia nervosa. Twenty-five ceramic torsos
on coat hangers are suspended on one of five clothes rails,
depending on how the body weight has been categorized.
Each torso is the skin of the departed schoolgirl, hanging
on meat hooks, as if in an abattoir.

SHELLEY WILSON
Female Puberty: A Search For Identity, 1998
30 x 72 x 60 in. (76 x 183 x 152 cm)
Ceramic; pinched, coiled, hand built; aluminum, steel

Photo by artist

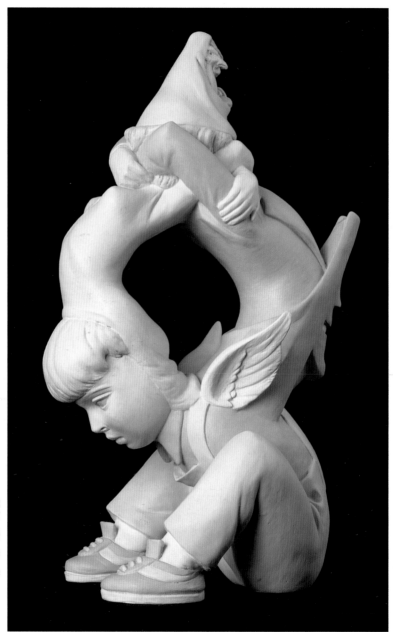

GEORGE WALKER
Angel Boy, 2002
14 ½ x 6 ½ x 8 ½ in. (37 x 16 x 21 cm)
Ceramic; hand built, coiled; vitreous slips

Photo by Artoptic

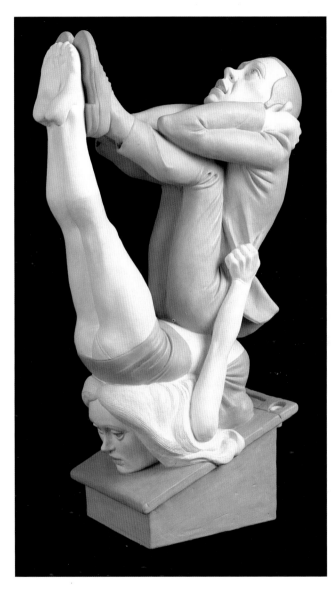

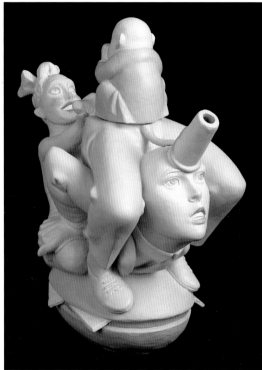

GEORGE WALKER
ABOVE
The Bernay's Burger, 2003

12 x 6 ½ x 11 in. (31 x 16 x 28 cm)

Ceramic; hand-built, coiled; vitreous slips

Photo by Artoptic

LEFT
Graduates II, 2002

18 x 6 ½ x 11 ½ in. (46 x 16 x 29 cm)

Ceramic; hand built, coiled; vitreous slips

Photo by Artoptic

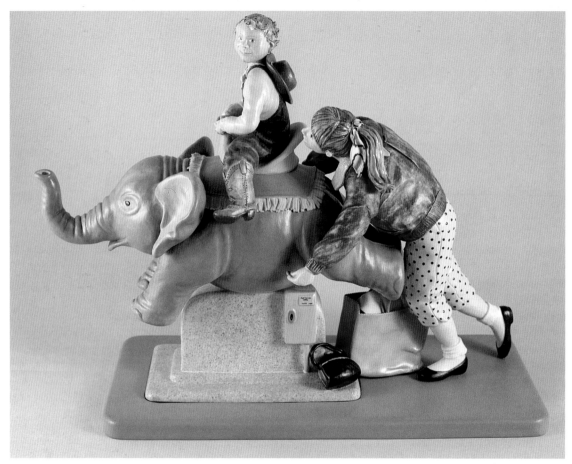

Mother and child take a break between errands on a busy day out.

KATHRYN MCBRIDE
Elephant Ride Teapot, 1995
10 x 12 x 6 in. (25 x 31 x 15 cm)
Hand-built porcelain; engobe; cone 8 oxidation

Photo by artist
Courtesy of Ferrin Gallery

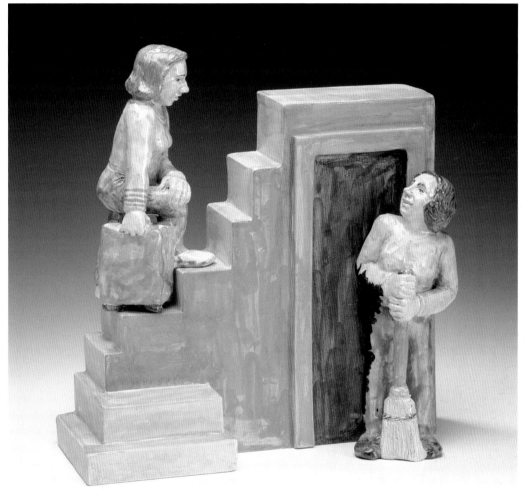

MARILYN ANDREWS
Morning Talk, 2003

12 x 11 x 5 in. (31 x 28 x 13 cm)

Hand-built stoneware; slip, clear glaze

Photo by Bob Barrett

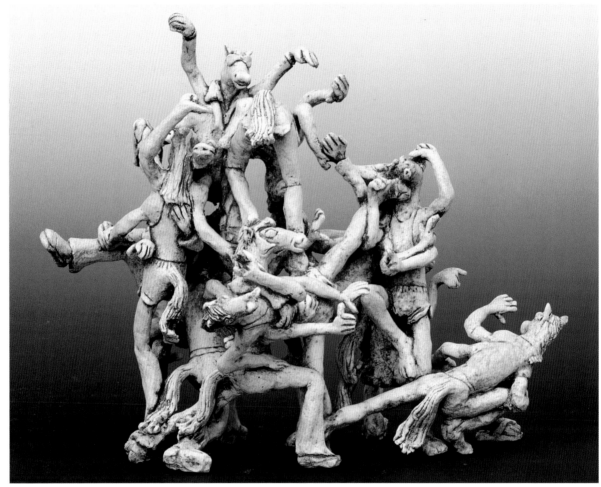

Inspired by *The Matrix,* martial art movies, and the swish of flares

BRIAN DOAR
Forty-Four Fingers Of Fury In The Year Of The Horse, 2002
17 ¾ x 21 ¼ x 14 ¾ in. (45 x 54 x 37 cm)
Hand-built paper clay; oxides, glaze

Photo by Joe Lafferty

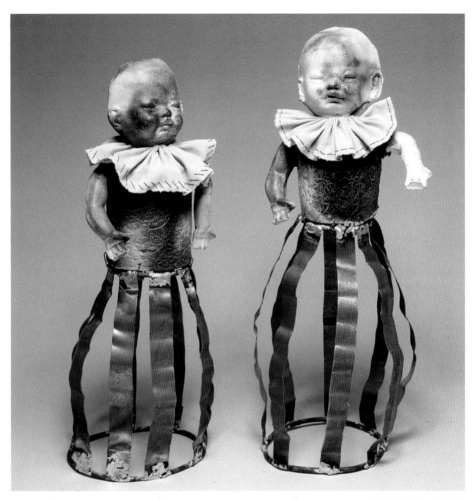

PAM LETHBRIDGE
Water Children, 2002

Left: 21 x 7 x 6 in. (53 x 18 x 15 cm)

Right: 22 ½ x 7 x 6 in. (57 x 18 x 15 cm)

Hand-built porcelain; fabric, wire,
hand-welded skirts; pit fired

Photo by John Carlano

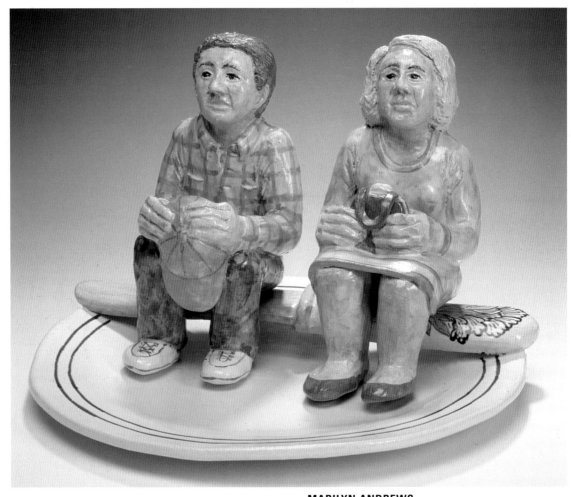

MARILYN ANDREWS
Knife and Plate, 2003

7 x 10 x 10 in. (18 x 25 x 25 cm.)

Hand-built stoneware; slip, clear glaze

Photo by Bob Barrett

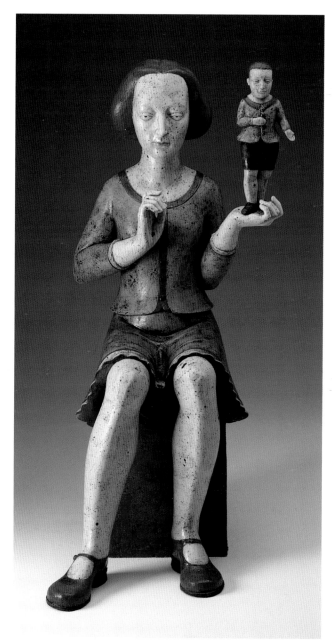

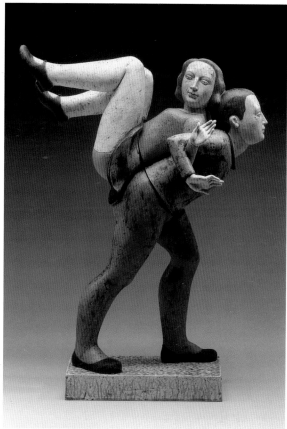

LAURA DE ANGELIS
ABOVE
Flip, 2003

22 x 15 x 9 in. (56 x 38 x 23 cm)

Ceramic; layered engobes, wood-ash glaze

Photo by E. G. Schempf

LEFT
Giant, 2002

32 x 15 x 17 in. (81 x 38 x 43 cm)

Ceramic; layered engobes, wood-ash glaze

Photo by Matthew McFarland/M Studios

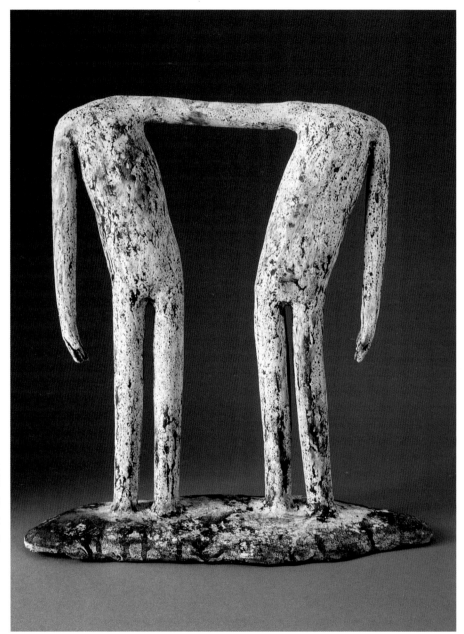

MELISSA STERN
Love, 2003
18 x 17 x 7 in. (46 x 43 x 18 cm)
Hand-built clay; paint, ink
Photo by Garry McLeod

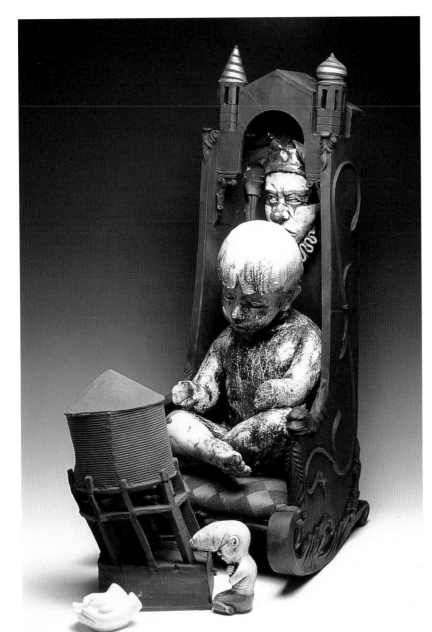

HIDE SADOHARA
Untitled, 2002

28 x 15 x 20 in. (71 x 38 x 51 cm)

Stoneware; low-fire slips and glazes,
fabric; pit fires, cold finish

Photo by artist

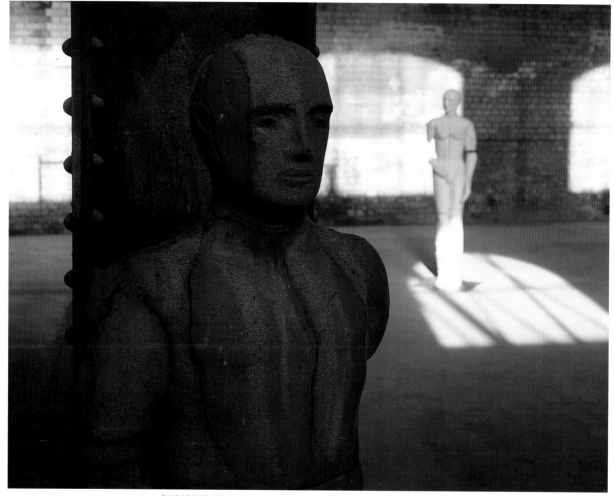

CHRISTIE BROWN
Prometheus, 1999

66 x 17 x 14 in. (168 x 43 x 36 cm)

Press-molded brick clay

Photo by David Ward

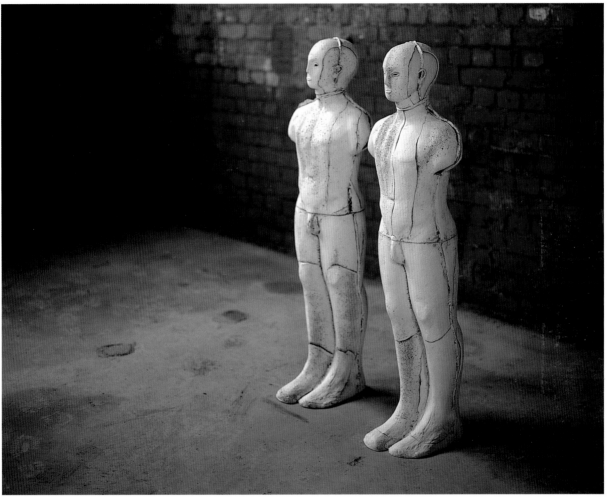

CHRISTIE BROWN
Kalos Thanatos, 2000

44 x 13 x 12 in. (111 x 33 x 29 cm.)

Press-molded clay

Photo by David Ward

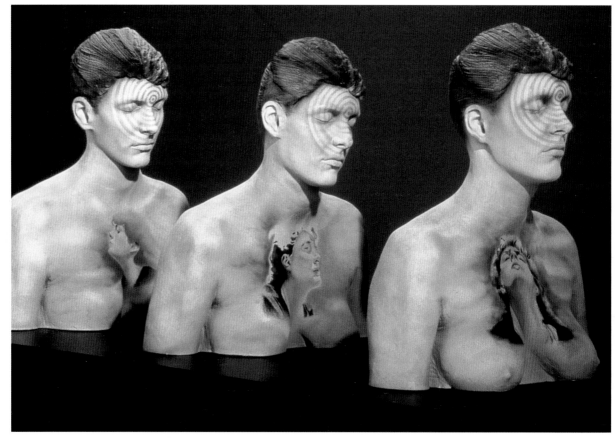

NAN SMITH
Guide, 1991

28 x 22 x 60 in. (71 x 56 x 152 cm)

Buff earthenware; press molded, modeled, carved; airbrushed underglazes, sprayed transparent glaze; cone 05 electric

Photo by Allen Cheuvront

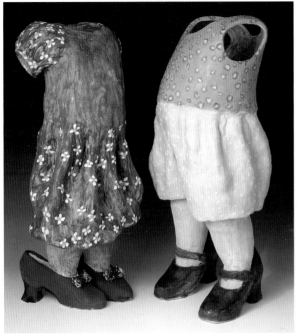

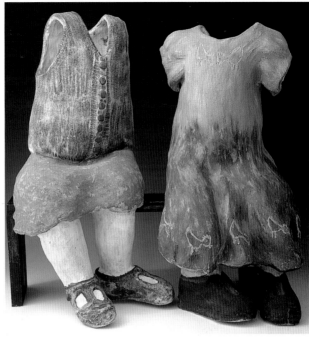

NUALA CREED
ABOVE
Fledglings, 1999

21 x 13 in. (53 x 33 cm)

Hand-built stoneware; colored clays,
oxides; cone 2, cone 06

Photo by Don Felton

LEFT
Fledglings, 2001

26 x 7 in. (66 x 18 cm)

Hand-built stoneware; colored clays,
glazes; cone 2, cones 04-06

Photo by Don Felton

I have always been intrigued by children's unique expressions and perspectives on life. For *Fledglings* I sculpted a number of children ... They are rendered without heads or limbs: their physical forms fill out the clothes they wear. Each sculpture represents a unique child. The clothes and body language reflect each individual personality. The children are grouped in pairs, revealing a range of possible dynamics in relationships between children.

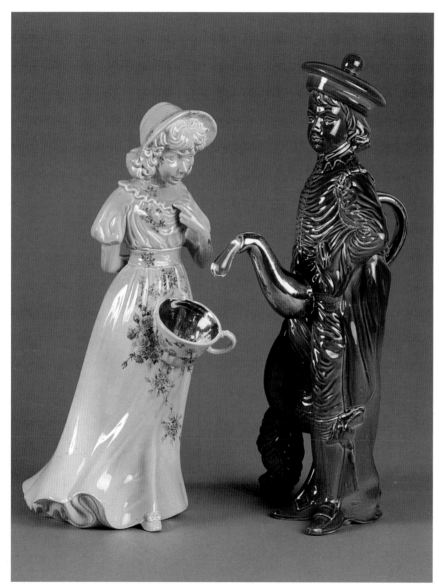

ROSE M. L. MISANCHUK
Pinkiet Blueboy, 1999

15 x 22 in. (38 x 56 cm)

Slip-cast earthenware; decals, lusters

Photo by artist

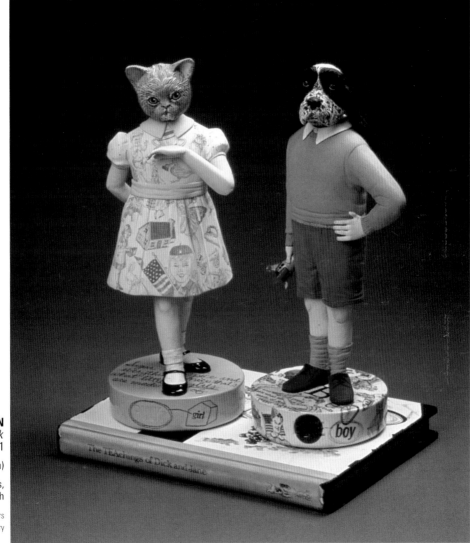

RED WELDON SANDLIN
*The Teachings of Dick
and Jane,* 2001

13 x 5 x 5 in. (33 x 13 x 13 cm)

Slab built; low-fire underglazes,
clear glaze, matte spray varnish

Photo by Charlie Akers
Courtesy of Ferrin Gallery

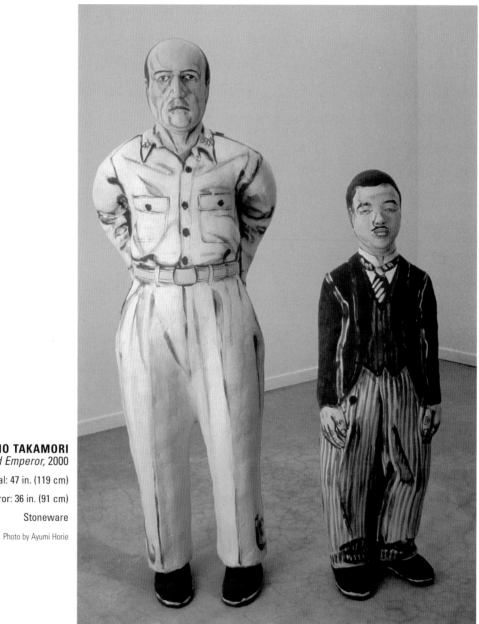

AKIO TAKAMORI
General and Emperor, 2000

General: 47 in. (119 cm)

Emperor: 36 in. (91 cm)

Stoneware

Photo by Ayumi Horie

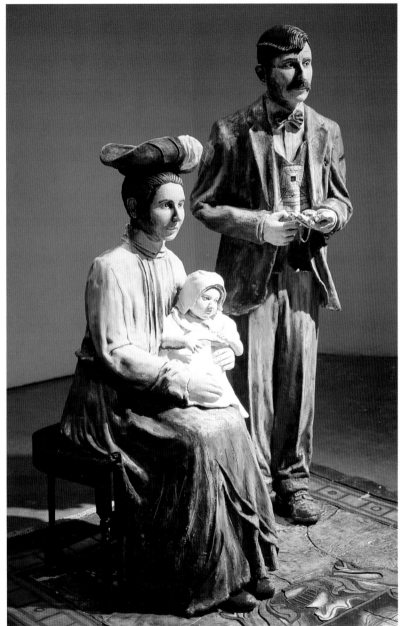

ANTONIO ROSATI PAZZI
Loss of Breath, 2000

66 x 60 x 108 in. (17 x 15 x 27 m)

Ceramic; mixed media

Photo by artist

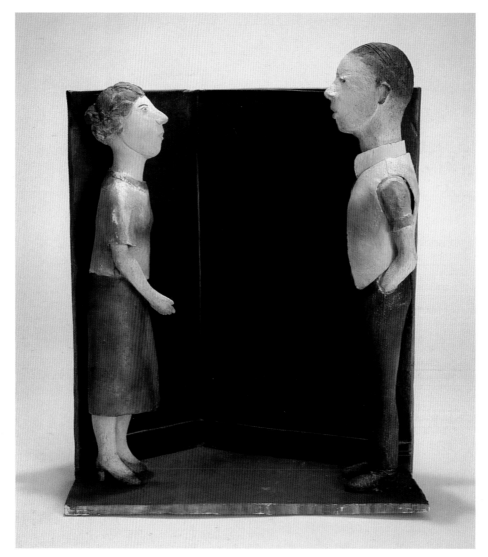

JOAN HOVERSTADT
Husband and Wife, 2002

15 x 12 ½ x 7 in. (39 x 32 x 18 cm)

Smoke-fired stoneware

Photo by artist

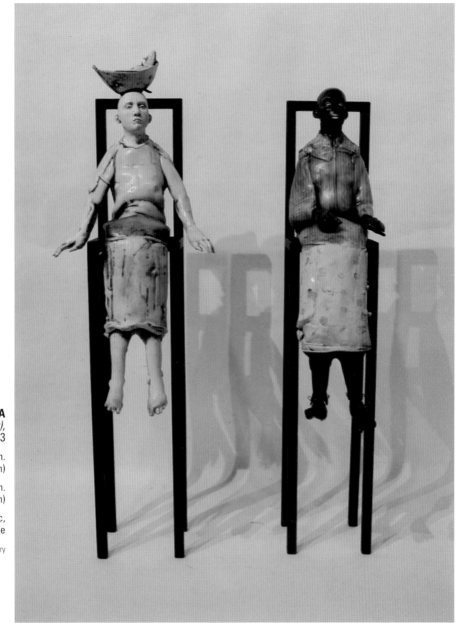

CRISTINA CORDOVA
Pasado Con Canasta (left),
Oscura Espera (right), 2003

Pasado Con Canasta: 25 x 4 x 5 in.
(64 x 10 x 13 cm)

Oscura Espera: 25 x 4 x 5 in.
(64 x 10 x 13 cm)

Porcelain; stain, resin, encaustic,
iron, acid-etched glaze

Photo courtesy of Ann Nathan Gallery

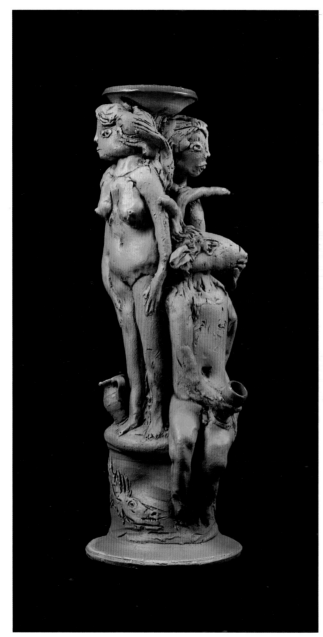

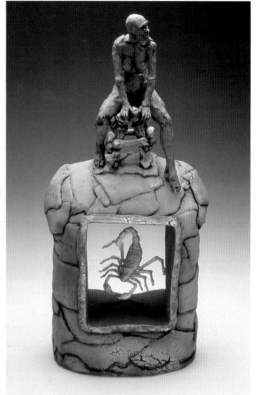

LEANDRA C. URRUTIA
ABOVE
Seven and the Maiden, 2001

19 x 5 x 9 ½ in. (48 x 13 x 24 cm)

Hand-built ceramic; low-fired

Photo by Rafael Molina

RON MEYERS
LEFT
Untitled (nudes and goat candlestick), 1995

20 x 7 x 7 in. (51 x 18 x 18 cm)

Clay; wheel thrown, sculpted

Photo by artist
Courtesy of The Signature Shop and Gallery

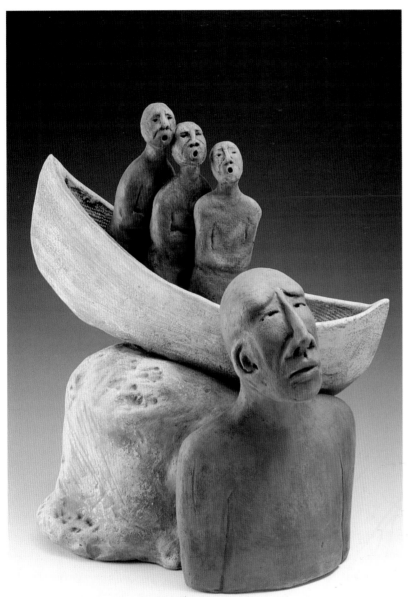

This piece came to me as a mental image during a very painful and lonely time when my mother was passing away. This sculpture made me realize that no matter what the circumstance we always have spiritual helpers to get us through the most difficult situations. Neither my mother nor I were alone during her crossing.

PAM SUMMERS
The Crossing, 2002

14 ½ x 12 x 8 in. (36 x 31 cm)

Clay; coiled, slab built; layered stains; multi-fired

Photo by Jerry McCollum

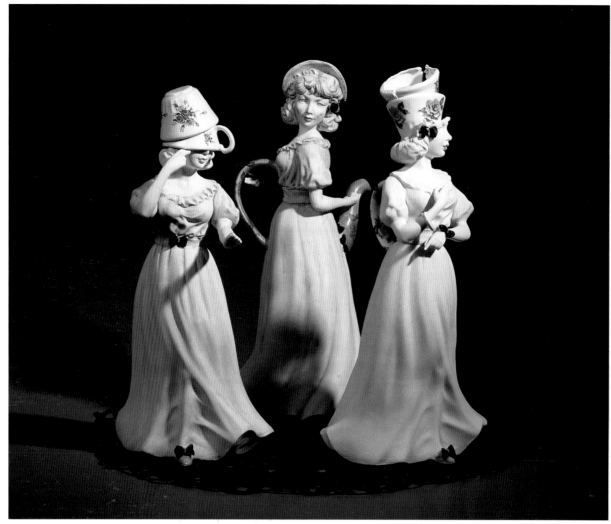

ROSE M. L. MISANCHUK
The Three Tchoctchkes, 1999

14 x 22 in. (36 x 56 cm)

Slip-cast earthenware; low-fire glazes,
decals, lusters; cone 06

Photo by artist

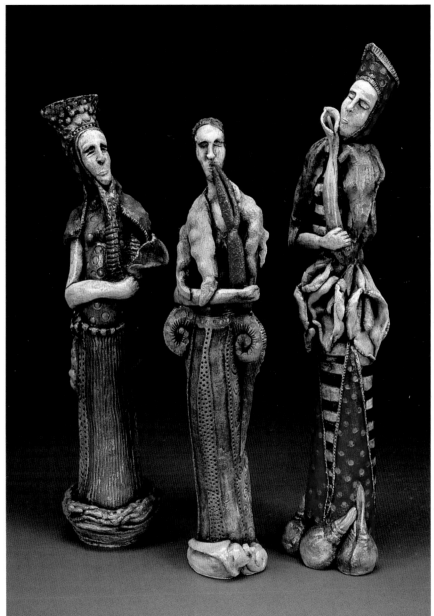

MARIE E. V. B. GIBBONS
Figments, 2003

Tallest figure: 19 in. (48 cm)

Hand built, slab construction; low fire, cold finishes, acrylic paint, washes, 22k-gold leaf

Photo by Maddog Studio/John Bonath

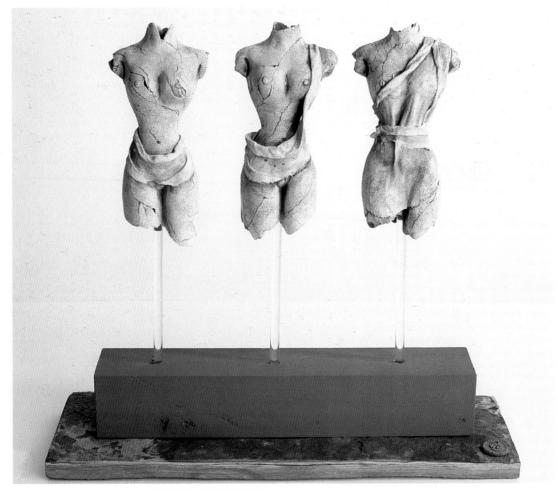

HAYLEY-JAY DANIELS
The Three Graces, 2003

11 ¾ x 11 ¾ x 4 ¾ in. (30 x 30 x 12 cm)

Porcelain, stoneware; press-molded figures, hand-sculpted additions; oxide finish, stain washes; acrylic, stone, and wood base

Photo by artist

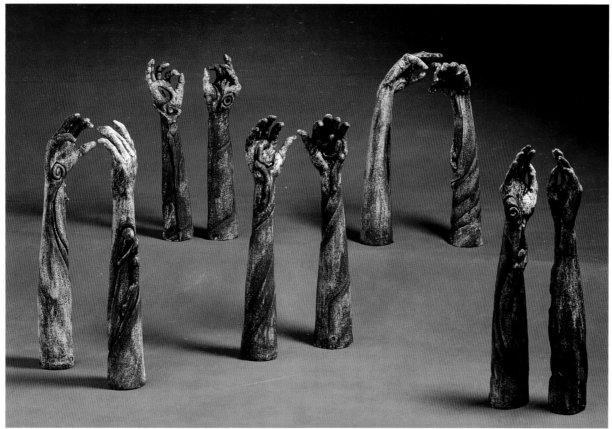

Tactile Communication is a story told in body/hand language. Each pair of hands has one male and one female figure within the arm/hand. Each pair represents a different stage in a relationship between a man and a woman.

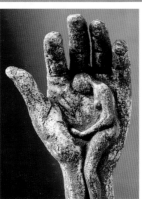
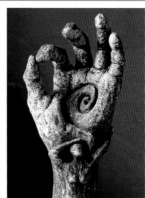

CEIL LEEPER STURDEVANT
Tactile Communication, 1999

33 x 7 x 5 in. (84 x 18 x 13 cm)

Architectural clay; hand built, extruded; oxides; gas fired

Photo by Peter Shefler

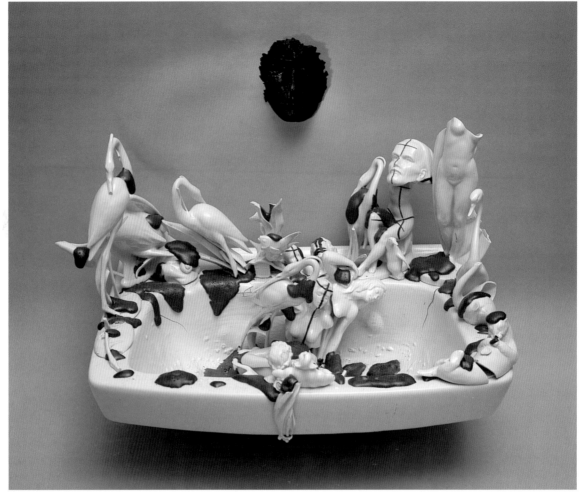

LASZLO FEKETE
Bathscene At the Crude Oil Well, 2003

19 ¼ x 26 x 19 ¼ in. (49 x 66 x 49 cm)

Constructed of fired pieces from Herend
Porcelain Factory, Hungary

Photo by Gyula Tahin

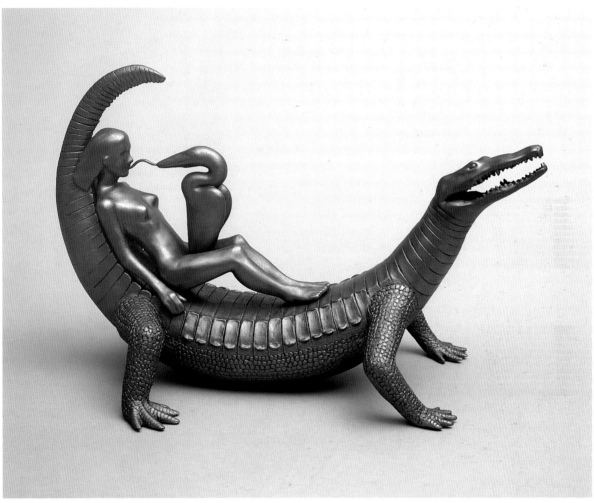

Inspired by Tlingit shaman's rattles

**JACK THOMPSON AKA
JUGO DE VEGETALES**
Animus Conveyance, 2002

12 x 19 x 11 in. (31 x 48 x 28 cm)

Ceramic; sculpted; painted

Photo by John Carlano

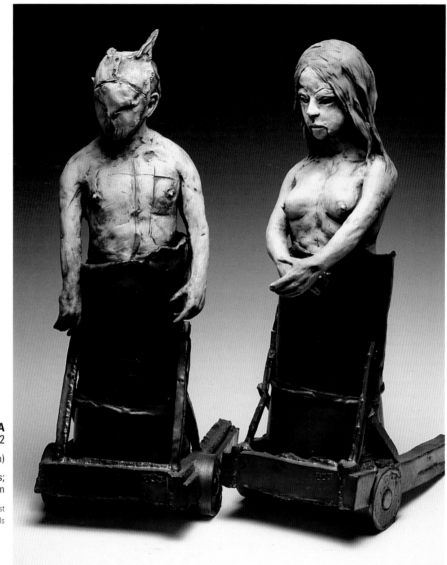

HIDE SADOHARA
Untitled, 2002

24 x 9 x 14 in. (61 x 23 x 36 cm)

Stoneware; slips, glazes;
cone 6 oxidation

Photo by artist
Collection of Elain Daniels

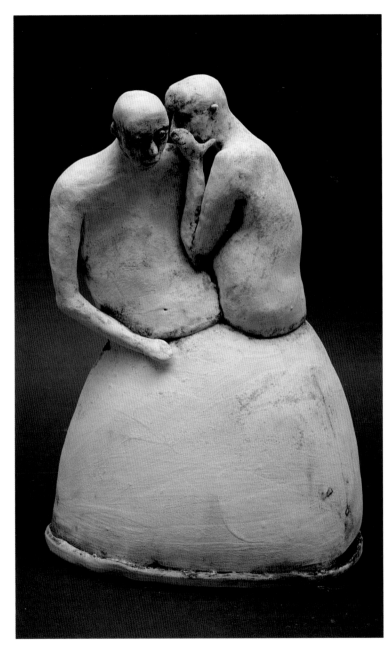

KICKI MASTHEM
Gossip, 2003

20 x 12 x 9 in. (51 x 31 x 23 cm)

Low-fire clay; hand built; slips, terra sigillata, glaze

Photo by artist

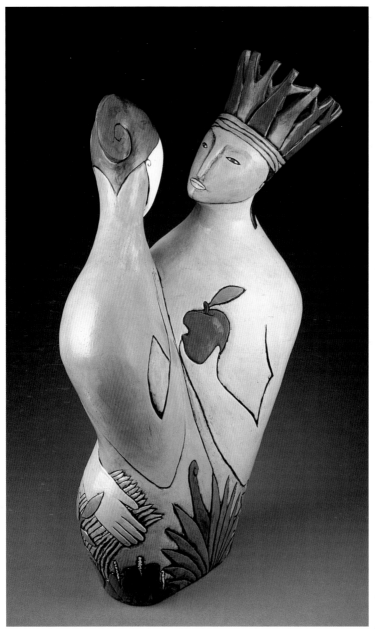

SANDRA ZEISET RICHARDSON
Alone, 2001

27 ½ x 10 x 7 ½ in. (70 x 25 x 19 cm)

Low-fire clay; coil built; underglazes

Photo by Stan V. Richardson

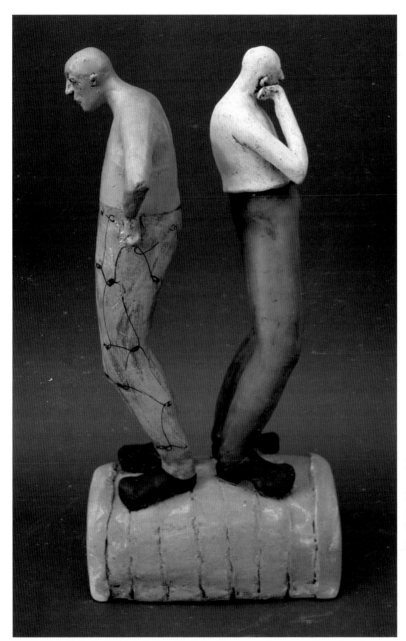

KICKI MASTHEM
Untitled (Pondering), 2003

24 x 12 x 10 in. (61 x 31 x 25 cm)

Low-fire clay; hand built; slips,
terra sigillata, glaze

Photo by artist

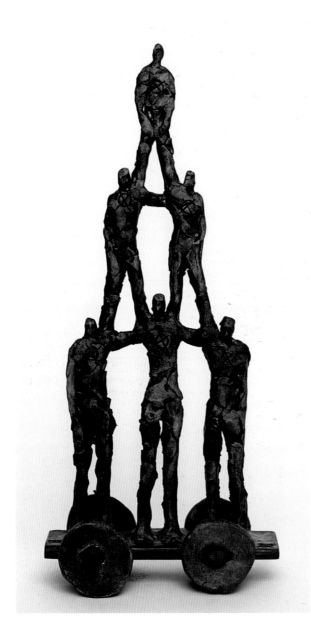

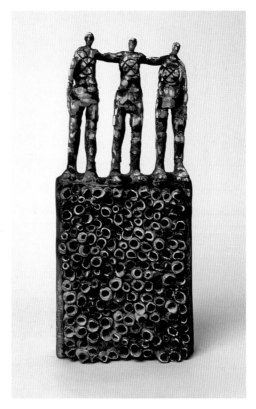

EDEN DANIELLE BENDER

ABOVE
Contact, 2003

12 x 4 x 3 in. (31 x 10 x 8 cm)

Low-fire paper clay; hand built; underglazes, India ink

Photo by Shawna Eberle

LEFT
Life Support, 2003

25 x 12 x 5 in. (64 x 31 x 13 cm)

Low-fire paper clay; hand built; underglazes, India ink

Photo by Shawna Eberle

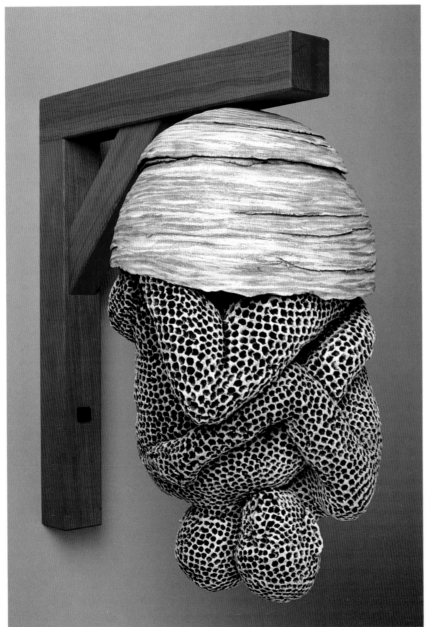

ADRIAN ARLEO
Wasp Nest—Embrace, 2003

17 x 9 x 15 in. (43 x 23 x 38 cm)

Clay, cherry wood; hand built, coiled;
glaze, pressed texture

Photo by Chris Autio
Courtesy of Ferrin Gallery

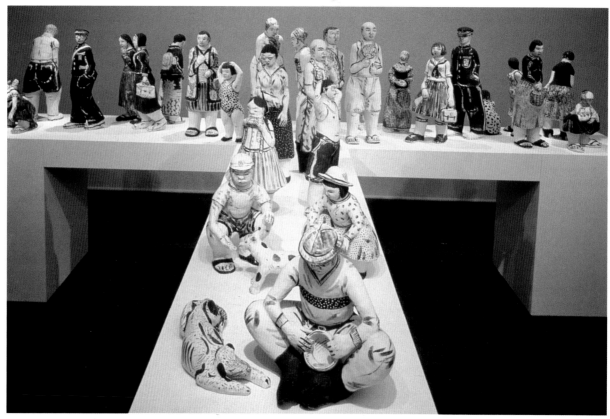

AKIO TAKAMORI
Installation at Garth Clark Gallery, 1997

Various dimensions

Stoneware

Photo by Noel Allum

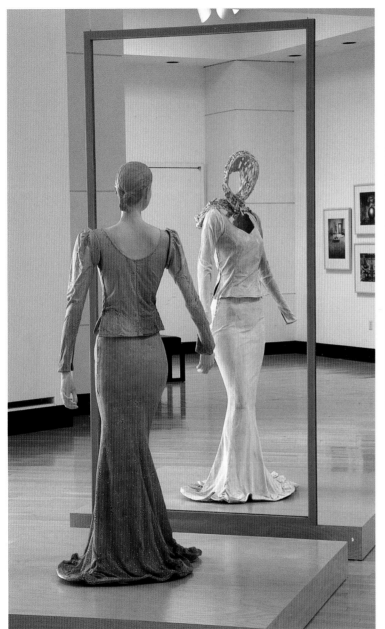

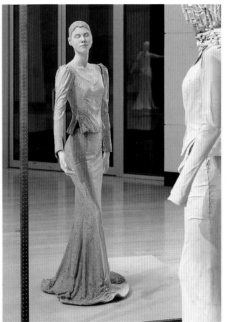

NAN SMITH
Flow, 1995

75 x 48 x 72 in. (191 x 122 x 183 cm)

Buff earthenware, painted wood, gypsum cement; press molded, modeled, carved, assembled after firing; airbrushed underglazes, sprayed and brushed glazes; cone 03 electric

Photo by Allen Cheuvront

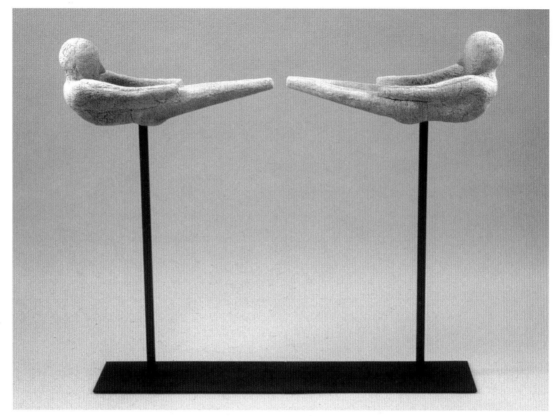

SUSAN LOW-BEER
ABOVE
Pool, 1998-99

9 ½ x 51 x 10 in. (24 x 130 x 25 cm)

Molded paper clay, metal stand;
stains, low-fired

Photo by Simon Glass

RIGHT
Curled Figures, 2000

14 ½ x 29 x 15 in. (37 x 74 x 38 cm)

Clay, paper clay; press molded;
stains, terra sigillata

Photo by Simon Glass

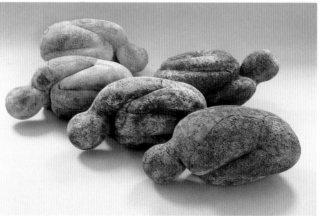

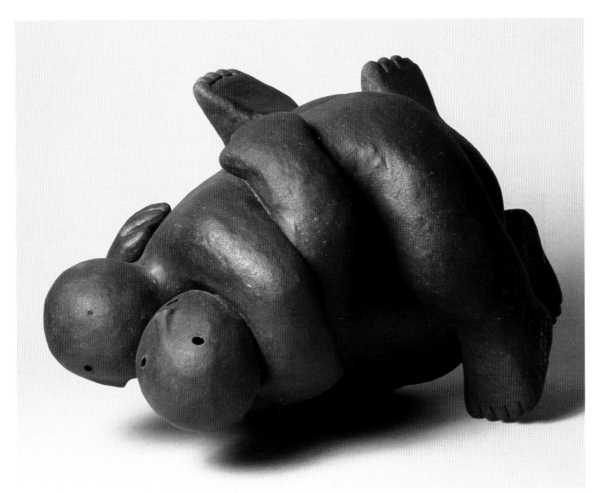

JOY BROWN
Two Together, 2002

10 x 18 x 10 in. (25 x 46 x 25 cm)

Ceramic; coil built, slab built;
anagama, wood-fired

Photo by Bobby Hansson
Courtesy of The Signature Shop and Gallery

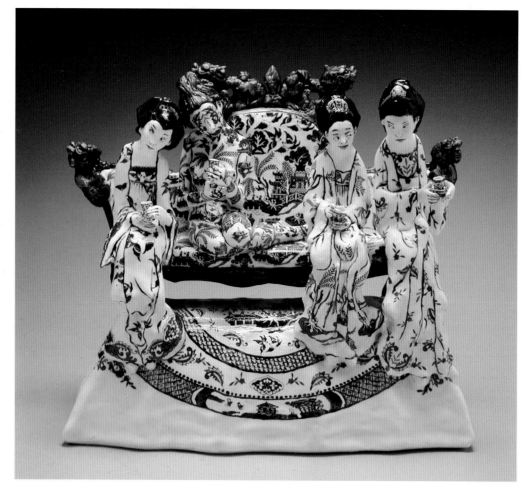

CHRIS ANTEMANN
Tea in Blue Willow, 2003

13 x 14 x 6 in. (33 x 36 x 15 cm)

Porcelain; enamels, decals; cone 10 oxidation, cone 018 enamel and decal fired

Photo by artist

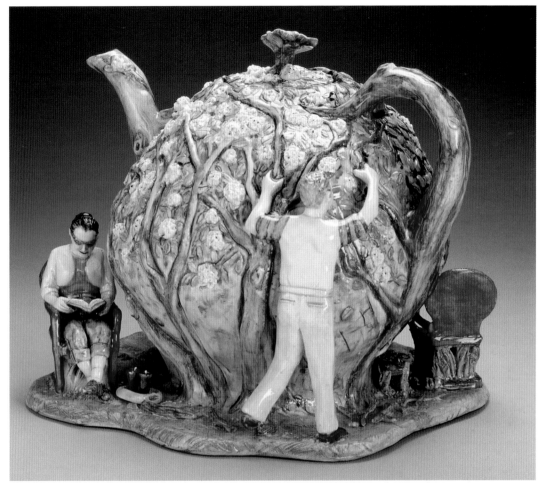

LAURA WILENSKY
Past and Present Teapot, 2003

9 x 10 x 9 in. (23 x 25 x 23 cm)

Hand-built porcelain; underglazes, clear
glaze, China paints; cone 10, luster cone 018

Photo by Allen Bryan

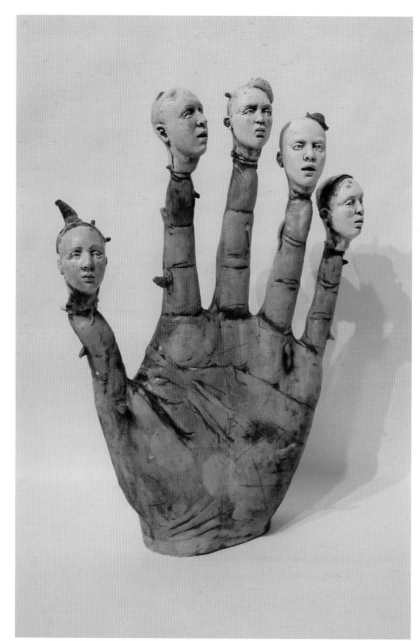

CRISTINA CORDOVA
La Tuya Poperosa, 2003

21 x 14 x 4 in. (53 x 36 x 10 cm)

Earthenware; slips, resin, encaustic,
acid-etched glaze

Photo courtesy of Ann Nathan Gallery

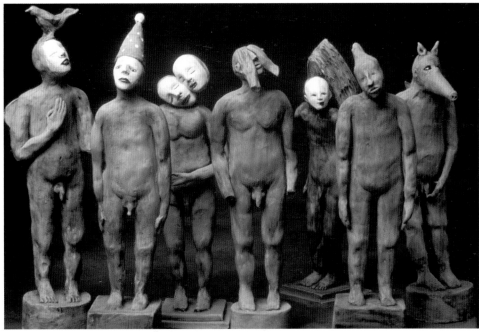

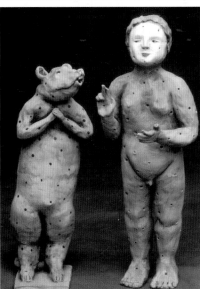

JULIELLEN BYRNE
ABOVE
Many Men, 2001

20 x 31 x 10 in. (51 x 79 x 25 cm)

Hand-built terra cotta

Photo by Stephen Webster

LEFT
Rat and Man-child, 2002

18 x 15 x 5 in. (46 x 38 x 13 cm)

Hand-built terra cotta

Photo by Stephen Webster

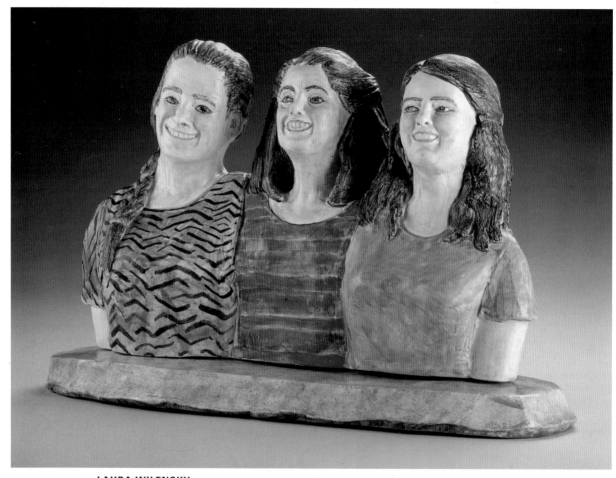

LAURA WILENSKY
Sisters, 2003

7 ¾ x 13 x 4 ¾ in. (20 x 33 x 12 cm)

Hand-built white clay; satin matte glaze, underglazes,
China paints; cone 04, cone 06, cone 018

Photo by Allen Bryan

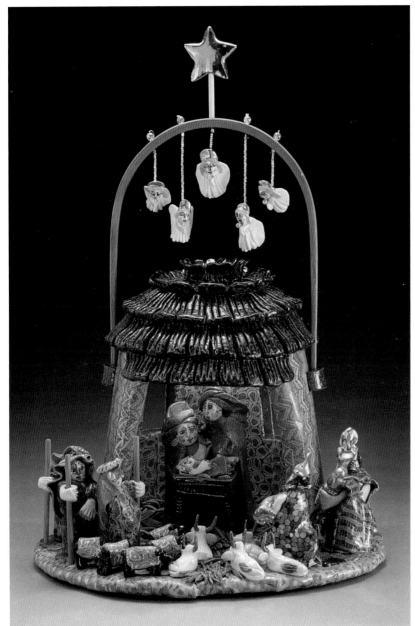

JANE PEISER
Nativity, 2003

18 x 12 x 11 in. (46 x 31 x 28 cm)

Colored porcelain, wood arch; hand built; salt glaze, neriagi; cone 10

Photo by Tom Mills

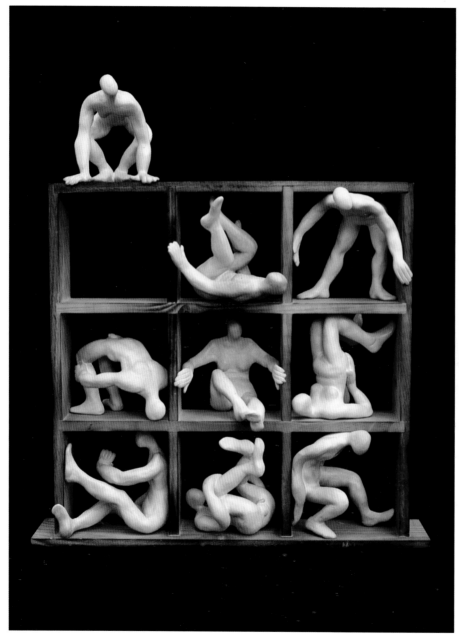

This work is one in a series titled *Humans Being.*

BARBARA A. SCAVOTTO-EARLEY
Dispositions, 1997

21 x 19 x 5 in. (53 x 48 x 13 cm)

Low-fire white clay; hand modeled; wooden chambers attached with epoxy glue, wood has been colored with fire; cone 04, lightly fumed, held over smoldering hay to desired smoked stain

Photo by artist

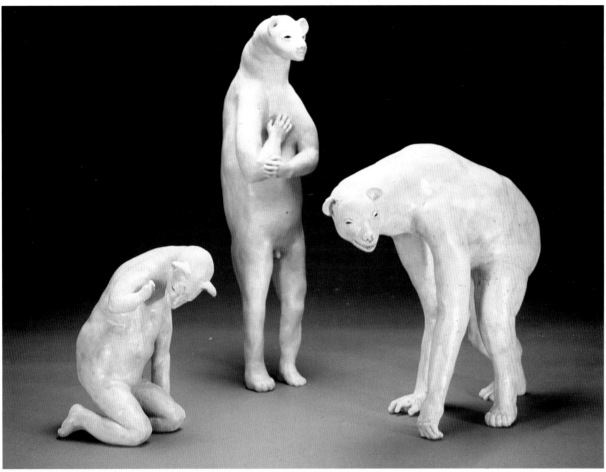

JAMI L. MCKINNON
Pack, 2002

15 x 20 x 15 in. (38 x 51 x 38 cm)

Pinched stoneware; slip, glaze,
pigment, encaustic

Photo by artist

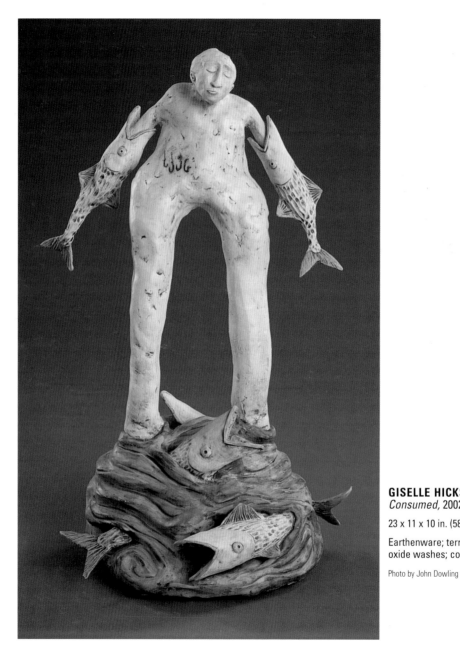

GISELLE HICKS
Consumed, 2002

23 x 11 x 10 in. (58 x 28 x 25 cm)

Earthenware; terra sigillata,
oxide washes; cone 04

Photo by John Dowling

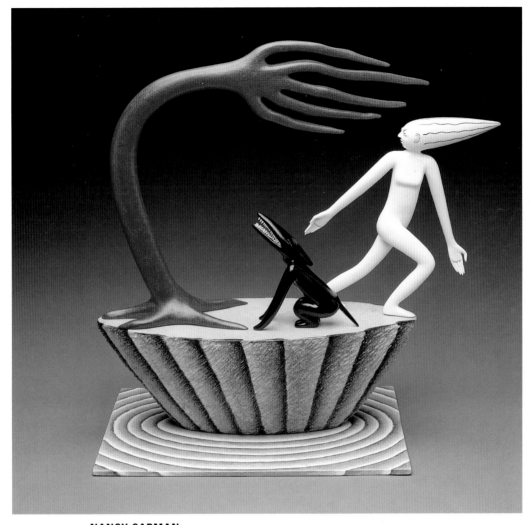

NANCY CARMAN
Fool, 2001

25 ½ x 24 ½ x 14 in. (65 x 62 x 36 cm)

Low-fire white earthenware; hand built; under-glazes, glazes

Photo by Joseph Painter

ARTHUR GONZÁLEZ
RIGHT
*What Tool Must I Use (To Separate
the Earth From the Sky),* 2003

52 x 27 x 13 in. (132 x 69 x 33 cm)

Coil-built ceramic; blown glass, red lead,
vodka, rope, wire, wood branches, glaze,
epoxy, gold leaf, cast iron

Photo by John Wilson White

BELOW
Sagging, 2002

28 x 60 x 18 in. (71 x 152 x 46 cm)

Coil-built clay; rope, horsehair, wood,
acrylic, paint, gold leaf, paper, antler

Photo by John Wilson White

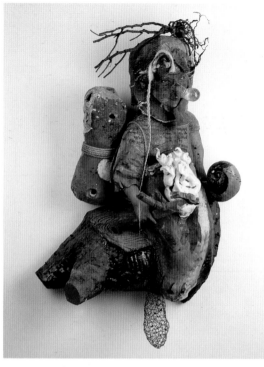

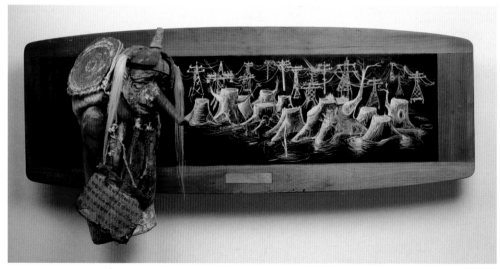

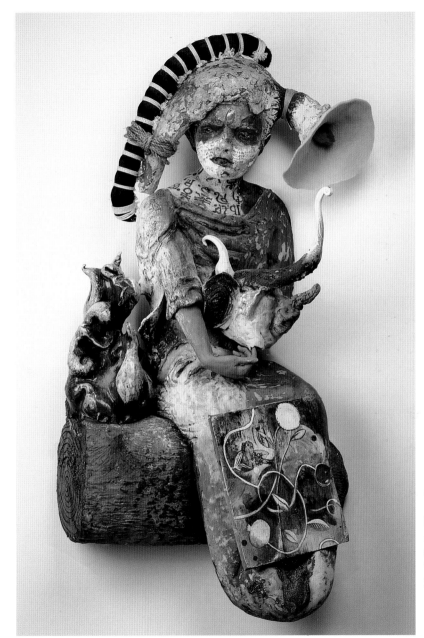

ARTHUR GONZÁLEZ
The Horizon is Sitting Beside You, 2002

52 x 27 x 13 in. (132 x 69 x 33 cm)

Coil-built ceramic; horsehair, rope natural sponge, rabbit's foot, twine, glaze, epoxy, gold leaf

Photo by John Wilson White

This work stems from a desire to collate fragments of history, myth, and legend, to provide a parallel world for my imaginary people.

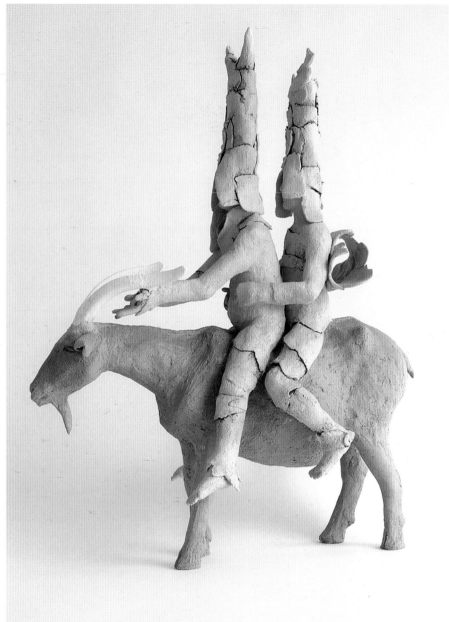

MARY E. KERSHAW
Nearly Home, 2003

16 ½ x 13 x 6 ¼ in. (42 x 33 x 16 cm)

Stoneware clays; slab built, coil built; stippled and sprayed matte glazes and oxides; Orton cone 8 electric

Photo by Robert J. Kershaw

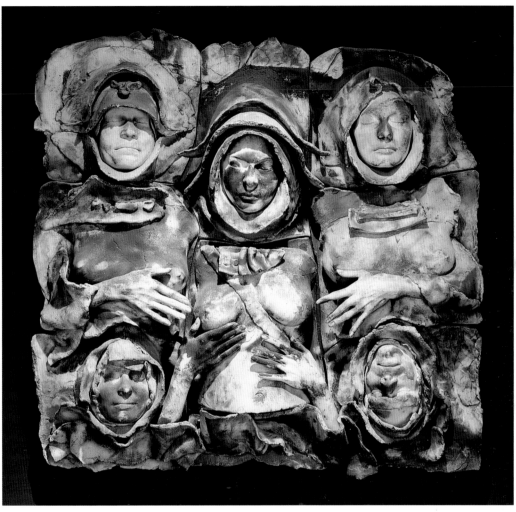

LOUIS MENDEZ
The Encounter, 1985

53 x 48 x 10 in. (135 x 122 x 25 cm)

Stoneware; slab built, pressed elements,
sawdust; pit-fired

Photo by Noel Allum

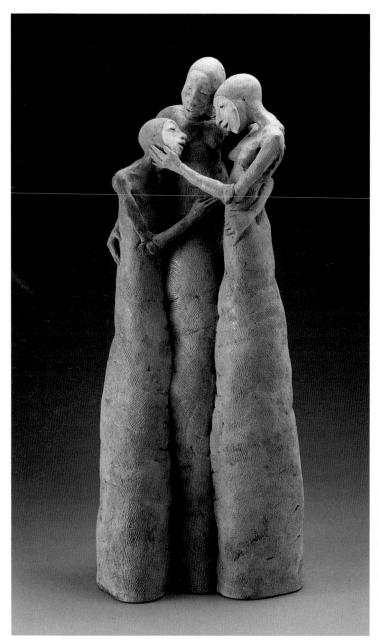

MELISA CADELL
She Would Dream Her Own Dreams Because of the Past in Front of Her, 2003

23 x 8 x 7 in. (58 x 20 x 18 cm)

Red earthenware; extended coil, slab built, pinched; engobe washes

Photo by Tom Mills

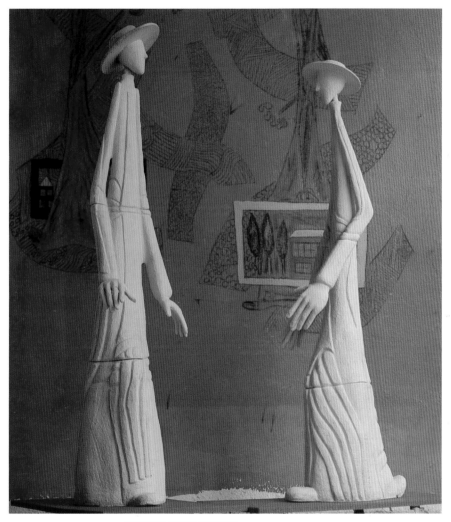

KOSTAS KARAKITSOS
Communicating, 2003

Left: 63 x 14 ½ x 21 ½ in. (160 x 37 x 55 cm)

Right: 59 x 11 ¾ x 18 in. (150 x 30 x 46 cm)

Slab-built stoneware; slip, oxide; 1260°C (2300°F)

Photo by artist

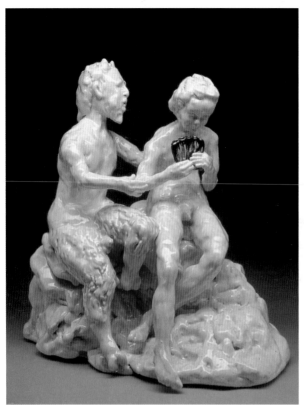

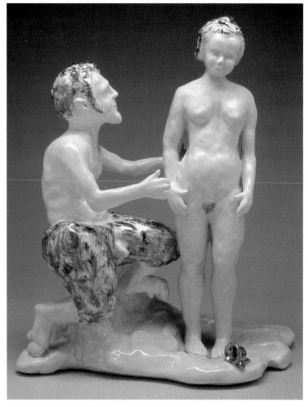

LOUISE RADOCHONSKI
LEFT
The Music Lesson, 2003

12 x 11 x 8 in. (31 x 28 x 20 cm)

Stoneware; solid construction; glazed,
gold luster; multi-fired

Photo by Jeff Maher

ABOVE
Seduction at Teatime, 2003

13 x 11 ½ x 6 in. (33 x 29 x 15 cm)

Solid construction, hand built; glazed,
gold luster; multi-fired

Photo by Jeff Maher

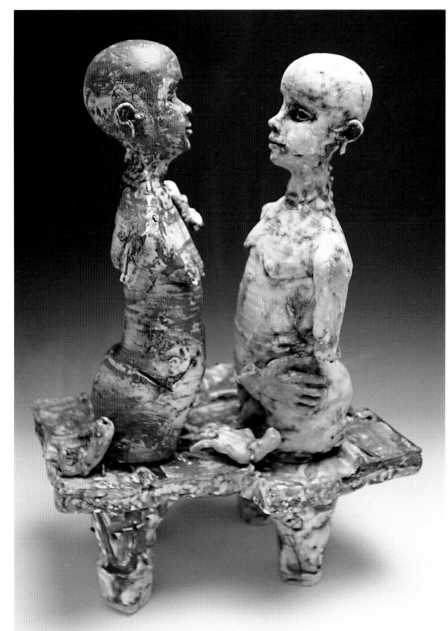

BRIAN K. MCCALLUM
Parting Ways, 2003

22 x 14 x 20 in. (56 x 36 x 51 cm)

Clay; thrown, altered; slips, glazes; multi-fired

Photo by artist

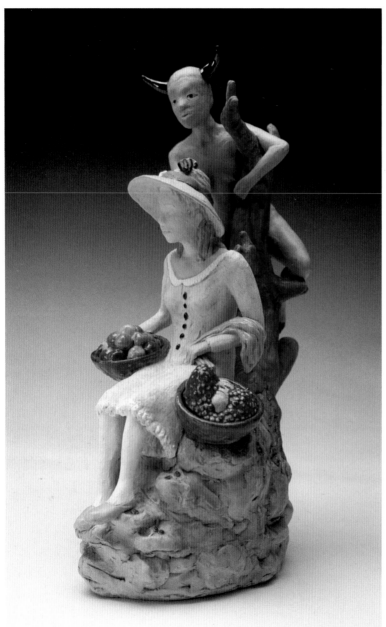

I use the natural environment frequently in my work because I find nature fascinating, beautiful, and slightly dangerous. The scenes depicted in my work also tap into my vivid memories of growing up in a peaceful natural environment.

CARRIANNE HENDRICKSON
In the Orchard II
(sculptural teapot), 2003

18 x 14 x 9 in. (46 x 36 x 23 cm)

Low-fire clay; hand built, hollowed; underglaze, glaze

Photo by artist

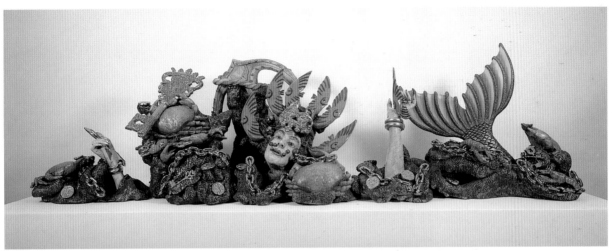

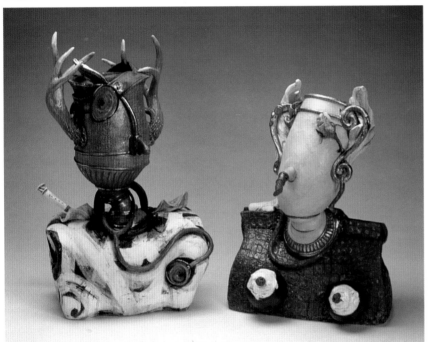

TOBY BUONAGURIO
ABOVE
*Radiant Creatures of the Blue
Coral Sea,* 1990

24 x 82 x 22 in. (61 x 208 x 56 cm)

Ceramic; hand-constructed, cast;
multi-fired and non-fired surfaces

Photo by Edgar Buonagurio

LINDA S. FITZ GIBBON
LEFT
Trophy Couple, 2000-2001

Husband: 25 x 15 x 11 in. (64 x 38 x 28 cm)

Wife: 22 x 14 x 14 in. (56 x 36 x 36 cm)

Hand-built ceramic; underglaze, stains,
glaze, metallic lusters; cones 04-019

Photos by Izzy Schwartz

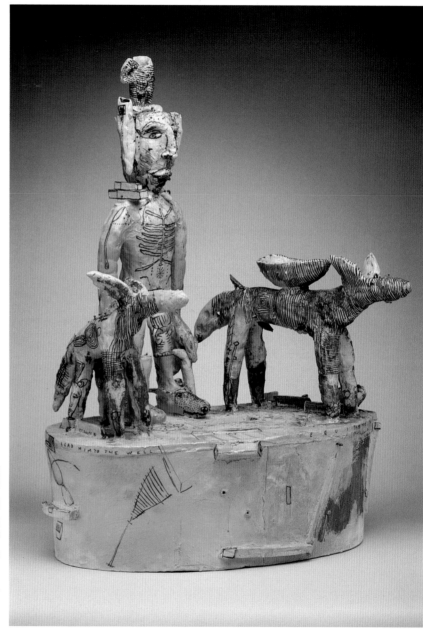

TED SAUPE
Lead Him To The Well, 1999

30 x 24 x 14 in. (76 x 61 x 36 cm)

Low-fire salt stoneware; white and
black slip; cone 1 salt

Photo by Walker Montgomery

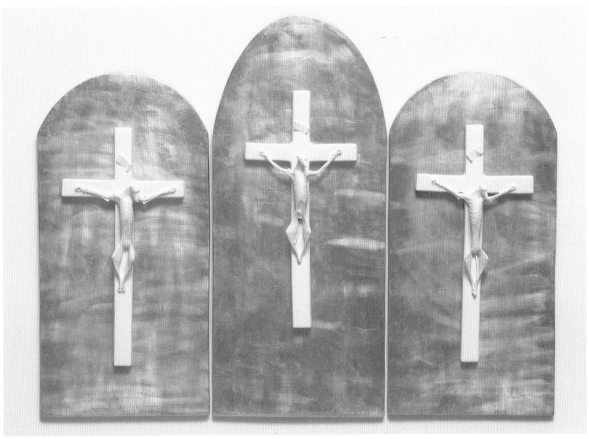

ADELAIDE PAUL
Win/Place/Show, 2001

26 x 32 x 2 in. (66 x 81 x 5 cm)

Carved porcelain, wood panels; 23k-gold leaf

Photo by John Carlano

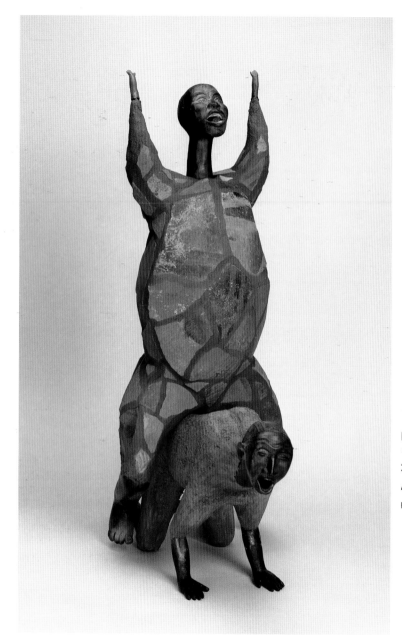

RONNA NEUENSCHWANDER
Riding Betty, 1996

21 x 10 x 18 in. (53 x 25 x 46 cm)

Adobe, earthenware; terra sigillata

Photo Dale Montgomery

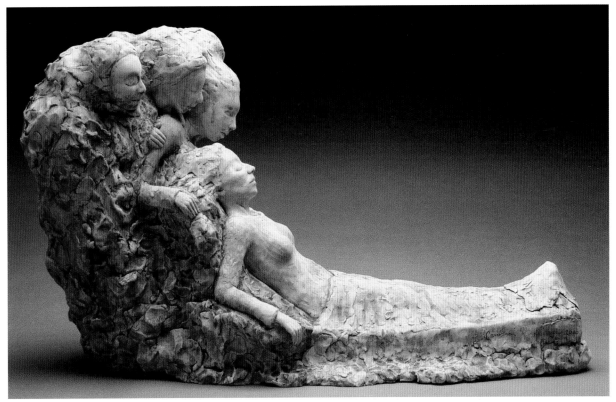

My final visit with my grandmother, now deceased, helped inspire this exploration of family bonds and the roots that are created.

CARRIANNE HENDRICKSON
Memory, 2000

26 x 32 x 18 in. (66 x 81 x 46 cm)

Low-fire clay; hand built, hollowed; oxides; cone 5

Photo by artist

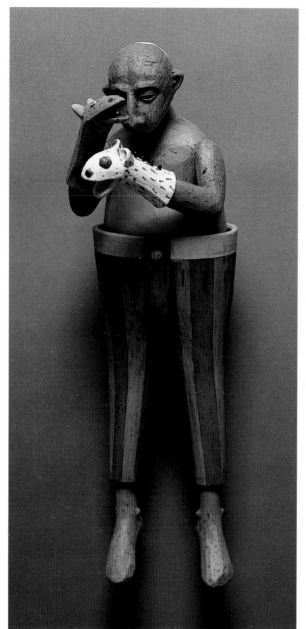 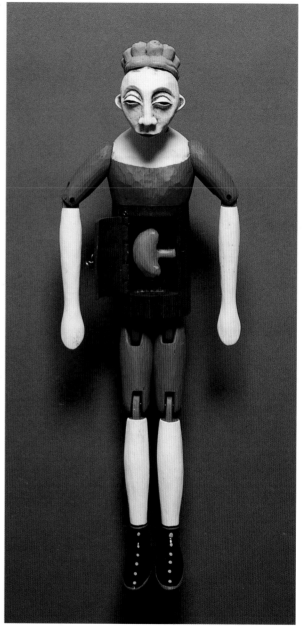

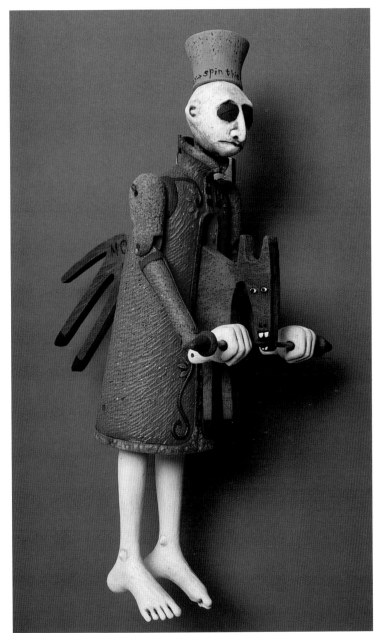

MELODY ELLIS
OPPOSITE PAGE LEFT
Puppet Master, 2003

10 x 3 x 4 in. (25 x 8 x 10 cm)

Hand-built earthenware; slips, glazes, high-fire wire; cone 04 oxidation

Photo by artist

OPPOSITE PAGE RIGHT
Spare Kidney, 2003

11 x 3 1/2 x 2 ½ in. (28 x 9 x 6 cm)

Hand-built earthenware; slips, glazes, high-fire wire; cone 04 oxidation

Photo by artist

LEFT
Riding Lesson, 2003

11 x 4 x 6 ½ in. (28 x 17 cm)

Hand-built earthenware; slips, glazes, high-fire wire; cone 04 oxidation

Photo by artist

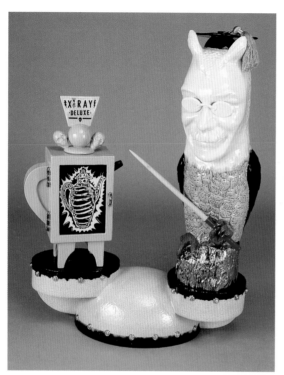

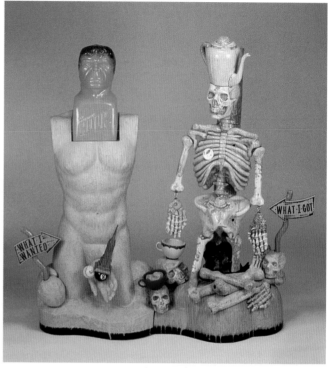

MARK BURNS
LEFT
Professor Burns Explains Teapot Anatomy, 2000

25 x 19 x 9 in. (64 x 48 x 23 cm)

Earthenware; glaze, wood

Photo courtesy of Ferrin Gallery

RIGHT
What I Wanted, What I Got, 2000

50 x 50 x 28 in. (127 x 127 x 71 cm)

Earthenware, stoneware; glaze

Photo courtesy of Ferrin Gallery

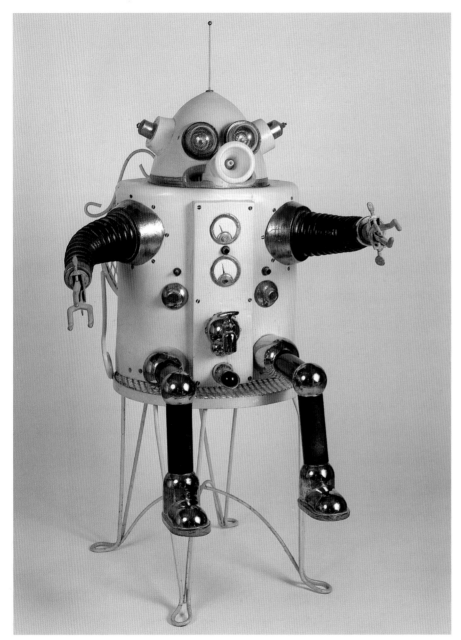

Every so often, the piece makes a noise like a broken spring.

CLAYTON BAILEY
Grandfather Robot, 1971-73

36 x 28 x 28 in. (91 x 71 x 71 cm)

Low-fire ceramic; hand built, thrown, cast; luster, sound effects, lights

Photo courtesy of claytonbailey.com
Collection of Tom Folk

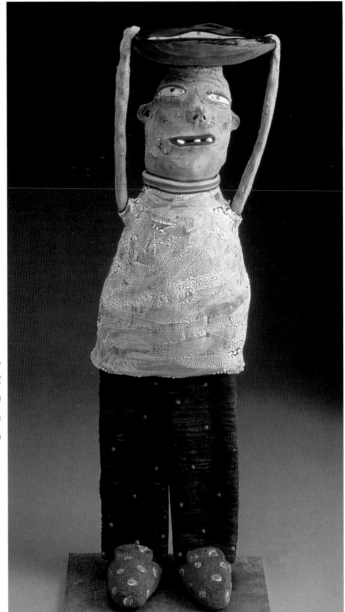

DEB FLECK-STABLEY
Nope, It's Too Tall for a Soap Dish, 2002

24 x 10 x 8 in. (61 x 25 x 20 cm)

Earthenware; underglazes, glazes; oxidation

Photo by Mark Ammerman

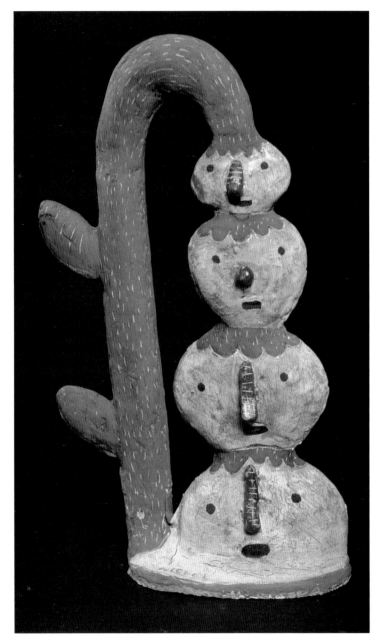

RICHARD NICKEL
Family, 2003

15 x 7 x 4 in. (38 x 18 x 10 cm)

Slab-built earthenware; engobes

Photo by Christine Nickel

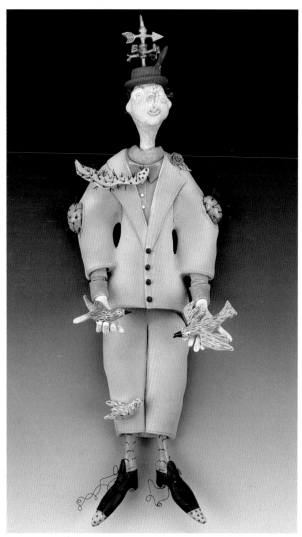
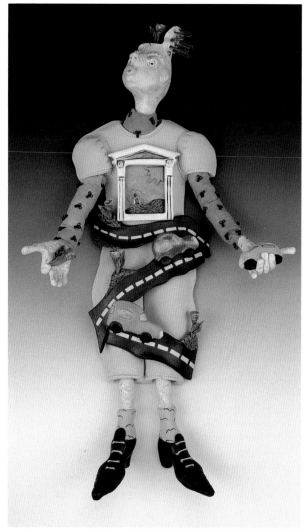

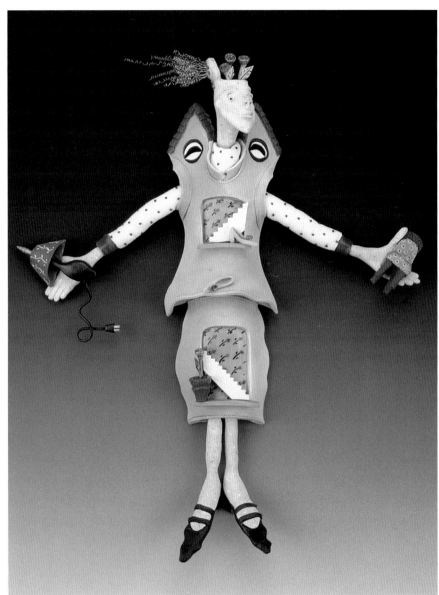

LAURA PEERY
OPPOSITE PAGE LEFT
Nesting Instinct, 2003

24 x 9 x 4 in. (61 x 23 x 10 cm)

Hand-built porcelain; metal fiber, stains, underglazes

Photo by Jerry Anthony

OPPOSITE PAGE RIGHT
One World, 2002

20 x 12 x 4 in. (51 x 31 x 10 cm)

Hand-built porcelain; metal fiber, stains, underglazes

Photo by Jerry Anthony

LEFT
In A Doll's House, 2003

21 x 17 x 4 in. (53 x 43 x 10 cm)

Hand-built porcelain; metal fiber, stains, underglazes

Photo by Jerry Anthony

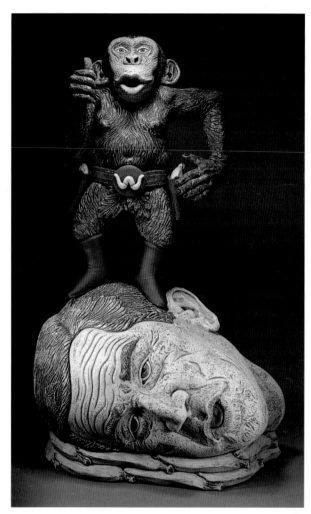

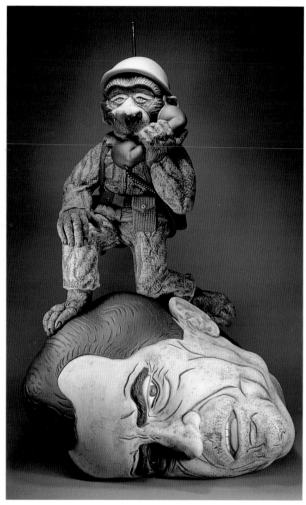

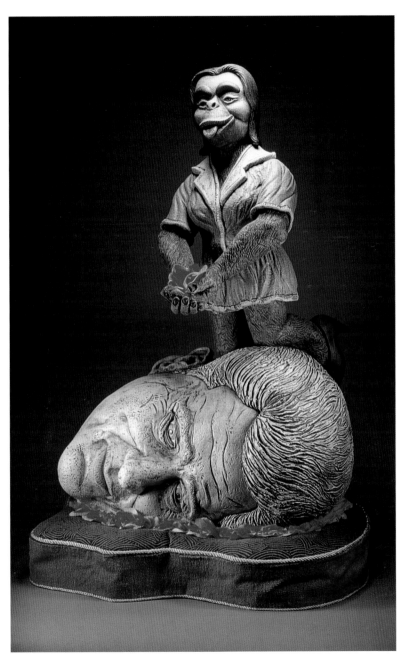

In these moments of presidential history, Bush, Clinton, and Nixon are suspended in a state of submission. Their prostrate heads are submissive to the primal monkeys that are symbolic of their personal shortcomings. Suggestions of these shortcomings are also portrayed graphically on the backs of their heads. In these three presidents, I believe there are profound distinctions between the nature of their human flaws and the consequence of their actions.

JIM BUDDE
OPPOSITE PAGE LEFT
Dubya, 2003

34 x 20 x 13 in. (86 x 51 x 33 cm)

Buff sculpture clay; glazes; cone 5, cone 08

Photo by artist
In the collection of Sanford M. Besser

OPPOSITE PAGE RIGHT
Calling Nixon, 2002

36 x 22 x 16 in. (91 x 56 x 41 cm)

Buff sculpture clay; glazes, phone cord, chrome antenna; cone 5, cone 08

Photo by artist

LEFT
Bill's American Beauty, 2002

31 x 21 x 14 in. (79 x 53 x 36 cm)

Buff sculpture clay; glazes, wood, fabric, plastic flowers; cone 5, cone 08

Photo by artist
In the collection of Sanford M. Besser

MATTHEW RICHARD SHAFFER
There Is No King, 2003

17 x 13 x 10 ½ in. (43 x 33 x 27 cm)

Earthenware

Photo by artist

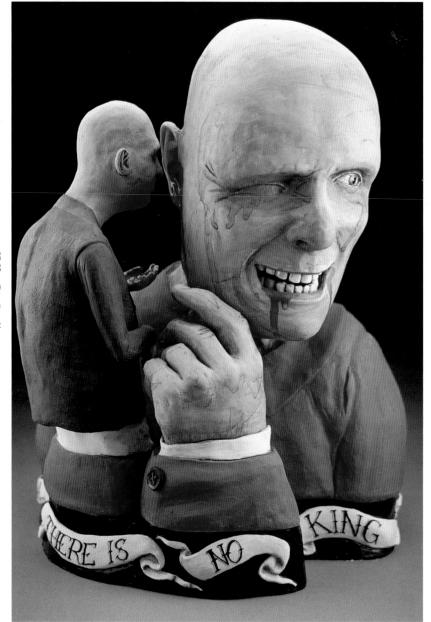

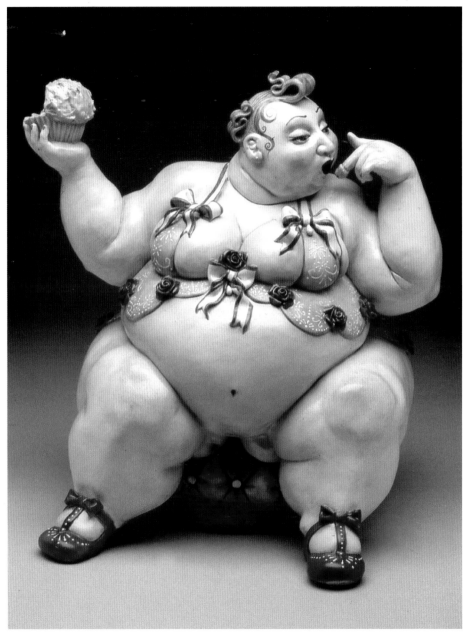

KAREN MARIE PORTALEO
*Tootsie Fay Fat Lady
Sideshow* (girlesque
teapot series), 2003

14 x 13 x 12 in. (36 x 33 x 31 cm)

White clay; glaze, China paints,
enamels, lusters

Photo by Joseph Brozino

My pieces have become
increasingly narrative,
personal, and figurative. They
convey ideas, stories, and
expressions of my irreverent
spirituality and sense of
personal mythology. If I can't
have fun with my work,
I might as well shoot myself.

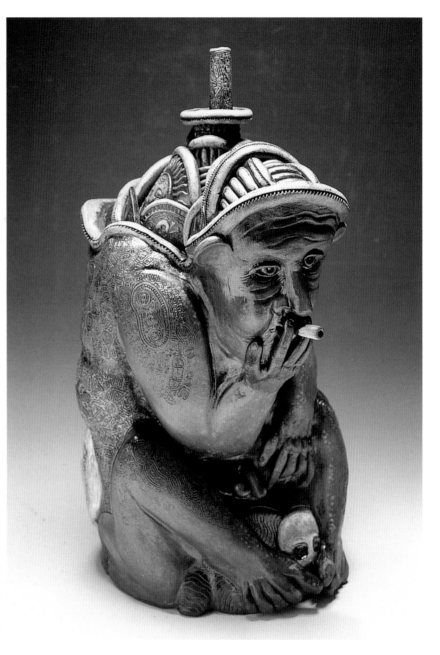

MARKO FIELDS
*St. Efficacious Mojo Oil Bottle, For
the Facilitation of Miraculous
Intervention,* 2002

21 x 8 x 9 in. (53 x 20 x 23 cm)

Stoneware, porcelain; hand built, thrown
elements, incised, carved, sgraffito; cone
8 reduction, cone 018 luster

Photo by artist
In the collection of Sanford M. Besser

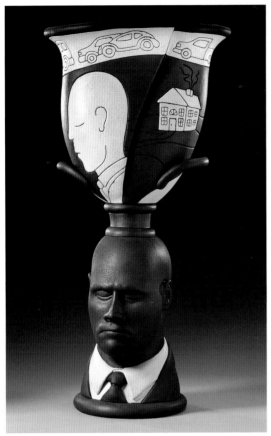

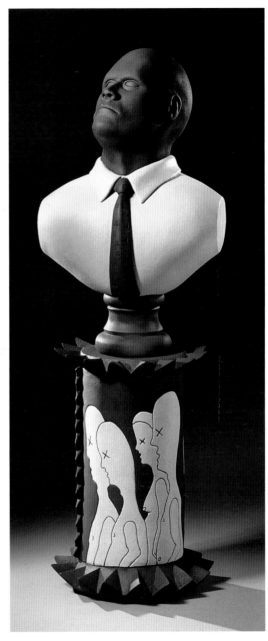

JEFF KELL
ABOVE
The Grind, 2002

38 x 18 x 14 in. (97 x 46 x 36 cm)

Hand-built earthenware; cone 06

Photo by Geoff Tesch

LEFT
Corporate Greed, 2003

56 x 19 x 16 in. (142 x 48 x 41 cm)

Hand-built earthenware; cone 06

Photo by Geoff Tesch

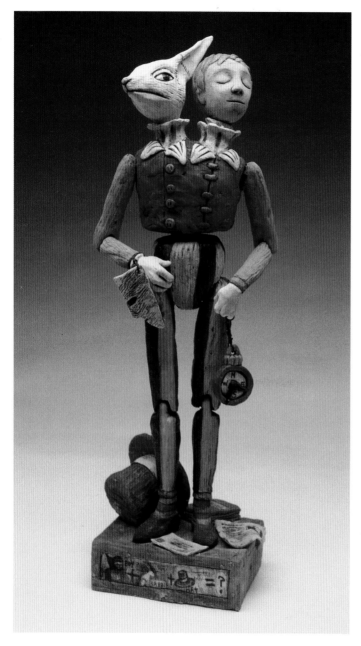

I designed this character to be a toy. What he became after that initial inspiration comes from my own experience and personality: as a child my mother greatly influenced my artistic and aesthetic inclinations. Much of her aesthetic focus was on Native American Art and Folk Art.

CARRIANNE HENDRICKSON
The Tale of Malcolm McGee (The Boy Who Loved Magic), 2000

28 x 12 x 10 in. (71 x 31 x 25 cm)

Low-fire clay; hand built; glaze, slip

Photo by artist

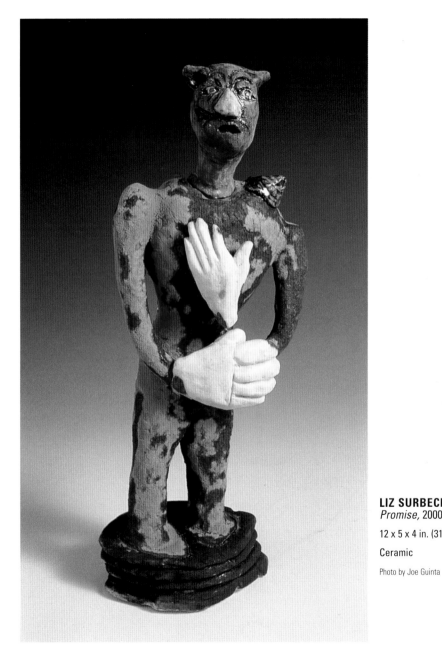

LIZ SURBECK BIDDLE
Promise, 2000

12 x 5 x 4 in. (31 x 13 x 10 cm)

Ceramic

Photo by Joe Guinta

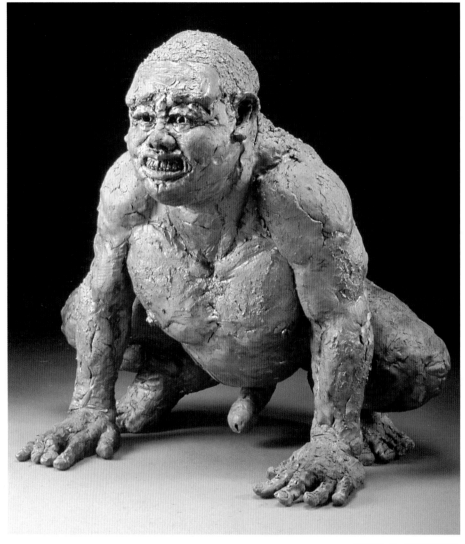

PAVEL G. AMROMIN
Ambition, 2003

25 x 29 x 23 in. (64 x 74 x 58 cm)

Slab-built stoneware; oxides; cone 10

Photo by Jeff Bruce

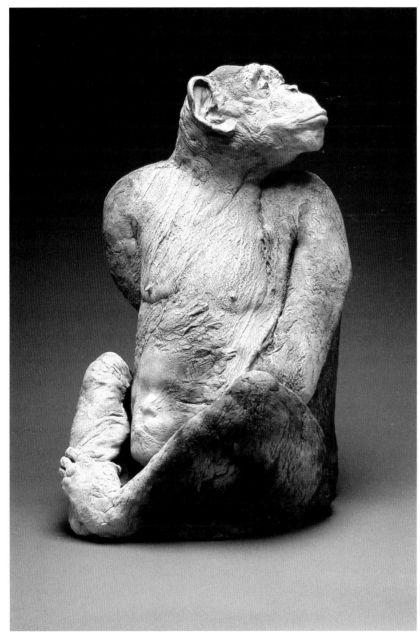

PAMELA EARIUSHAW KELLY
Brothers, 2001

24 ½ x 16 x 16 in. (62 x 41 x 41 cm)

Slab-built clay; raku-fired

Photo by artist

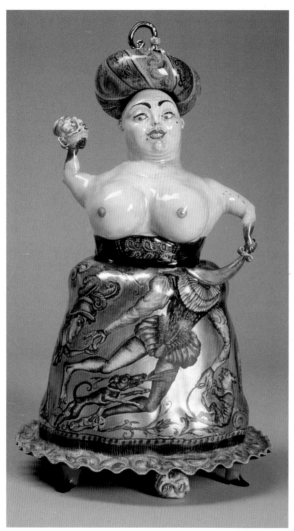

IRINA S. ZAYTCEVA
LEFT
Woman in Charge, 2000

16 x 9 in. (41 x 23 cm)

Hand-built porcelain; overglazes, underglazes, 24k-gold paint

Photo by artist

BELOW
Chinese Acrobat, 2001

8 x 14 in. (20 x 36 cm)

Hand-built porcelain; overglazes, underglazes, 24k-gold paint; high fire

Photo by artist

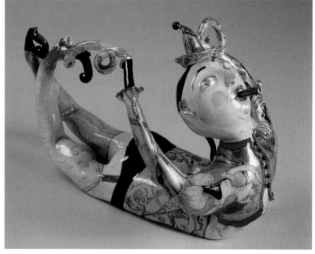

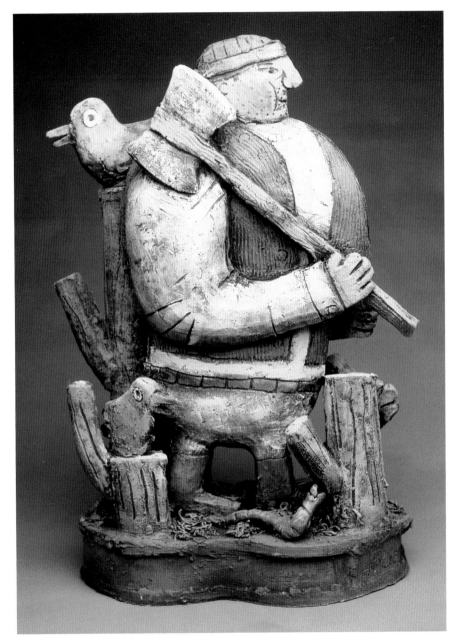

RICHARD NICKEL
Lumberjack, 2002

14 x 10 x 5 in. (36 x 25 x 13 cm)

Slab-built earthenware; mason stains

Photo by Christine Nickel

HENRY CAVANGH
RIGHT
Bed Habits, 1980

Height: 4 in. (10 cm)

Base: 9 x 13 in. (23 x 33 cm)

Porcelain, walnut base; grogged, hand built;
stains, lusters, China paints; cone 10

Photo by Ralph Gabriner
Commission, in a private collection

BELOW
Saturday Afternoon, 1988

6 ½ x 6 x 8 ½ in. (17 x 15 x 22 cm)

Porcelain, walnut base; grogged, hand built;
stains, glaze, China paints, lusters; cone 10

Photo by Ralph Gabriner
Commission, in a private collection

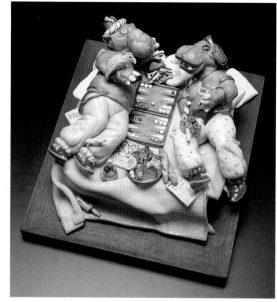

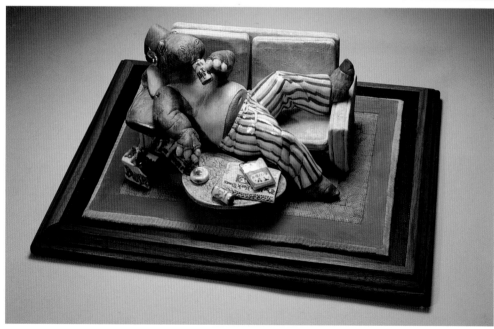

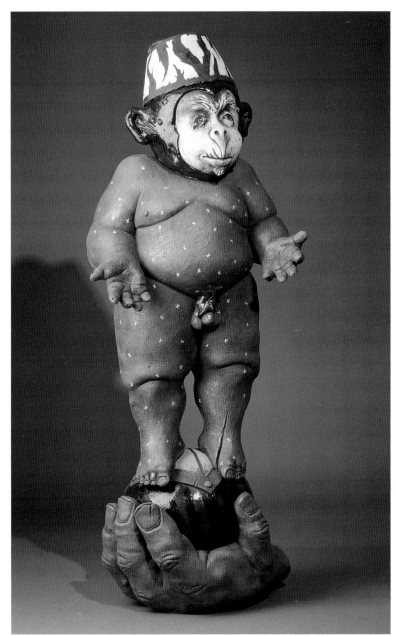

JAMES TISDALE
Through These Fingers, 2002

42 x 23 x 19 in. (105 x 58 x 48 cm)

Earthenware terra cotta; coil built

Photo by Chris Zaleski

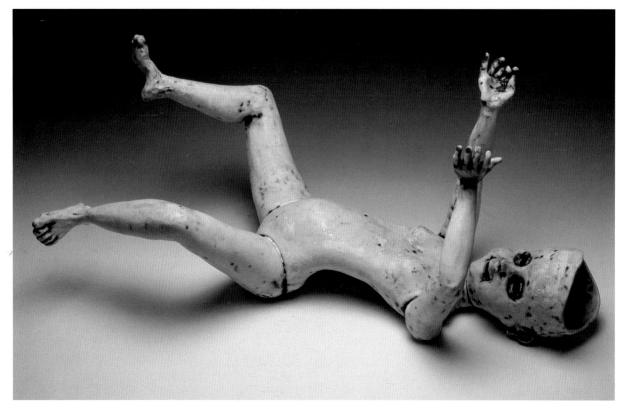

BRIAN K. MCCALLUM
Little Known Facts about Babies, 2002

9 x 10 x 18 in. (23 x 25 x 46 cm)

Clay; thrown, altered; slips, glazes; multi-fired

Photo by artist

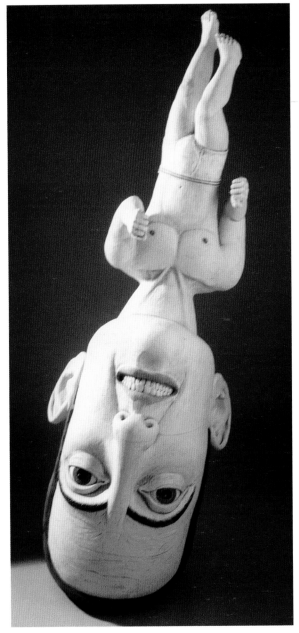

This traditional caricature is a critical and compassionate portrayal of contemporary man. The ridiculous stance and form he takes depicts his relationship to the world and nature.

CYNTHIA CONSENTINO
Big Head, 2002
65 x 22 ½ x 23 in. (165 x 57 x 58 cm)
Coiled clay; underglazes, glazes, oils
Photo by artist

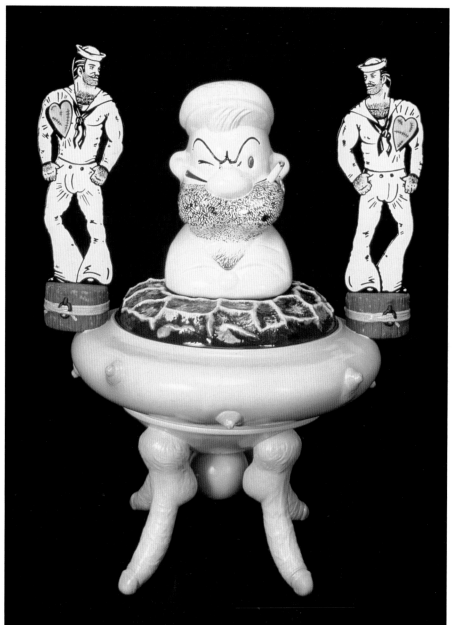

MARK BURNS
Hey, Sailor! (Popeye in Love), 2000

24 x 18 x 14 in. (61 x 46 x 36 cm)

Ceramic

Photo courtesy of Ferrin Gallery

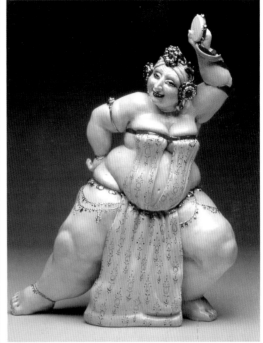

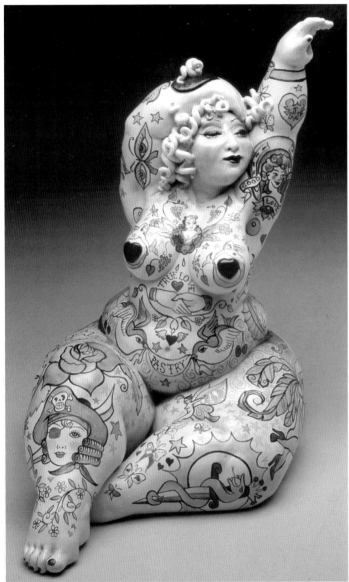

KAREN MARIE PORTALEO
ABOVE
Little Cairo Gypsy Fortune Teller Sideshow
(girlesque teapot series), 2003

16 x 12 x 12 in. (41 x 31 x 31 cm)

White clay; glaze, China paints, enamels, lusters

Photo by Joseph Brozino

LEFT
Sailor Rose, 2003

12 x 9 x 11 in. (31 x 23 x 28 cm)

White clay; glaze, China paints, enamels, lusters

Photo by Joseph Brozino

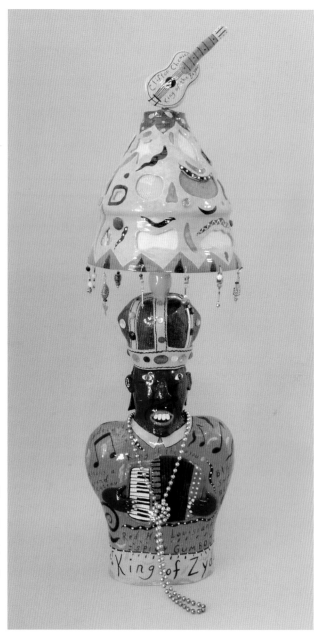

SUSAN GARSON AND THOMAS PAKELE
King of the Bayou, 2001

36 x 10 ½ x 10 in. (91 x 27 x 25 cm)

Earthenware; cast, hand built; glaze, mixed media,
fabricated lighting, handmade paper

Photo by artists

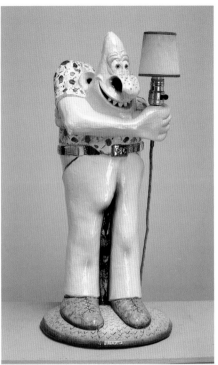

CLAYTON BAILEY
LEFT
Demented Pinhead Lamp, 1970

36 x 18 x 18 in. (91 x 46 x 46 cm)

Low-fire ceramic; slip cast in three sections, assembled; China paint, luster, electric light

Photo courtesy of claytonbailey.com

CLAYTON BAILEY AND PETER SAUL
BELOW
The Mad Doctor's Operation, 1975

28 x 72 x 36 in. (71 x 183 x 91 cm)

Low-fire ceramic; hand built; luster, China paint, acrylic day-glow paint

Photo courtesy of claytonbailey.com

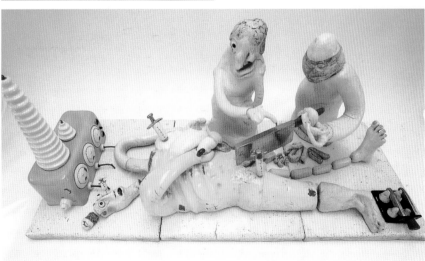

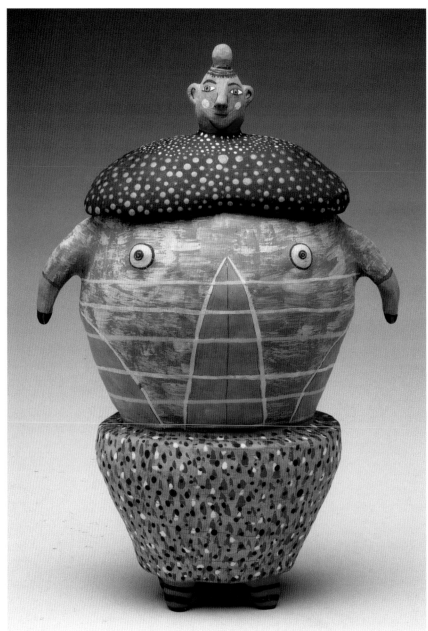

JENNY MENDES
Pretty Girl, 2003

7 x 5 x 3 in. (18 x 13 x 8 cm)

Coiled terra cotta; terra
sigillatta; cone 03

Photo by Heather Protz

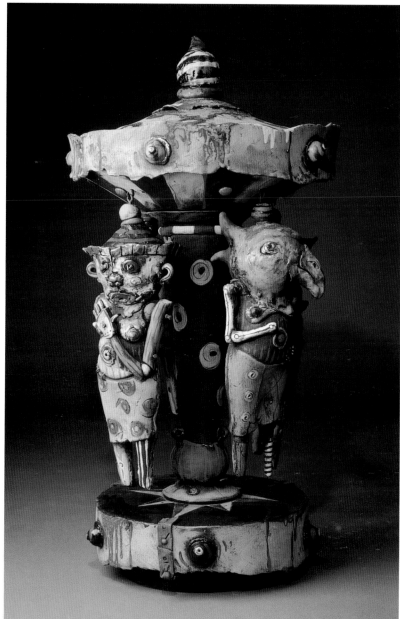

JAMES TISDALE
Here We Go Again, 2003

37 x 24 x 25 in. (94 x 61 x 64 cm)

Earthenware terra cotta; coil built,
slab construction, pinched; slips,
glazes; multi-fired

Photo by Chris Zaleski

ANTHONY NATSOULAS
RIGHT
*Lady Donna Bow Bonna with
Baby Mer,* 2002

53 x 44 x 20 in. (135 x 112 x 51 cm)

Low-fire clay; slab built; low-fire
glazes, glass globe light

Photo by Stuart Allen

OPPOSITE PAGE LEFT
*DiPasqua De Comedia
Del Arte,* 2002

56 x 32 x 20 in. (142 x 81 x 51 cm)

Low-fire clay; slab built; low-fire
glazes, metal bird cage

Photo by Stuart Allen

OPPOSITE PAGE RIGHT
*Sir Stevens of the Royal
Puppeteers,* 2002

48 x 36 x 23 in. (122 x 91 x 58 cm)

Low-fire clay; slab built; low-fire
glazes

Photo by Stuart Allen

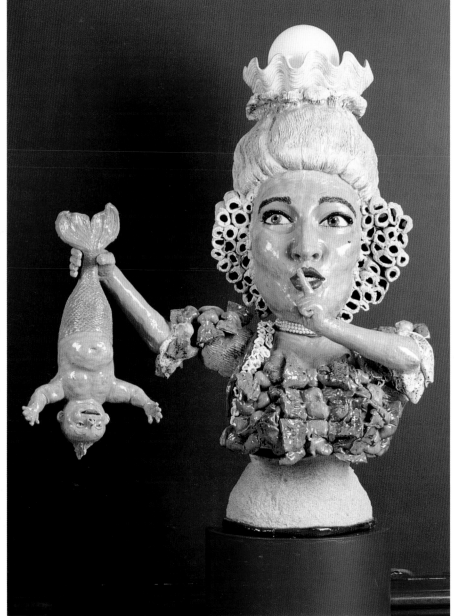

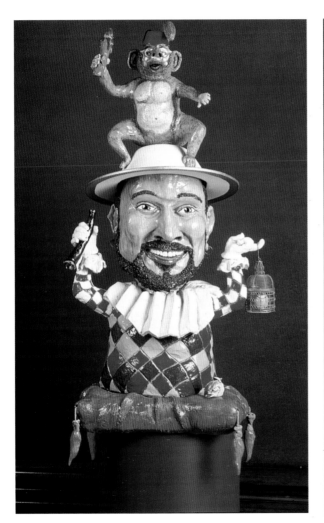

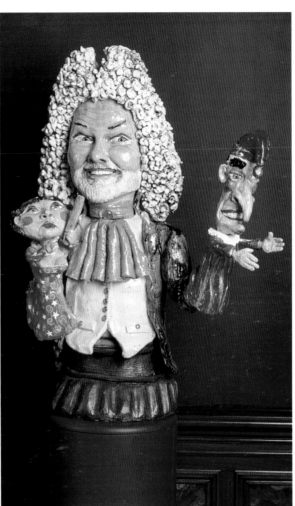

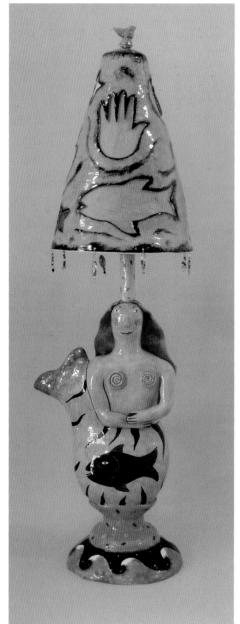

**SUSAN GARSON AND
THOMAS PAKELE**
LEFT
Mermaid, 2003

37 x 10 ½ x 8 in. (94 x 27 x 20 cm)

Earthenware; cast, hand built;
mixed media

Photo by artists

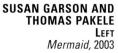

TRUDY EVARD CHIDDIX
RIGHT
Drought Dreams, 2003

31 x 11 x 6 in. (79 x 28 x 15 cm)

Slab-built porcelain paper clay;
fused glass, copper wire

Photo by Eric Lars Bakke

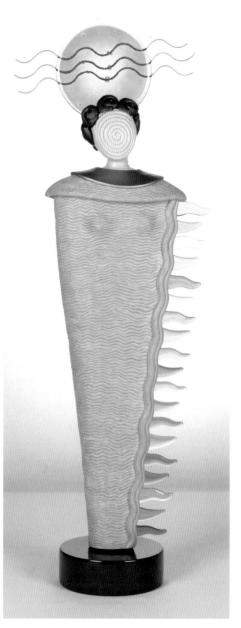

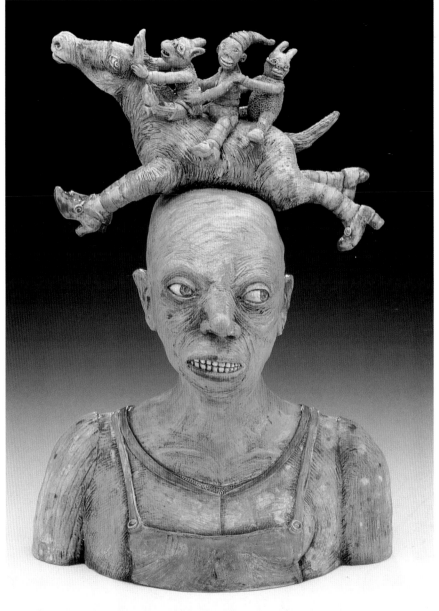

This piece symbolizes how I feel about my "journeys" in motherhood. It has been a fun, somewhat bumpy, crazy, wonderfully full ride so far.

JANIS MARS WUNDERLICH
Horse Hair, 2003

18 x 9 x 7 in. (46 x 23 x 18 cm)

Hand-built earthenware; underglaze, slips, glaze; multi-fired

Photo by Jerry Anthony Photography

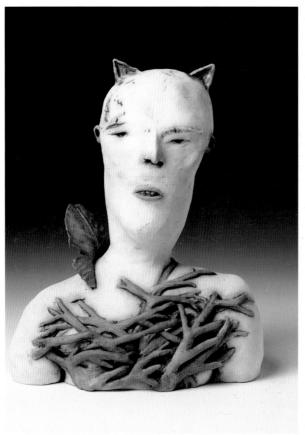

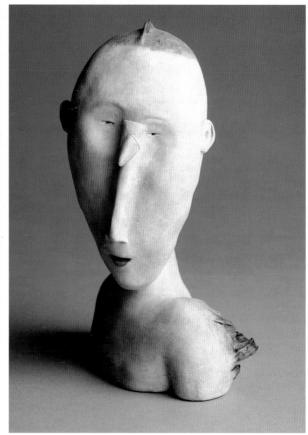

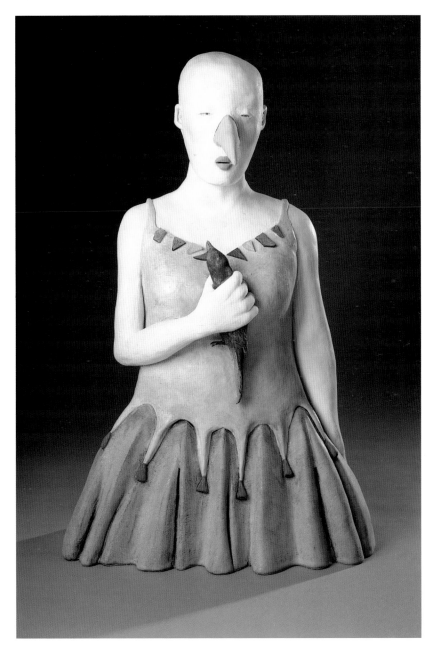

LESLIE ROSDOL
OPPOSITE PAGE LEFT
Self-Portrait As a Bird II, 2003

8 x 4 ½ x 4 in. (20 x 11 x 10 cm)

Porcelain; hand built, coiled; oil

Photo by Susan Einstein

OPPOSITE PAGE RIGHT
Laying in Wait, 2002

6 ½ x 5 ½ x 3 in. (16 x 14 x 8 cm)

Porcelain; hand built, coiled

Photo by Susan Einstein

LEFT
Self-Portrait As a Bird, 2003

25 x 16 x 10 in. (64 x 41 x 25 cm)

Ceramic, glass; hand built, coiled

Photo by Susan Einstein

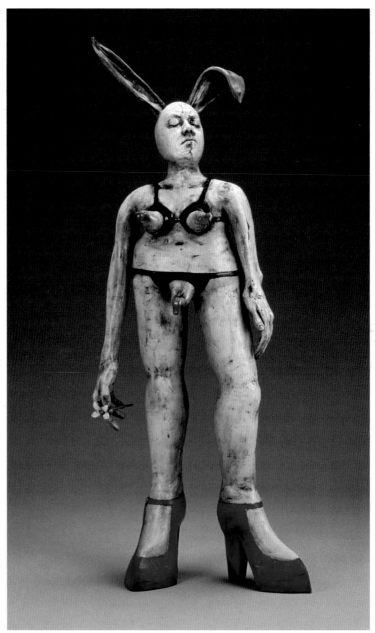

INGRID HENDRIX
Anima/Animus, 2002

43 x 17 x 10 in. (109 x 43 x 25 cm)

Ceramic; hand built, mold formed

Photo by Bill Bachhuber

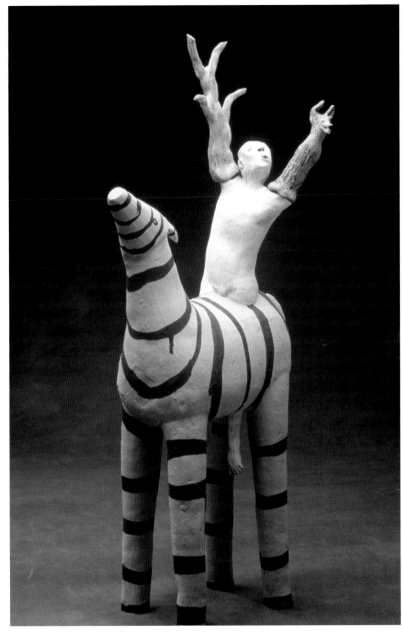

JULIELLEN BYRNE
Yellow Horse with Puppet Rider, 2000

29 x 10 x 6 in. (74 x 25 x 15 cm)

Hand-built terra cotta

Photo by Stephen Webster

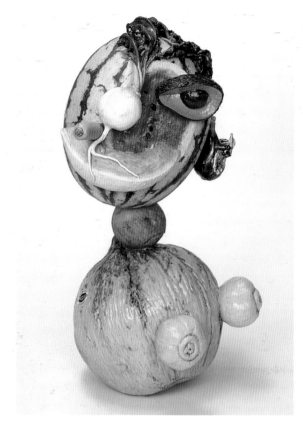

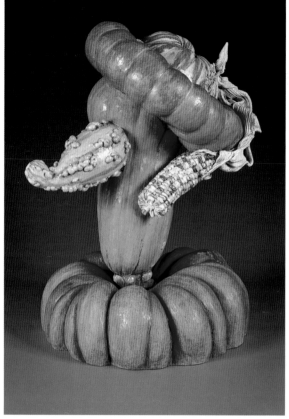

LINDA S. FITZ GIBBON
LEFT
Love Ya Honey, 2002

24 ½ x 13 ½ x 13 in. (62 x 34 x 33 cm)

Hand-built ceramic; low-fire underglaze, stains, glaze

Photo by Izzy Schwarz
Private collection

RIGHT
Do You Like My Hat?, 2000

21 ½ x 16 x 15 ½ in. (55 x 41 x 39 cm)

Hand-built ceramic; low-fire underglaze, stains, glaze

Photo by Izzy Schwarz

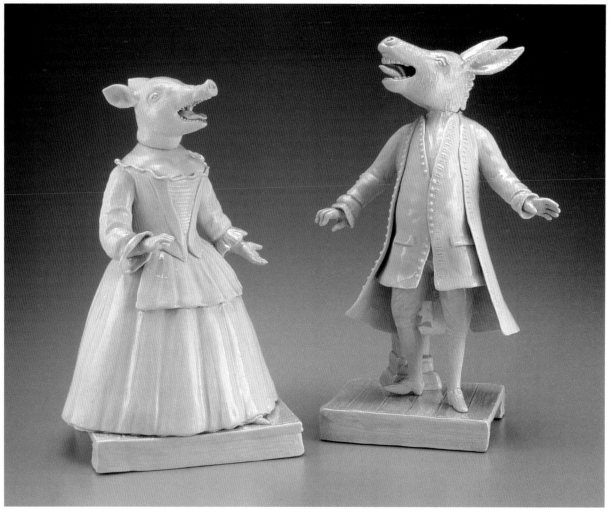

MICHELLE ERICKSON
The Beggar's Opera, 2003

Right: 12 x 9 ½ x 8 in. (31 x 24 x 20 cm)

Left: 12 x 8 x 6 in. (31 x 20 x 15 cm)

Porcelain; thrown, hand built

Photo by Gavin Ashworth, New York

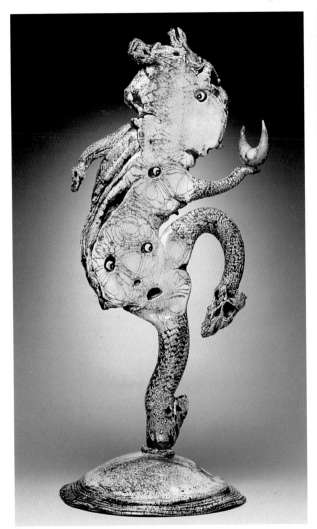 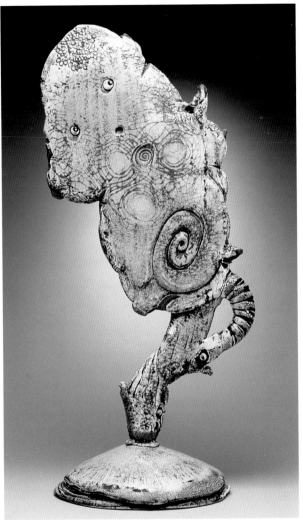

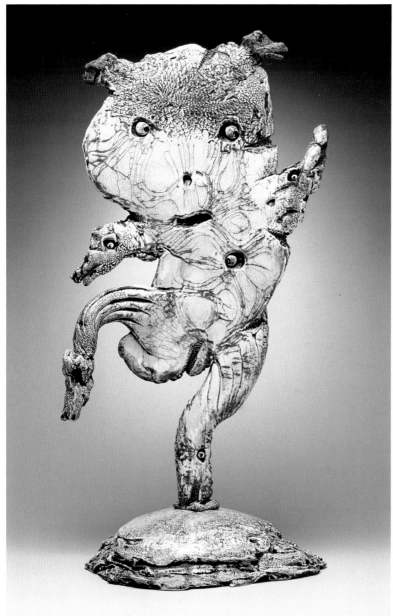

ANDY NASISSE
OPPOSITE PAGE LEFT
Abra Cadabra, 2002

36 x 14 x 15 in. (91 x 36 x 38 cm)

Ceramic; overglazes; mid-range multi-fired

Photo by Walker Montgomery

OPPOSITE PAGE RIGHT
Eco Echo, 2002

34 x 13 x 12 in. (86 x 33 x 31 cm)

Ceramic; overglazes; mid-range multi-fired

Photo by Walker Montgomery

LEFT
Be Bop, 2002

32 x 15 x 14 in. (81 x 38 x 36 cm)

Ceramic; overglazes; mid-range multi-fired

Photo by Walker Montgomery

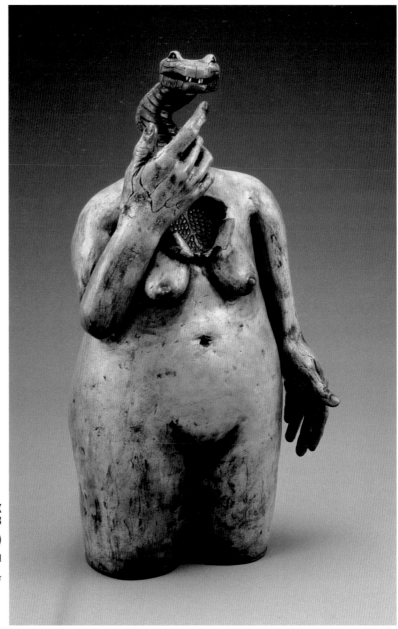

INGRID HENDRIX
Pomegranate, 2003
23 x 13 x 18 in. (58 x 33 x 46 cm)
Ceramic; hand built, mold formed
Photo by Bill Bachhuber

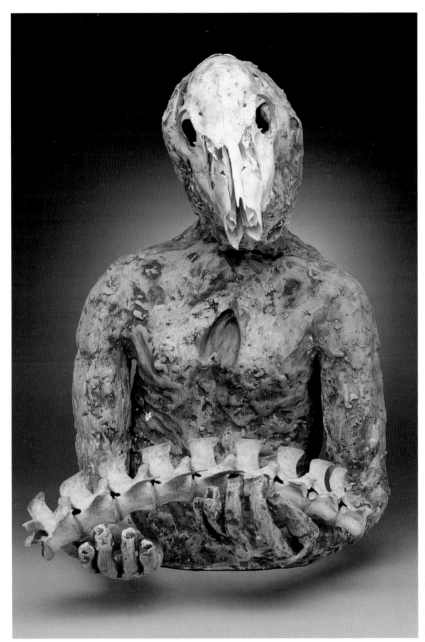

My sculpture and mixed media pieces reflect my dark yet whimsical view of the human condition as it interacts with the surrounding natural environment. Coil and slab hand-built pieces roughly textured with hues of nature's earthen palette, in combination with seemingly discordant salvaged objects, provide a glimpse of man's stumbling impact upon the natural world.

CHERI WRANOSKY
Winners and Losers, 2001

26 x 15 x 20 in. (66 x 38 x 51 cm)

Clay; hand built, coiled; bones, slips, stains, found objects

Photo by Walker Montgomery

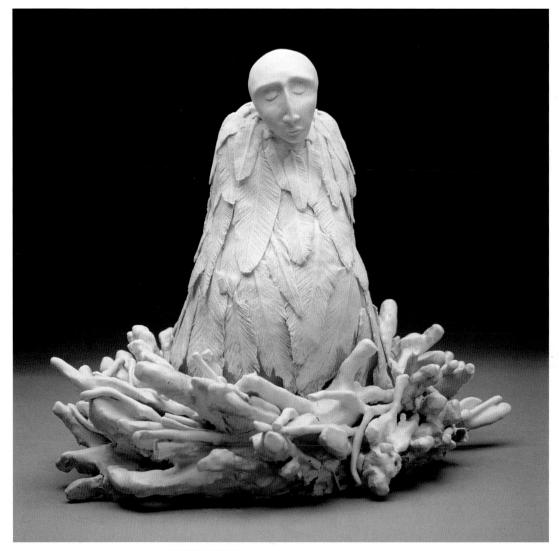

GISELLE HICKS
Passage, 2003

11 x 10 x 8 in. (28 x 25 x 20 cm)

Porcelain; reduction

Photo by artist

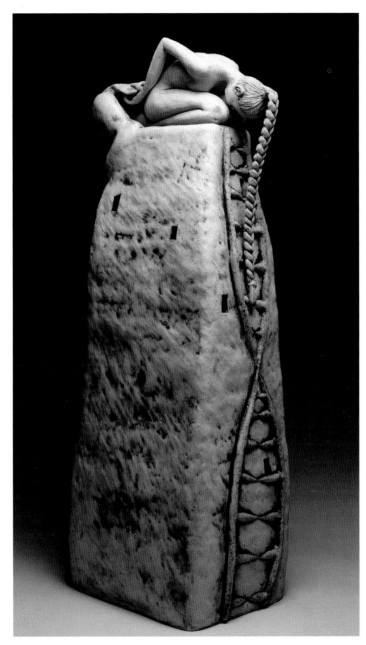

LINDA GANSTROM
Rapunzel's DNA Ladder, 2003

28 x 5 x 10 in. (71 x 13 x 25 cm)

Ceramic stoneware; coil built, modeled; cone 04

Photo by Sheldon Ganstrom

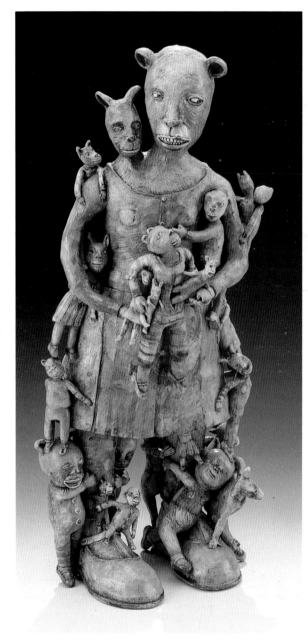

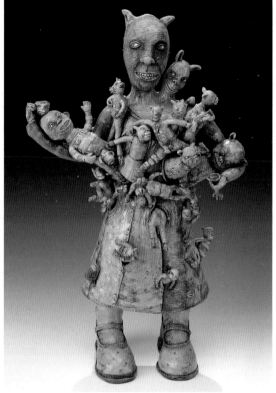

JANIS MARS WUNDERLICH
ABOVE
Parenting is No Cup of Tea, 2002

22 x 10 x 8 in. (56 x 25 x 20 cm)

Hand-built earthenware; underglaze, slips, glaze; multi-fired

Photo by Jerry Anthony Photography
In the collection of Signature Shop Gallery, Atlanta

LEFT
Family Supports, 2001

23 x 8 x 9 in. (58 x 20 x 23 cm)

Hand-built earthenware; underglaze, slips, glaze; multi-fired

Photo by Jerry Anthony Photography
In the collection of Wustum/Racine Art Museum

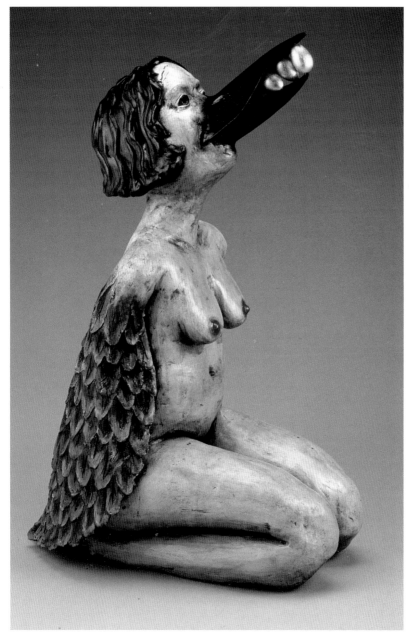

INGRID HENDRIX
Harpy, 2003

25 x 16 x 11 in. (64 x 41 x 28 cm)

Ceramic; hand built, mold formed

Photo by Bill Bachhuber

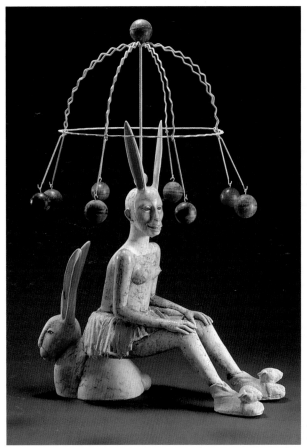

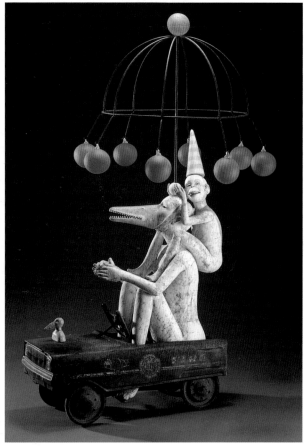

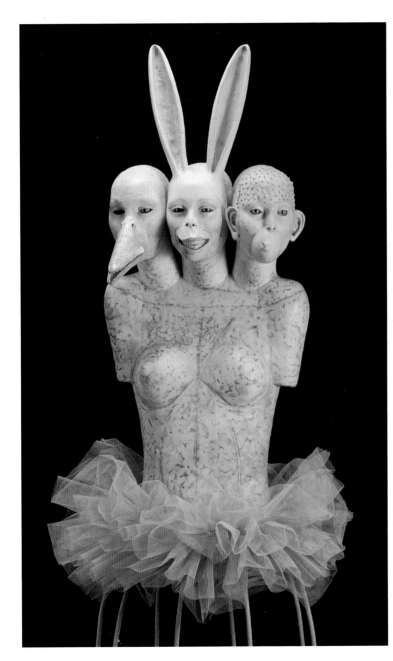

LISA CLAGUE
OPPOSITE PAGE LEFT
Whirligig Rabbit, 2003

58 x 39 x 32 in. (147 x 99 x 81 cm)

Clay; hand built, coiled; metal, wood, low-fire oxides, stains, wax

Photo by Tom Mills

OPPOSITE PAGE RIGHT
Monkey On My Back, 2003

63 x 47 x 32 in. (160 x 119 x 81 cm)

Clay, metal, glass; coiled; low-fired

Photo by Tom Mills

LEFT
Enigma, 2003

80 x 32 x 22 in. (20 x 8 x 6 m)

Clay, metal; coiled; fabric, low-fire oxides, stains, wax

Photo by Tom Mills

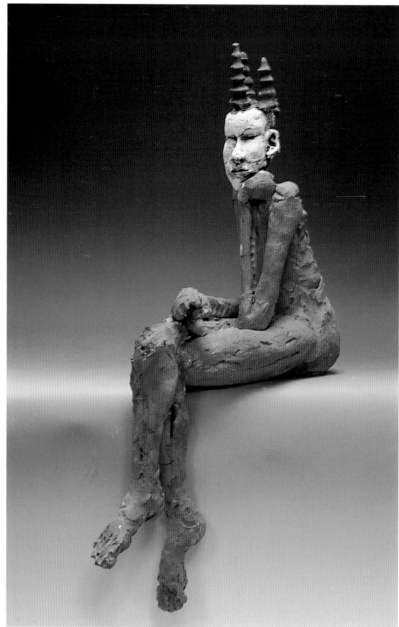

SUSANNAH ISRAEL
Antelope Girl, 2002

50 x 15 x 30 in. (127 x 38 x 76 cm)

Red sculpture clay; coiled, pinched,
slab built; slip glazes and oxides;
cone 3 oxidation

Photo by artist

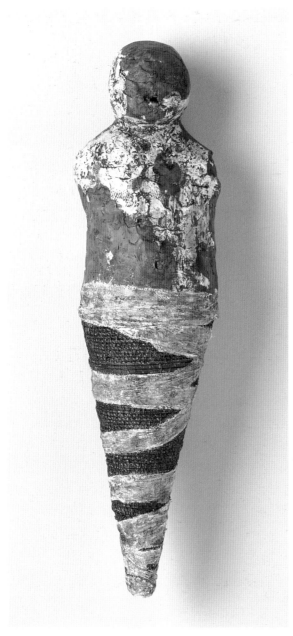

RENEE ROUILLIER
Metamorphism II, 2002

30 x 9 x 6 in. (76 x 23 x 15 cm)

Low-fire clay; hand built; woven rope and
reed, plaster wrap, oxides, slips, glazes

Photo by David Ramsey

This sculpture arose from the world of fairy tales and make-believe. Like a fairy tale, it uses story and the imagination to investigate the nature of things.

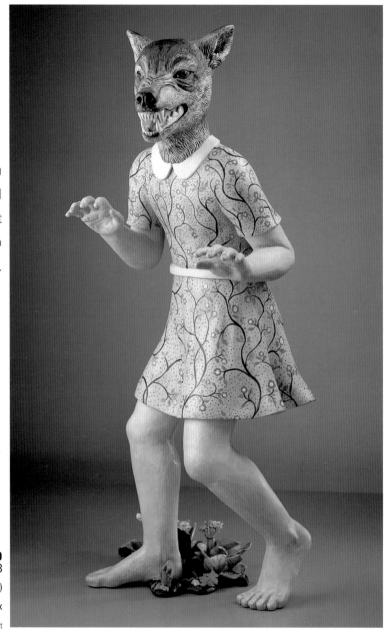

CYNTHIA CONSENTINO
Wolf Girl II, 2003
44 ½ x 23 x 19 in. (113 x 58 x 48 cm)
Clay; coiled, hand built; slip; oils, wax

Photo by artist

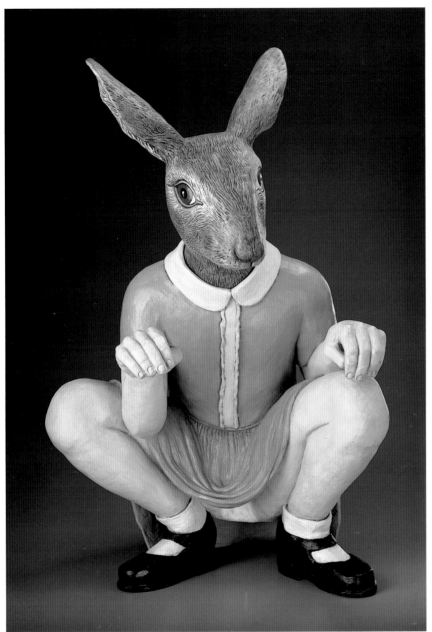

In this piece familiar ingredients are reassembled into unfamiliar configurations. Things are not what one would expect, reflecting the complexity of our cultural experience.

CYNTHIA CONSENTINO
Rabbit Girl, 2003
30 ¼ x 20 x 17 ¼ in. (77 x 51 x 44 cm)
Coil-built clay; oils, wax

Photo by artist

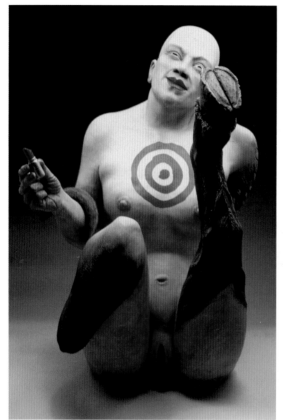

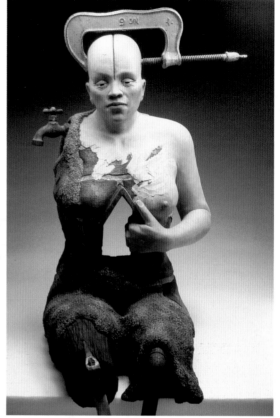

DANA GROEMMINGER
LEFT
Game, 2000

30 x 20 x 20 in. (76 x 51 x 51 cm)

Coiled clay; oils

Photo by artist

RIGHT
Housekeeper, 2000

50 x 21 x 21 in. (127 x 53 x 53 cm)

Clay; coil built, hard slab construction;
oils, axe, clamp, pipe, spigot

Photo by artist

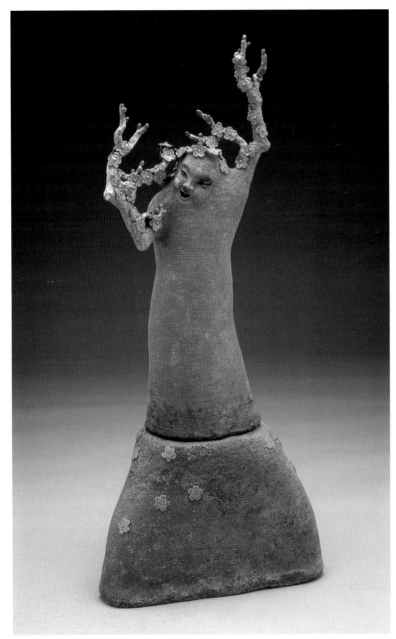

Blossom explores the path and journey of birth and growth, influenced and shaped by the emotional and spiritual experience of life.

ROCHELLE E. LUM
Blossom, 2003

30 ¾ x 13 x 11 in. (76 x 33 x 28 cm)

Clay, stoneware; hand built; raku-fired

Photo by Nathan Chung
Courtesy of del Mano Gallery, Los Angeles

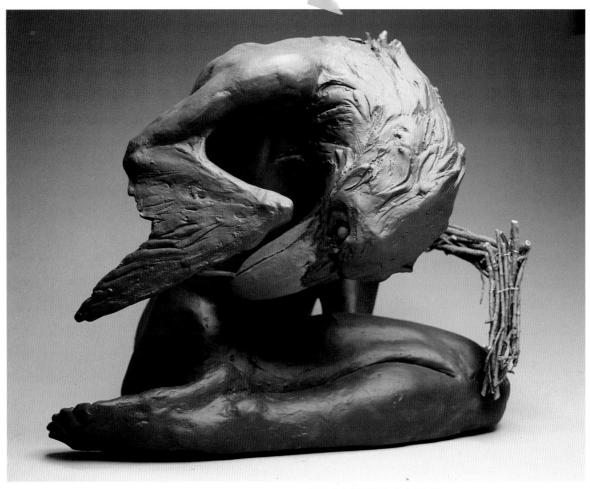

BETH CAVENER STICHTER
She Speaks In Whispers, 2002

22 x 37 x 34 in. (56 x 94 x 86 cm)

Stoneware; built solid, hollowed out; black
porcelain slip, terra sigillata; wire-bound sticks

Photo by artist

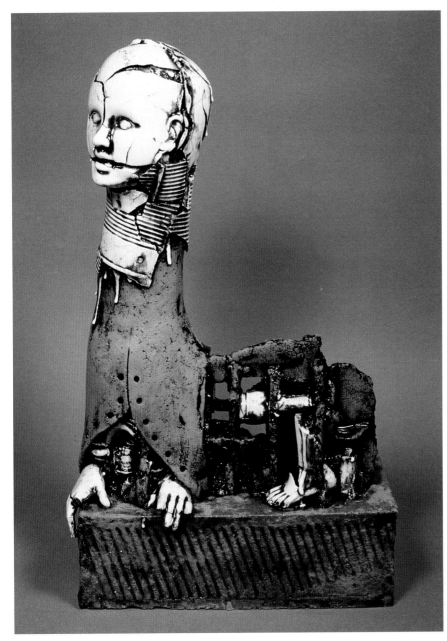

CARA MOCZYGEMBA
Sphinx, 2003

18 x 11 x 5 in. (46 x 28 x 13 cm)

Ceramic; slab built, slip cast; low fired

Photo by artist

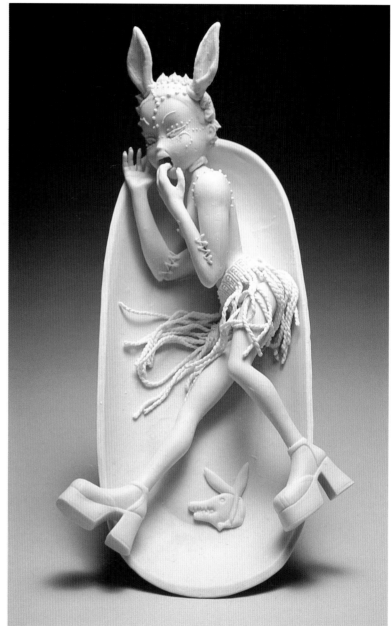

KATY RUSH
Purge Dishgirl, 2002

11 x 6 x 4 in. (28 x 15 x 10 cm)

Porcelain; slip cast, altered; cone 6

Photo by artist

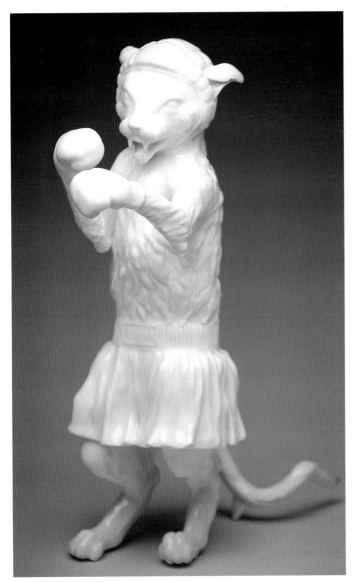

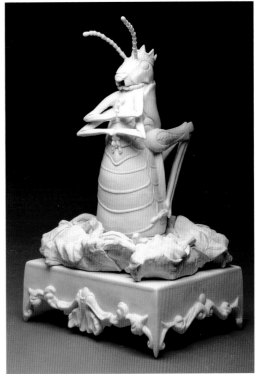

LINDA CORDELL
ABOVE
Por-king, 2000

18 x 10 x 6 in. (46 x 25 x 15 cm)

Handbuilt porcelain

Photo by artist

LEFT
Catfight, 2001

18 x 5 x 10 in. (46 x 13 x 25 cm)

Slipcast porcelain

Photo by artist

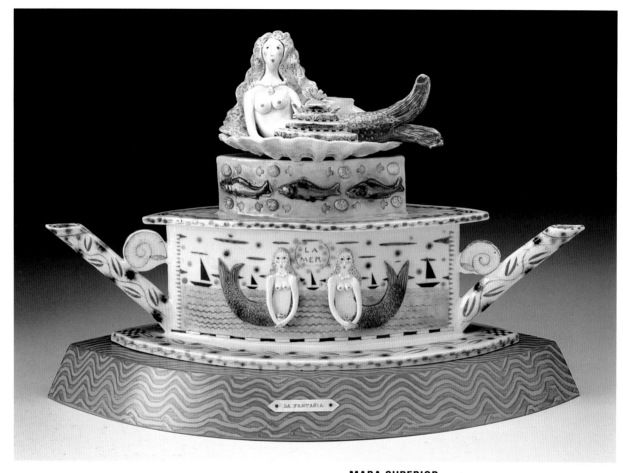

MARA SUPERIOR
Tea by the Sea, 2001

16 x 24 x 10 in. (41 x 61 x 25 cm)

Porcelain; slab construction

Photo by John Polak

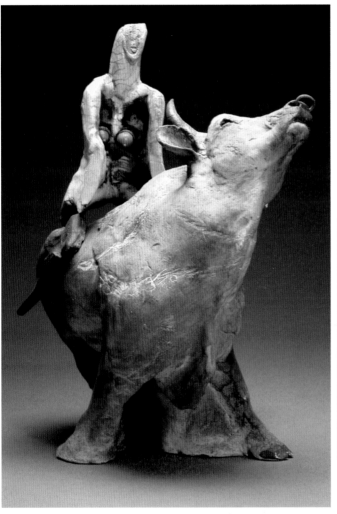

PAMELA EARIUSHAW KELLY
Left
Acorn, 1996

18 x 20 x 12 in. (46 x 51 x 31 cm)

Raku clay; acorns; raku-fired

Photo by artist

Below
Bison 2001, 2001

14 x 19 ½ x 10 in. (36 x 50 x 25 cm)

Molded clay; raku-fired

Photo by artist

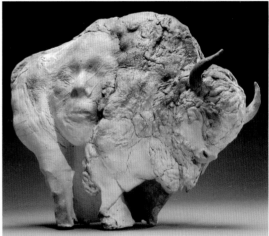

This work features the face of the artist.

When some people go out
into the world they put their
protection on to face the world.
The helmet is a visual metaphor
about what people present them-
selves as. Underneath the
helmet is a full figure.

MARK CHATTERLEY
Woman with Dog-Head Helmet, 2003
81 x 22 x 14 in. (206 x 56 x 36 cm)
Slab-built clay; crater glaze; cone 6

Photo by artist

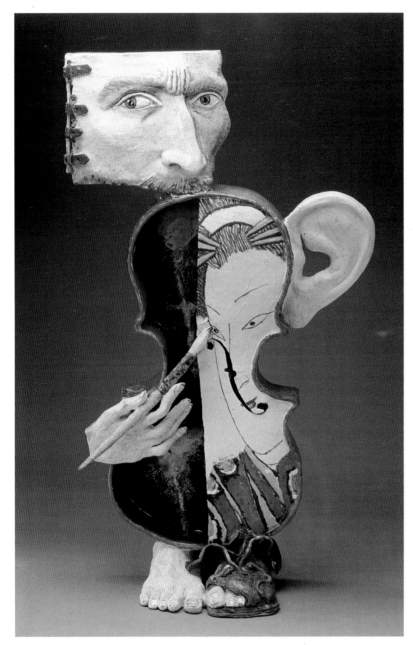

NOI VOLKOV
Colored Music, 2003

27 x 16 x 7 in. (69 x 41 x 18 cm)

Ceramic, earthenware; hand built;
mixed media, metal

Photo by John De Camillo

Time passes by . . .
With his past, history, and symbols
Man faces his own metamorphosis
Surrounded by coded liens and digits
Thus creating a new code-bar
Making out his future

FRANÇOIS RUEGG
OPPOSITE PAGE LEFT
Sunset Blvd. Hotel Rooms # 32, 1999

57 ¾ x 11 ¾ x 12 ¾ in. (147 x 30 x 32 cm)

Porcelain, black clay, metal; slab built; serigraphy, underglazes, overglazes; cone 8, cone 018

Photo by G. Boss

OPPOSITE PAGE RIGHT
Sunset Blvd. Hotel Rooms # 34, 1999

58 1/4 x 11 1/2 x 11 3/4 in. (148 x 29 x 30 cm)

Porcelain, black clay, metal; slab built; serigraphy, underglazes, overglazes; cone 8, cone 018

Photo by G. Boss

LEFT
Sunset Blvd. Hotel Rooms # 33, 1999

57 ¾ x 11 ¼ x 11 ¼ in. (147 x 28 x 28 cm)

Porcelain, black clay, metal; slab built; serigraphy, underglazes, overglazes; cone 8, cone 018

Photo by G. Boss

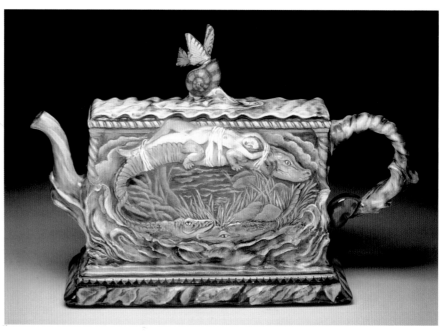

SUSAN THAYER
ABOVE
Farewell Florida, 2001

9 ½ x 13 ½ x 3 in. (24 x 34 x 8 cm)

Slip-cast porcelain; assembled,
carved; China paint

Photo by Deon Reynolds
Courtesy of Ferrin Gallery

BELOW
Something to Worry About, 2001

8 ½ x 12 x 4 ½ in. (22 x 31 x 11 cm)

Slip-cast porcelain; assembled,
carved; China paint

Photo by Dennis Purdy
Courtesy of Ferrin Gallery

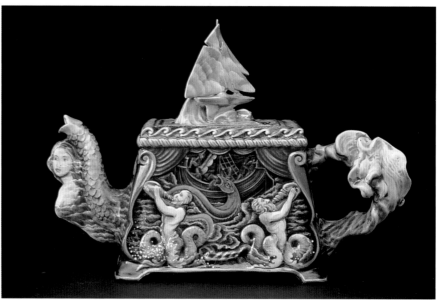

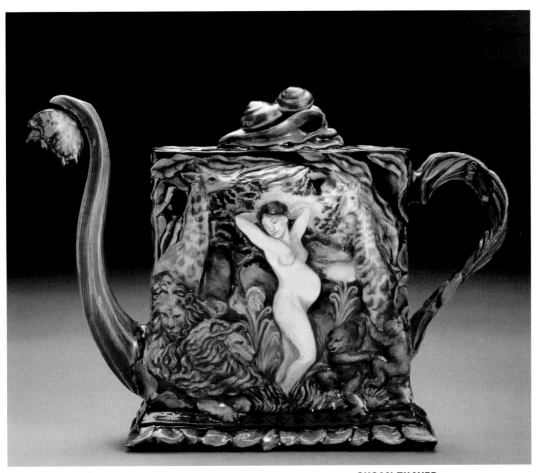

SUSAN THAYER
After the Rain, 1999

7 ¼ x 10 x 2 ½ in. (18 x 25 x 6 cm)

Slip-cast porcelain; assembled, carved; China paint

Photo courtesy of Ferrin Gallery

For many years my interest in mythological and historical narrative found expression in figurative sculpture. Working with mosaics lets me explore the fragmentary nature of our cultural understanding.

MARGARET FORD
Sapere Aude (Dare to be Wise), 2001
38 x 34 1/2 x 1 1/4 in. (97 x 88 x 3 cm)
Low-fire whiteware; underglazes

Photo by artist

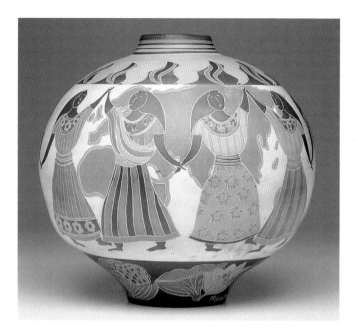

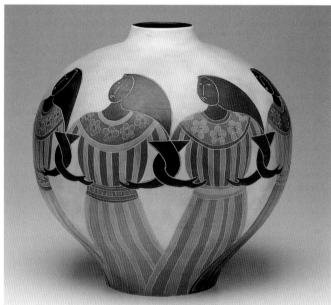

MELISSA GREENE
ABOVE
Love Your Mother, 2003

16 x 16 in. (41 x 41 cm)

White earthenware clay; thrown, carved, burnished;
terra sigillata; fired, lightly smoked

Photo by Ray Michaud

BELOW
Women in Arms, 2001

15 x 16 in. (38 x 41 cm)

White earthenware clay; thrown, carved, burnished;
terra sigillata; fired, lightly smoked

Photo by Ray Michaud

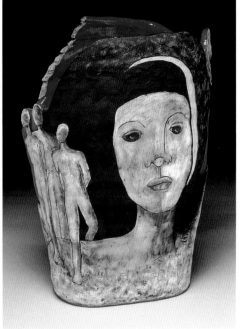

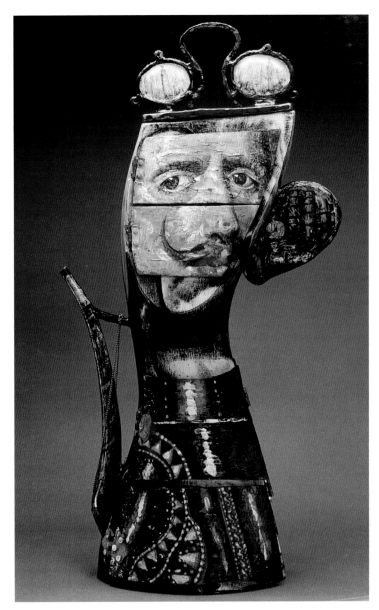

BETH J. TARKINGTON
ABOVE
Eclipse, 2002

17 x 10 ½ x 8 in. (43 x 27 x 20 cm)

Hand built, relief-carved in-the-round; colored slips, stains, underglazes, glazes; multi-fired

Photo by Michael Noa

NOI VOLKOV
LEFT
Double Life, 2003

24 x 14 x 10 in. (61 x 36 x 25 cm)

Earthenware; hand built; mixed media

Photo by John De Camillo

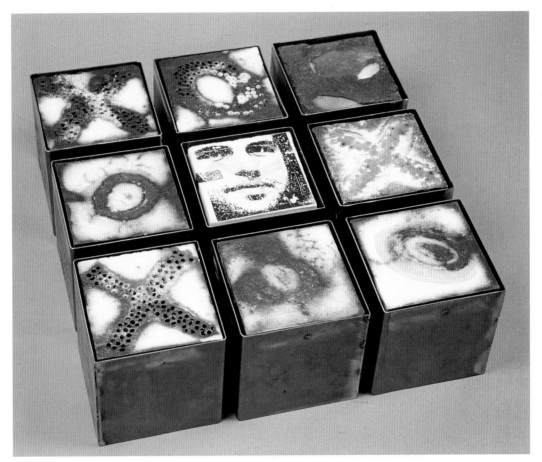

VERBRUGGEN MARC
Inside-Out, 2003

23 ½ x 23 ½ x 6 in. (60 x 60 x 15 cm)

Grogged white stoneware; press molded tiles;
porcelain slips, terra sigillata, metal oxides,
decals; gas multi-fired

Photo by Erwin Mertens

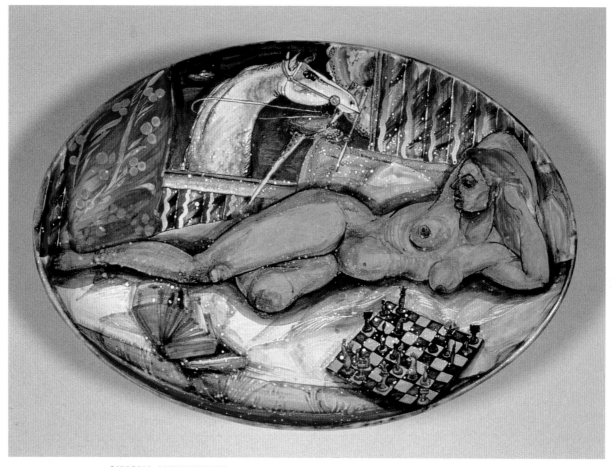

SIMONA ALEXANDROV
Daydreamer (platter), 2001

7 ½ x 10 ½ in. (19 x 27 cm)

Majolica, lusters

Photo by artist

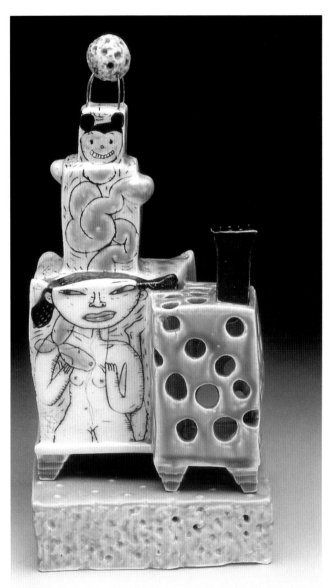

Both figures consider
themselves the winner
of the competition.

KEVIN SNIPES
LEFT
Balloon Animal Competition, 2003

Left: 11 x 5 x 5 in. (28 x 13 x 13 cm)

Right: 5 x 9 x 3 ½ in. (13 x 23 x 9 cm)

Mid-range porcelain; slab built, pinched, carved, incised, inlayed; glazed

Photo by John Knaub

BELOW
Secret Passage Teapot, 2002

5 x 9 x 3 1/2 in. (13 x 23 x 9 cm)

Mid-range porcelain; slab built, pinched, carved, incised, inlayed; glazed

Photo by John Knaub

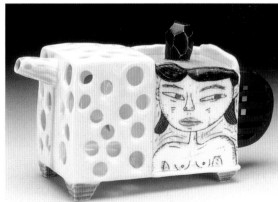

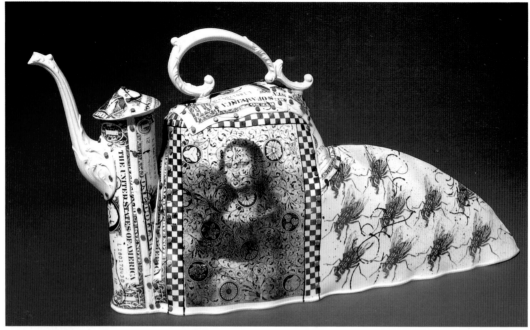

LES LAWRENCE
ABOVE
Teapot, 2003

9 x 3 x 16 in. (23 x 8 x 41 cm)

Slab-built porcelain; monoprint silkscreen, stainless steel

Photo by artist

RON MEYERS
LEFT
Untitled (vase with female nude reclining), 2003

12 x 11 x 11 in. (31 x 28 x 28 cm)

Earthenware; wheel thrown, hand altered; transparent glaze; bisque, glaze fired

Photo by artist
Courtesy of The Signature Shop and Gallery

I made a commitment to do a total stream-of-consciousness painting on this vessel. I had just finished re-reading Steinbeck's *East of Eden* and images dealing with good and evil, sacrifice, temptation, love, death, and truth all came into the painting. These merged with other images from recent dreams and personal relationships to create the visage.

PATRICK L. DOUGHERTY
Are you Experienced?, 2002

40 x 15 ½ in. (102 x 39 cm)

Wheel-formed clay; underglazes, clear glaze; cone 04 oxidation

Photo by Jerry Anthony

MARYANN WEBSTER
Motherboard III, 1999

19 x 15 x 6 in. (48 x 38 x 15 cm)

Porcelain; circuit board fragment,
China paint

Photo by Dennis Haynes

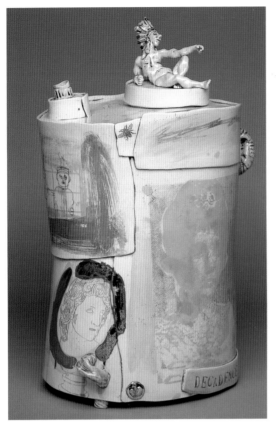

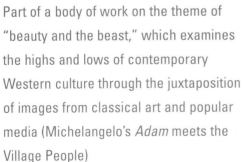

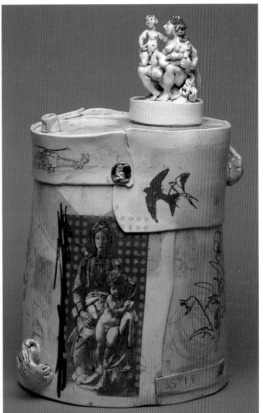

Part of a body of work on the theme of "beauty and the beast," which examines the highs and lows of contemporary Western culture through the juxtaposition of images from classical art and popular media (Michelangelo's *Adam* meets the Village People)

STEPHEN DIXON
LEFT
Decadence, 2000

21 ¼ x 12 ¾ x 10 3/4 in. (54 x 32 x 27 cm)

Earthenware; slab built, modeled, sprigged; underglaze slips, photocopy decals and on-glaze ceramic decals

Photo by Joel Fildes

RIGHT
Asylum, 2001

20 ¾ x 13 x 10 ¾ in. (53 x 33 x 27 cm)

Earthenware; slab built, modeled, sprigged; underglaze slips, photocopy and on-glaze ceramic decals

Photo by Joel Fildes

RUDY AUTIO
RIGHT
Allemande, 2001

25 x 22 x 15 in. (64 x 56 x 38 cm)

Hand-built stoneware; under-
glazes; wood-fired

Photo by Chris Autio

OPPOSITE PAGE LEFT
Sanibel, 2001

34 x 30 x 21 in. (86 x 76 x 53 cm)

Hand-built stoneware; under-
glaze, clear glaze, colored
glazes; cone 3, cone 0/0

Photo by Chris Autio

OPPOSITE PAGE RIGHT
Mankato, 2003

35 x 32 x 25 in. (89 x 81 x 64 cm)

Hand-built stoneware; under-
glaze, clear glaze, colored
glazes; cone 3, cone 0/0

Photo by Chris Autio

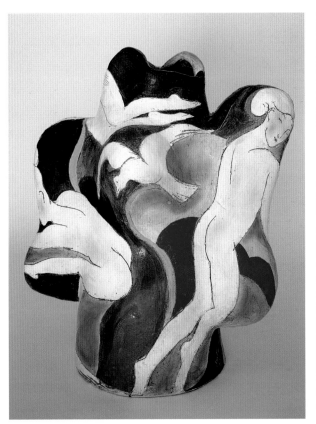

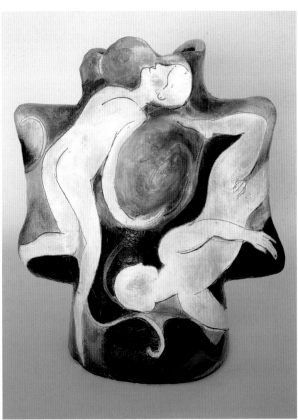

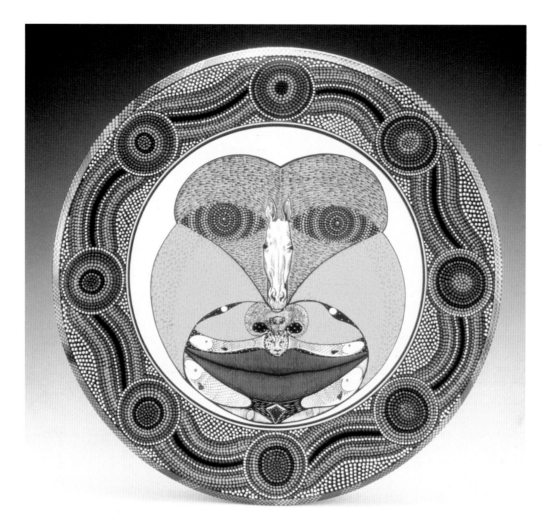

The white horse was a dream messenger that brought along a pearl of wisdom that has had a life-changing effect. Contrary to the saying, the leopard can change its spots.

PATRICK L. DOUGHERTY
Soul Dreamer, 2002

4 x 24 in. (10 x 61 cm)

Wheel-formed clay; underglazes, clear glaze; cone 04 oxidation

Photo by Tim Barnwell

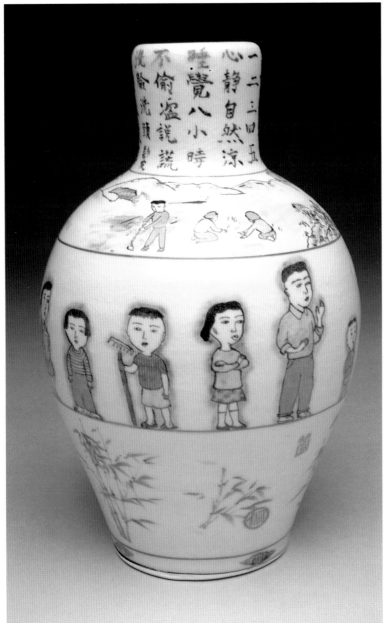

My mother and I have been collaborating lately. She painted the bamboo on the bottom.

BETH LO AND KIAHSUANG SHEN LO
Good Children Vase, 2003

12 x 6 x 6 in. (31 x 15 x 15 cm)

Thrown porcelain; underglazes

Photo by Chris Autio

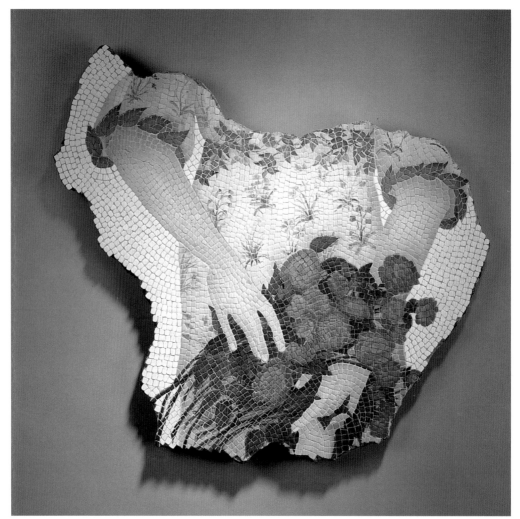

Flora was the Roman goddess of flowers and spring. The image in this fragment is derived from Botticelli's *Primavera,* yet it's rendered in ceramic mosaic to recall the architectural mosaics of ancient Rome.

MARGARET FORD
Flora, 2001
26 x 27 ½ x 1 ¼ in. (66 x 69 x 3 cm)
Low-fire whiteware; underglazes
Photo by Robert Vinnedge

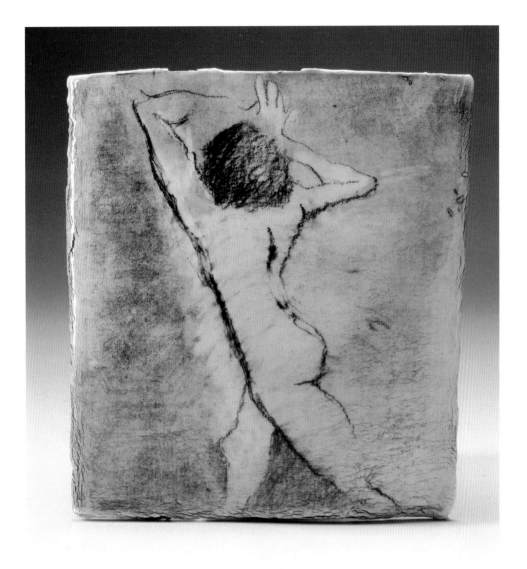

JAN SCHACHTER AND PEGGY FORMAN
Barbara, 2003

1 x 7 ½ x 8 in. (3 x 19 x 20 cm)

Slab-built porcelain; pastel underglaze, underglaze pencils

Photo by John Brennan

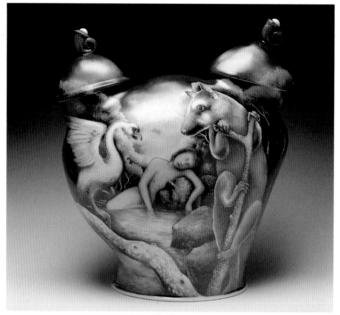

KURT WEISER
ABOVE
Orbit, 2002

17 ½ x 15 x 8 in. (45 x 38 x 20 cm)

Porcelain; overglaze enamel

Photo by artist
Courtesy of Garth Clark Gallery, New York

RIGHT
Roulette, 2002

15 x 17 x 8 in. (38 x 43 x 20 cm)

Porcelain; overglaze enamel

Photo by artist
Courtesy of Garth Clark Gallery, New York

OPPOSITE PAGE
Chihuahua, 2002

19 ½ x 10 ½ x 8 in. (50 x 27 x 20 cm)

Porcelain; overglaze enamel

Photo by artist
Courtesy of Garth Clark Gallery, New York

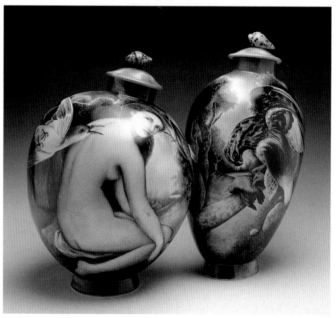

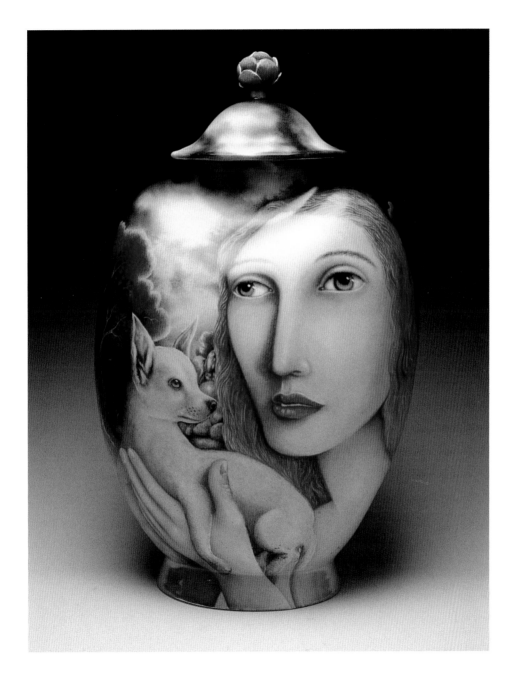

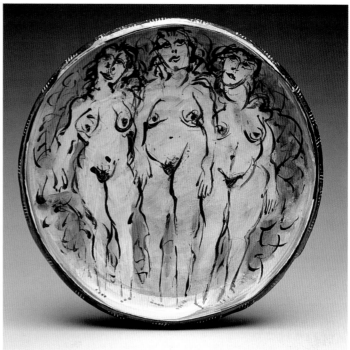

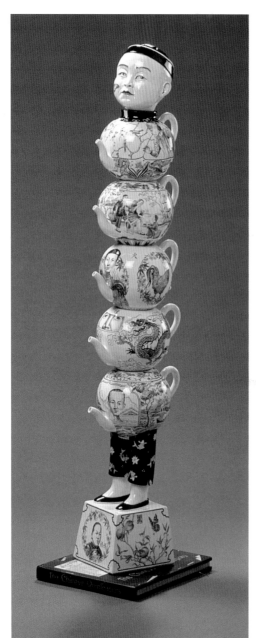

RON MEYERS
ABOVE
Three Graces Platter, 2003

17 in. (43 cm)

Earthenware; wheel thrown, hand altered; transparent glaze;
bisque, glaze fired

Photo by artist
Courtesy of The Signature Shop and Gallery

RED WELDON SANDLIN
LEFT
The Chinese Quin Teapots, 2003

38 x 5 ½ x 5 ¾ in. (97 x 14 x 15 cm)

Ceramic pots: hand coiled, legs: slab built

Head: sculpted; Chinese blue one stroke underglaze, low-fire
clear glaze

Photo by Charlie Akers
Courtesy of Ferrin Gallery

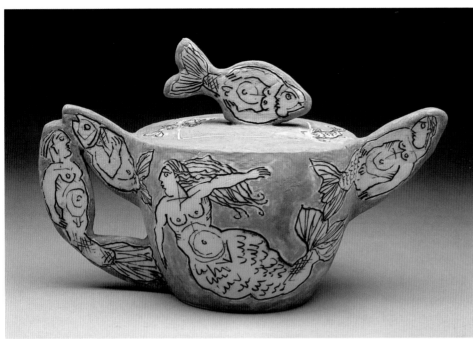

MATTHIAS OSTERMANN
LEFT
Tea Pot Vessel Mermaid,
2002
9 ½ in. (24 cm)

Earthenware; clay sgraffito,
copper wash, colored
vitreous engobes, dry-smudged
colored stains; 1904°F (1040°C)
oxidation multi-fired

Photo by Jan Thijs
In the collection of Sonny and Gloria Kamm

BELOW
Sculpture House, 2002

12 3/4 in. (32 cm)

Earthenware; clay sgraffito,
copper wash, colored vitreous
engobes, dry-smudged
colored stains; 1904°F (1040°C)
oxidation multi-fired

Photo by Jan Thijs
Courtesy of Prime Gallery, Toronto

At present, all of my work makes some kind of allusion to the human figure, either as a mythological reference (i.e., *Tea Pot Vessel "Mermaid"*) or, more relevantly, in the context of some kind of human drama. Figures interact to create a narrative or allegory that might describe existing human realities and conflicts, and our ways of dealing with them (or not). The ceramic vessel still remains a potent metaphor for the human being as a container—of our inner life, our spirit, and our creativity.

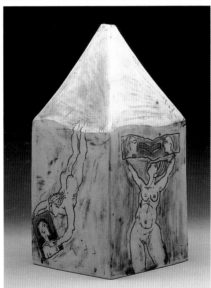

ACKNOWLEDGMENTS

To the 1,200 artists who answered our call for art: It was a pleasure and a privilege to view your work.

Leslie Ferrin, your commitment and patience were essential to our success. Your knowledge, intelligence, and good humor came in handy, too.

Stacey, we assembled terrific artworks for this book, but it's your design that invites the reader to savor each piece. Lance, your work on the production always makes for a great-looking book. Melanie and Jason, your contributions didn't go unnoticed by me.

Deborah, Suzanne, and Rob, you provided much-appreciated editorial guidance. Delores, Rosemary, Nathalie, and freelance copyeditor and proofreader Marilyn Hastings, your labors were behind the scenes, but your hard work shows on every page. Rebecca, Meghan, Kalin, and Ryan, the book and I benefited from your timely assistance.

Thank you.

Veronika Alice Gunter, Editor

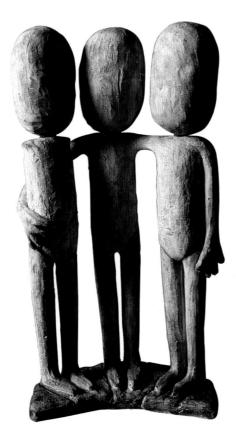

MELISSA STERN
Three Friends, 2003
Photo by Garry McLeod

ARTIST INDEX